New Mexico

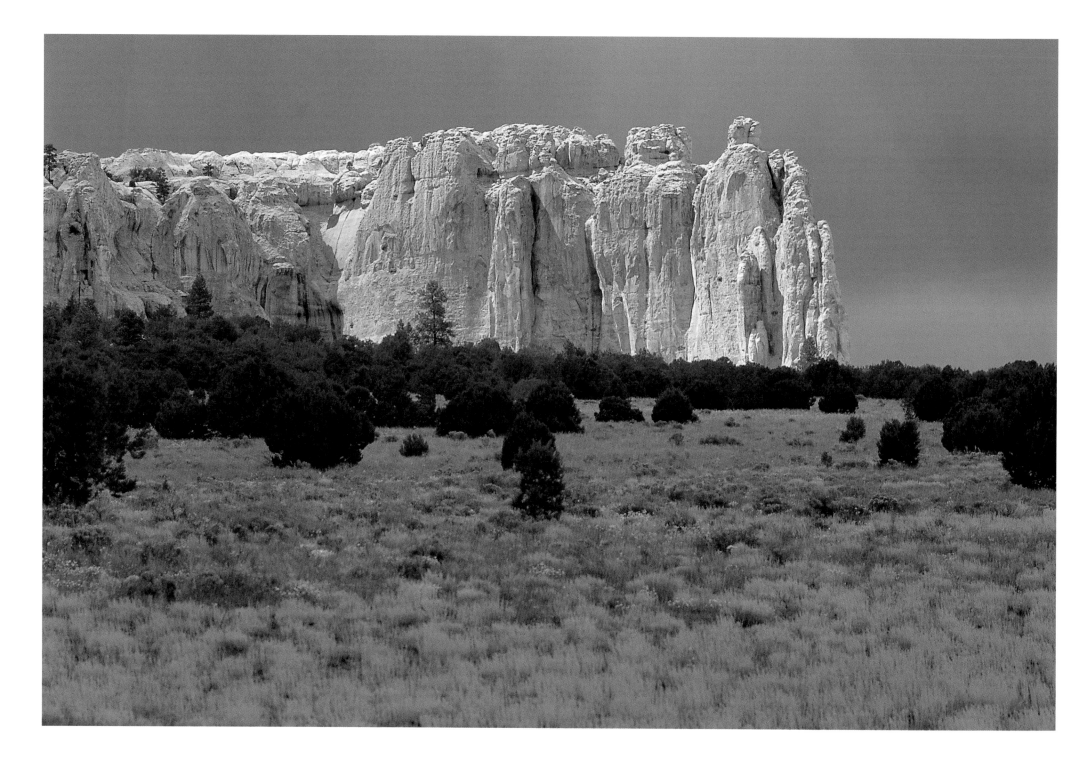

New Mexico

IMAGES OF A LAND AND ITS PEOPLE

LUCIAN NIEMEYER

Foreword by GOVERNOR BILL RICHARDSON

Text by ART GÓMEZ

UNIVERSITY OF NEW MEXICO PRESS ALBUQUERQUE

10 09 08 07 06 05 04 1 2 3 4 5 6 7

Library of Congress Cataloging-in-Publication Data

Niemeyer, Lucian.

 New Mexico : images of a land and its people / Lucian Niemeyer ;
foreword by Bill Richardson ; text by Art Gómez.

 p. cm.

 ISBN 0-8263-3257-9 (cloth : alk. paper)

 1. New Mexico—Pictorial works. 2. New Mexico—Social life
 and customs—Pictorial works. 3. Landscape—New Mexico—Pictorial works.
4. New Mexico—Description and travel. I. Gómez, Art, 1946– II. Title.

 F797.N54 2004

 978.9—dc22

 2004010600

Printed and bound in Singapore by Tien Wah Press ⊠ Design and Composition by Melissa Tandysh

Lyrics from *New Mexico Rain* by Michael Hearne appear courtesy of Michael Hearne.

FRONTISPIECE: Inscription rock at El Morro National Monument

For Heather and Andrew,

who made this journey possible.

Contents

Foreword

New Mexico tells many stories. The struggles and celebrations of people in a land both nurturing and hostile. A landscape of dramatic beauty that evolves in response to a greater force. A subtle interweaving of people and land, cultures and ethnicities, that at times almost disappears, only to re-emerge later with greater clarity and strength.

Numerous writers, artists, and musicians have told these stories. Willa Cather, in *Death Comes For the Archbishop*, wrote of the arrival of a French priest, Bishop Lamy, who struggled to tame the ancient land and people, only to discover that he was the one truly transformed by his encounters with New Mexico and its cultures. Georgia O'Keeffe, who painted the landscape of Abiquiú with such awe and respect believed in the power of the land itself to transform the human soul. But maybe Nat King Cole best captured New Mexico for modern-day road warriors who hope to "get their kicks on Route 66."

In their masterful book, *New Mexico*, Lucian Niemeyer and Art Gómez have created another thoughtful, beautiful text that will be appreciated by both those who know New Mexico and those who have yet to experience our state. Niemeyer's photographs capture the amazing diversity of our landscape. From the snow- and tree-covered mountains of the north to the mesmerizing clarity of the desert of White Sands, the images reward us with an ever-changing spectacle. The diversity of our landscape is matched only by the diversity of our people. I believe, and am proud to say, that New Mexico presents to the twenty-first century a model for American society. Multicultural, environmentally aware, proud, and respectful—these are just some of the attributes New Mexicans have which they willingly share with the rest of the world. I consider this book part of the rich gift that New Mexico offers to others.

I am fortunate that outside of the Governor's Office are many of the photographs in this book. Every day visitors comment on the images that line the hallway. Yesterday a mother recognized her daughter at a fiesta; last week an officer remembered a trip to Lake Quemado with his father. Having had the privilege of traveling throughout New Mexico, I, too, glance at the photographs and remember the pride of the chile farmer, the Balloon Fiesta, the smell of rain. The photographs hold not only memories, but also a promise. Sealed long ago, this promise is for everyone who comes to New Mexico: you will never forget, you will never leave, you will always be remembered.

BILL RICHARDSON

Governor of New Mexico
Capitol-Santa Fe, 2004

New Mexico has a unique character as a member of the United States. Its human history is as old as any in this country. Ancestral Puebloans and their predecessors lived in the *Land of Enchantment* many millennia before the Spanish and the Anglos. They left ruins and artifacts throughout the state and their descendants live and practice their old traditions, passed on in the oral manner, much the same as they did. The traditions of Native Americans permeate the character of the populace via their ceremonies and practices. The Puebloans teach us that time, relative to humans, relates to eons and that each individual has a responsibility to his or her ancestors and to future generations. It is a quality lacking in many Americans. Each of the Puebloans' lives has meaning found through a process that becomes the basis of who they are and the placement of their life's endeavors.

In the 1500s, Spanish explorers entered this land from Mexico seeking the famous seven cities of gold of Cibola. Instead, they found a series of pueblos and tribes that lived along rivers throughout the state as the Conquistadors pressed north and east. They returned to Mexico with their stories. Soon, adventurers and Catholic missionaries moved to colonize the land where the Puebloans and other Native Americans lived. The priests and brothers created missions at the pueblos, converting Native Americans to Christianity even

as Puebloans retained their native customs. The traditions of Native Americans and Catholicism combined with the Spanish culture of horse, music, food, color, and language. All came together to form the cultural background of contemporary New Mexicans, be they Native American, Hispanic, Anglo, Jewish, and so many others.

While the topography of the state is elevated and the north-south mountain corridors follow well-known rivers, it is the desert air, extraordinary light, and climate that rule the lives of New Mexicans. The *Camino Real* was the main north-south highway from earlier times. It led from Mexico City to Española just north of Santa Fe. Basque sheepherders from Spain found the land inviting and raised their flocks throughout New Mexico as did cattle ranchers. Miners came and found riches. Drillers found abundant oil and gas. A main route of western European migration led over the Santa Fe Trail, which terminated just south of the Rockies in Santa Fe. As lumber and mining interests grew, railroads were constructed to carry the riches to eastern refineries and markets. Later, Routes 66 and 40 would add to the migration corridors, increasing the speed and accessibility of the southern route around the Rockies that headed west. Santa Fe was thus an important crossroads. Travelers found New Mexico inviting and settled here. The warm

Preface

LUCIAN NIEMEYER

Santa Fe, 2004

sunny days with cool, star-filled nights are precious to its inhabitants. There is an ease in the population that revels in its festivals, dances, music, and food.

This is a special state in the union. Much of western lore known universally by Americans was written by authors who chose to live in Santa Fe and Taos. So when one reads of the Gila, Mogollon, or Sawtooth Mountains, or one sees the names Rio Grande, Canadian or Pecos Rivers in literature, many times the story was set in New Mexico. The art created by New Mexicans is world famous and is the trademark of the style called *Santa Fe*. When I go out of the country and tell people that I am from New Mexico the question always follows: "Where in Mexico is that? North or South?" When I say I am from Santa Fe, they reply, "Ah, yes, we know Santa Fe." Earthtones, starry cool nights, sunny days, brilliant light, Rocky Mountain highs with towering ponderosa and quaking aspen, adobe homes with cool fountains in atriums, beautiful winding rivers, blue lakes, hot springs, Pueblo dances, piñon wood fires, cowboys and ranches, enchiladas, and the classic guitar of the Spanish troubadour playing to the dance of Flamenco—yes, New Mexico is the *Land of Enchantment*.

This book would not have been possible without the help of so many people. John Glass always pointed me in the right directions. Nancy Warren and Marc Simmons's fine book,

New Mexico, and other works led me to so many places. The *Penitentes* in Mora; the museum staff of Rancho de las Golondrinas; the committee staffing of the Albuquerque Balloon Fiesta; Bonita and Michael Kernodle; Mary and Henry Street of Ponderosa Winery; Cumbres & Toltec Scenic Railroad manager Dan Ranger; Arturo Valdez; Julian Prada; Mike Taylor; Bill Baxter; and "Indian" Joe; along with many others offered valuable advice and assistance. I photographed the book using a Leica SLR R-7 with a variety of lenses from 35mm to 560mm. I shot with Agfachrome 100 and Provia 100. No filters or artifical light was used. No images were manipulated.

I also wish to thank Luther Wilson at the University of New Mexico Press, who immediately embraced the book proposal and published it. Melissa Tandysh was creative in her design.

I thank my partner and wife, Joan, who traveled the whole mile with me and is my most important critic. I thank also Art Gómez, who wrote the sensitive essay for the book with a rare passion and insight, and Penny, his wife. I also thank Governor Bill Richardson and his wife Barbara for their support and his foreword. I thank my maker for bringing me to this wonderful land, which Joan and I have adopted.

OPPOSITE: La Ventana Natural Arch in the El Malpais National Monument on Route 117. El Malpais is a lava-strewn badland, the result of volcanic activity eons ago.

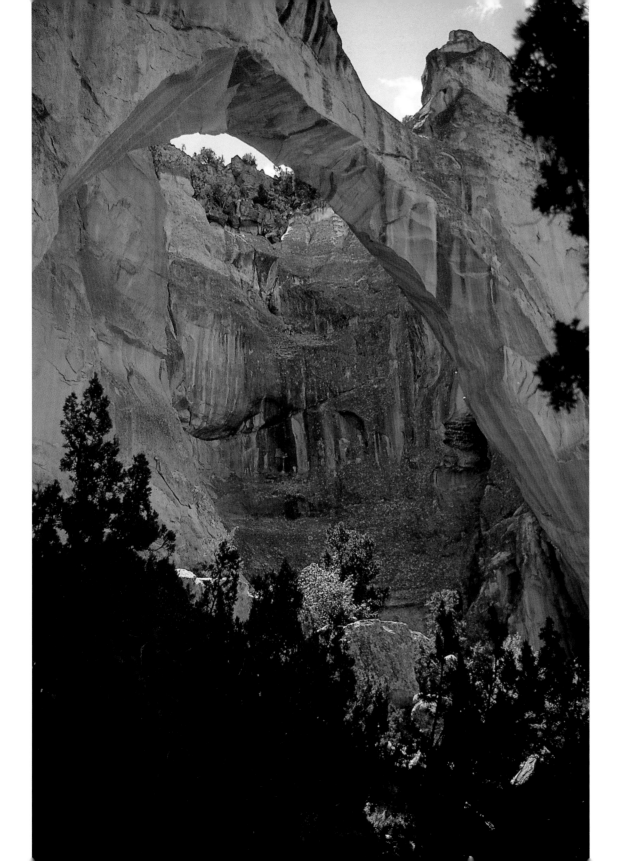

For Ray and Verna,
loving parents and devout *nuevomexicanos.*

New Mexico

IMAGES OF A LAND AND ITS PEOPLE

ART GÓMEZ

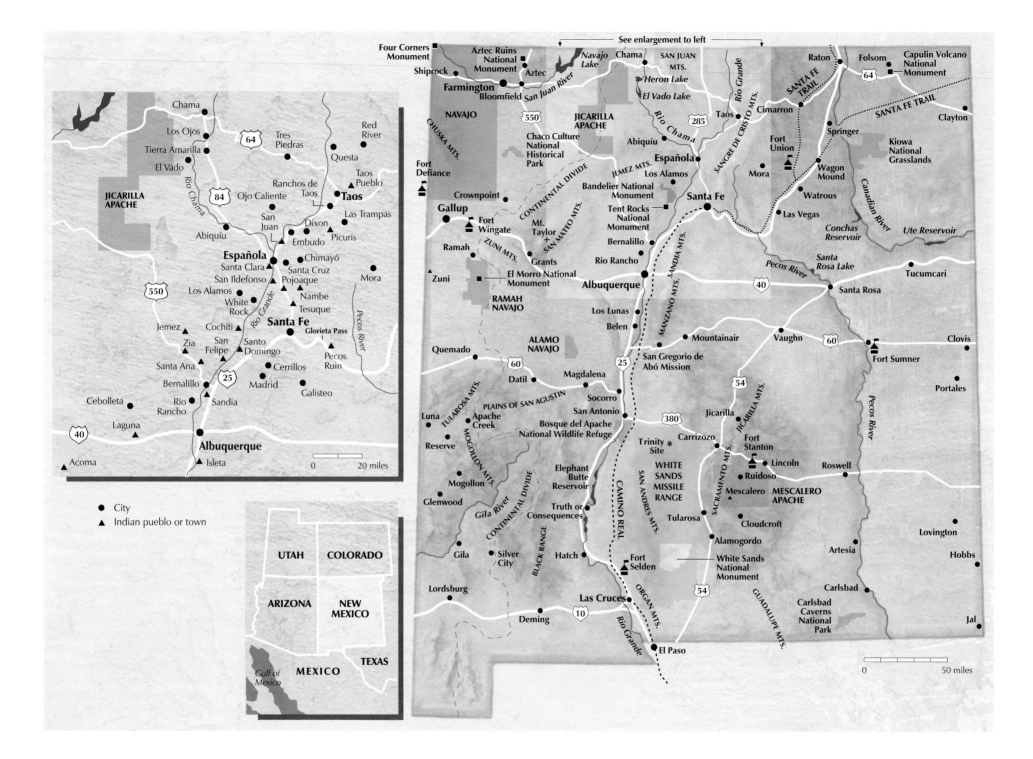

See enlargement to left

Main map labels:

Four Corners Monument
Aztec Ruins National Monument
Aztec
Navajo Lake
Chama
SAN JUAN MTS.
Raton
Folsom
Capulin Volcano National Monument

Shiprock
Bloomfield
San Juan River
Heron Lake
Rio Grande
64

Farmington
NAVAJO
550
JICARILLA APACHE
El Vado Lake
Rio Chama
SANTA FE TRAIL
SANTA FE TRAIL
Clayton

Chaco Culture National Historical Park
Taos
285
Cimarron
Springer
Kiowa National Grasslands

Fort Defiance
CONTINENTAL DIVIDE
Abiquíu
SANGRE DE CRISTO MTS.
Fort Union
Wagon Mound
Canadian River

Crownpoint
JEMEZ MTS.
Española
Mora
Watrous

Gallup
Fort Wingate
Mt. Taylor
SAN MATEO MTS.
Bandelier National Monument
Los Alamos
Santa Fe
Las Vegas
Conchas Reservoir
Ute Reservoir

Ramah
ZUNI MTS.
Grants
Tent Rocks National Monument
Bernalillo
Santa Rosa Lake
Tucumcari

Zuni
El Morro National Monument
Rio Rancho
SANDIA MTS.
Pecos River
40
Santa Rosa

RAMAH NAVAJO
Albuquerque
MANZANO MTS.

Los Lunas
Clovis

ALAMO NAVAJO
Belen
Mountainair
Vaughn
60
Fort Sumner
Portales

Quemado
60
Magdalena
25
San Gregorio de Abó Mission
54
Jicarilla
JICARILLA MTS.

Luna
TULAROSA MTS.
PLAINS OF SAN AGUSTIN
Socorro
380
Carrizozo
Fort Stanton
Lincoln
Roswell

Apache Creek
MOGOLLON MTS.
San Antonio
Bosque del Apache National Wildlife Refuge
Trinity Site
Fort Stanton
Ruidoso

Reserve
Elephant Butte Reservoir
WHITE SANDS MISSILE RANGE
SACRAMENTO MTS.
Mescalero
MESCALERO APACHE

Mogollon
SAN ANDRES MTS.
Tularosa
Cloudcroft

Glenwood
Gila River
CONTINENTAL DIVIDE
Truth or Consequences
CAMINO REAL
Alamogordo
Artesia
Lovington

Gila
Silver City
BLACK RANGE
Hatch
Fort Selden
White Sands National Monument
Carlsbad
Hobbs

Lordsburg
54
GUADALUPE MTS.
Carlsbad Caverns National Park

Deming
Las Cruces
ORGAN MTS.
10
Rio Grande
Jal

El Paso

0 50 miles

Enlargement (top left):

Chama
Los Ojos
Tierra Amarilla
Tres Piedras
Red River
64

El Vado
Rio Chama
Questa
Ranchos de Taos
Taos Pueblo
Taos

JICARILLA APACHE
84
Ojo Caliente
Las Trampas

Abiquíu
San Juan
Dixon
Picuris

550
Embudo
Española
Chimayó
Santa Clara
Santa Cruz
Mora

San Ildefonso
Pojoaque
Los Alamos
Nambe
Tesuque

White Rock
Santa Fe

Jemez
Cochiti
Santo Domingo
Glorieta Pass
Pecos River

Zia
San Felipe
Pecos Ruin

Santa Ana
Cerrillos
25
Madrid
Galisteo

Cebolleta
Bernalillo
Rio Rancho
Sandia

Laguna
40

Acoma
Isleta
Albuquerque

0 20 miles

State inset map:

UTAH COLORADO
ARIZONA NEW MEXICO
MEXICO TEXAS
Gulf of Mexico

● City
▲ Indian pueblo or town

Cottonwood seeds in the Bosque del Apache National Wildlife Refuge in the spring.

Introduction

*T*HERE IS A LYRIC THAT SAYS: "If I ain't happy here, I ain't happy nowhere, New Mexico rain when my mind starts to roam." This popular song by Santa Fe recording artists Bill and Bonnie Hearn is for some a pledge of allegiance to an austere yet mystifying subregion of the West. For those of us who embrace New Mexico as home, it is not surprising to hear others marvel at its "unique" or "unusual" attributes. Across the centuries, ardent diarists, literary devotees, and artistic impressionists declared their profound admiration for this land. Its haunting beauty, resolute ethnicity, and engaging history fueled their imaginations. Equally impressive, though perhaps less apparent to most newcomers, New Mexico is a place of extraordinary superlatives.

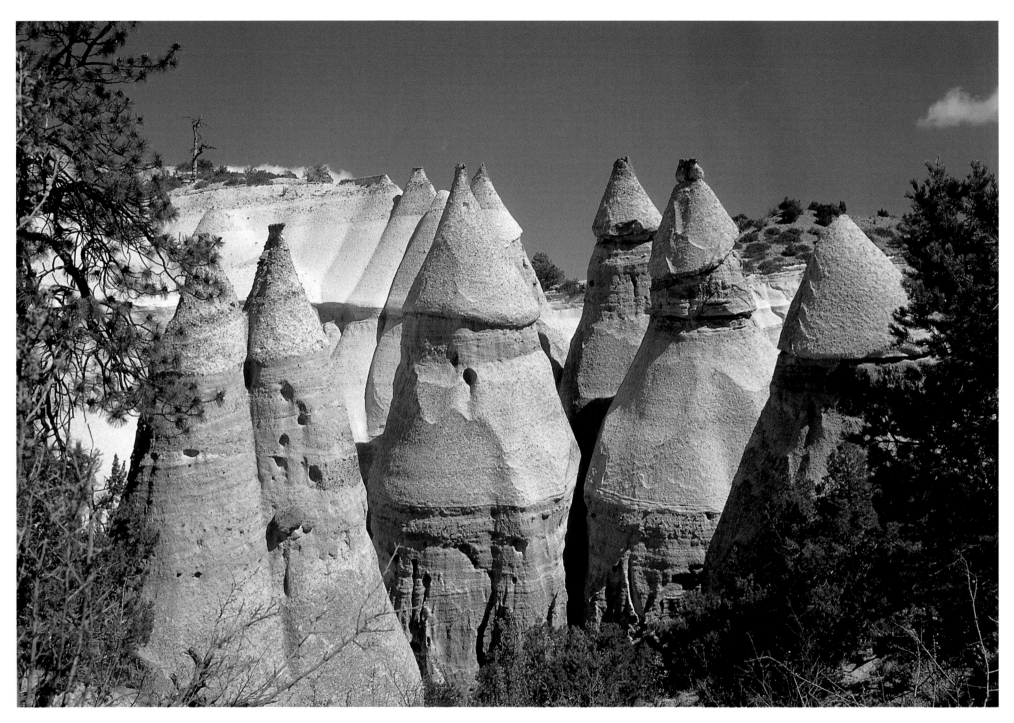

Tent Rocks National Monument near Cochiti Pueblo is also known as *Kasha Katuwe*.

The northern part of the state claims Santa Fe, the nation's oldest European settlement west of the Mississippi River. In 1992, the World Heritage Committee distinguished Taos, northernmost of the state's nineteen pueblos, as the oldest continuously inhabited community in North America. Clovis, located in eastern New Mexico, and Folsom, near the Colorado–New Mexico border, claim to be the earliest known human occupation sites in the United States. In operation since 1803, the Santa Rita del Cobre Mine near Silver City may be the nation's oldest producing copper mine. The southern portion of the state harbors other remnants of Spanish colonial occupation. Faint traces of the Camino Real de Tierra Adentro, America's first government-sponsored transnational highway, parallel Interstate 25—the road's modern counterpart. Meanwhile, the Trinity Site, located just north of Alamogordo, stands in mute yet somber testimony to global modernization and the dawn of the nuclear age.

Despite this remarkable litany of precedents, few if any books have captured the full range and complexity of the state's epic history. New Mexico's geographic disparity limited early undertakings to a regional rather than a comprehensive treatment. Exhaustive analyses of Spanish colonization and territorial government often diminished or completely ignored New Mexico's outstanding achievements since state-hood. Scientific advancements coupled with the

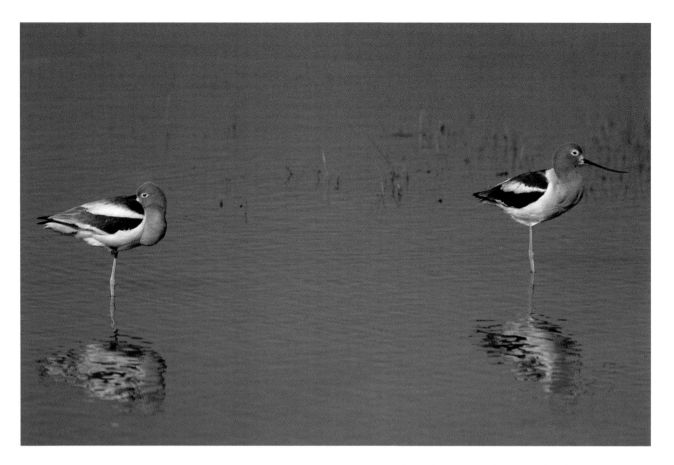

American avocets, *recurvirostra americana,* in the Bosque del Apache National Wildlife Refuge.

unprecedented production of strategic minerals confirm the state's lasting contribution to postwar development and national prosperity in more recent centuries. Other publications glamorize military conquest and religious evangelization while minimizing the significance of frontier adaptation and cultural coexistence. Until recently, only a handful of authors addressed the contributions of determined farmers, resourceful tradesmen, industrious ranchers, resilient miners, independent lumbermen, and itinerant laborers. Their story contributes as much to the New

Mexico chronicle as the exploits of Coronado, Oñate, Anza, Carson, Bent, Lamy, and other more notable personalities.

The difficulty in undertaking a comprehensive visual and narrative overview such as this lies in the constant interplay between the natural and cultural forces that have shaped the state's character since the prehistoric age. Moreover, there is no easy way to gauge the extent to which aridity, geographic isolation, resource exploitation, linguistic separation, and cultural interdependency still govern the lives of New Mexicans today. If ever a state represented a mosaic of its rich ancestral past, contemporary

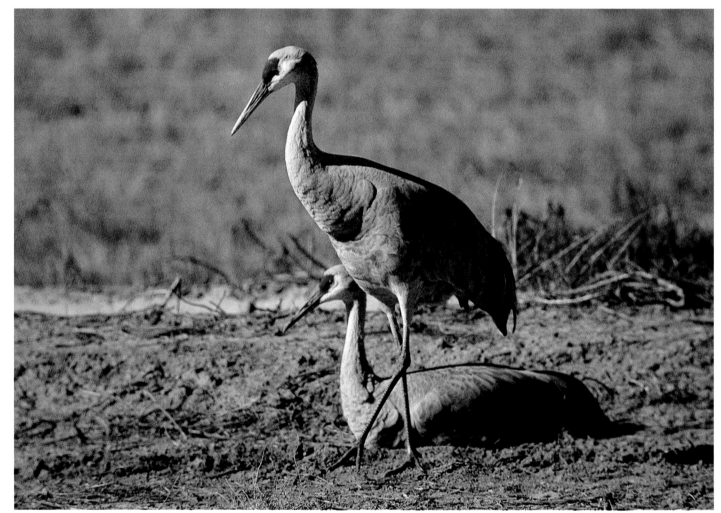

Sandhill cranes, *grus canadensis,* Bosque del Apache National Wildlife Refuge. From November to March sandhill cranes winter here in great numbers.

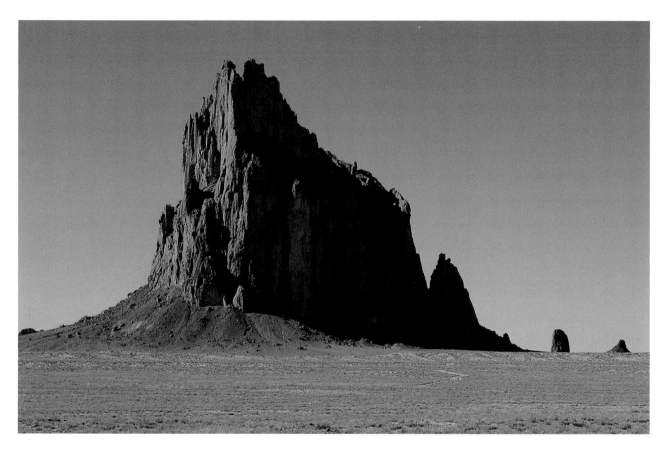

Ship Rock was a guide for early settlers traveling through the Four Corners region in northwestern New Mexico.

New Mexico casts a mirror image. Throughout its history, three distinct cultures have jockeyed for preeminence, none ever achieving complete domination over the other. The resilience of the Pueblo communities in the wake of Spanish intrusion, for example, invoked a strategy of adaptive coexistence that proved expedient to their survival under extreme circumstances.

The violence that marked the Europeans' early *entradas* gradually gave way to pragmatic accommodation between two assertive cultures.

The subsequent arrival of white Americans in 1848, bent on imposing Anglo values onto the preexisting society, galvanized Pueblo and Hispano resolve to preserve their ethnic integrity. Both sought to appease the English-speaking intruders with minimal compromise of their own valued traditions and religious convictions. Selective adaptation explains in part how, despite the traumatic disruption to the Pueblo world beginning in the sixteenth century, nineteen indigenous communities

Early morning in August on the San Agustin Plain on Route 12.
During the rainy period the once arid desert turns green and colorful with wildflowers.

survived to the present day. Although many endured physical dislocation after the insurrection of 1680, the Pueblo people basically inhabit the same locales where Spaniards first encountered them nearly five hundred years ago. In similar fashion, the persistence of the Spanish language and the Roman Catholic faith in the backwash of successive waves of Protestant migrations to the region affirms the sustainability of Hispano culture throughout the American Southwest. Recent immigration in increasing numbers from Mexico and Central America only strengthens the vitality of New Mexico's Hispano/Latino legacy.

For the purpose of this book it seemed practical to view New Mexico in the context of the natural and cultural corridors that have consistently influenced its historical development. Lakes and rivers make up less than one percent of the state's total land surface, the lowest water-to-land ratio among all of the fifty states. Not surprisingly, the Rio Grande—the state's most prominent natural feature—defined all manner of human and non-human activity in New Mexico throughout its long history. Corridors can be physical, such as El Camino Real, the Santa Fe Trail, the Denver & Rio Grande and the Santa Fe Railroads, Route 66, and the Interstate Highway system. Their presence advanced the cattle and sheep industry, mining and lumbering communities, oil and gas activities, as well as scientific research and technology. Corridors were also spiritual, such as the Franciscan-built missions and the Penitente *moradas* that became agents for the

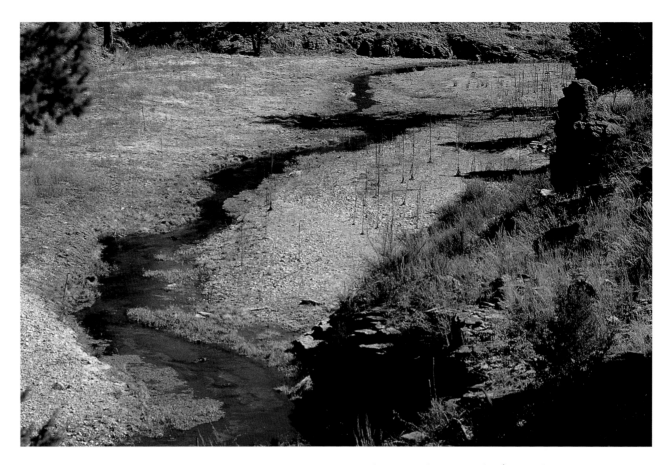

transference of culture and religion. Others, like the remnants of frontier military installations or the discernible alignment of air force bases that today link Albuquerque to Clovis, served as conduits for New Mexico's pervading military influence. The multiple corridors that have shaped the state's history are geographic overlays in which various cultures interacted and coexisted. The use of natural and cultural corridors hopefully provides the reader with a framework to better comprehend and appreciate the events that forged New Mexico into

A mountain stream in the Zuni Mountains on Route 400 in the Cibola National Forest. The wetlands in the mountains act like a sponge releasing water slowly, so that growth is maintained over time.

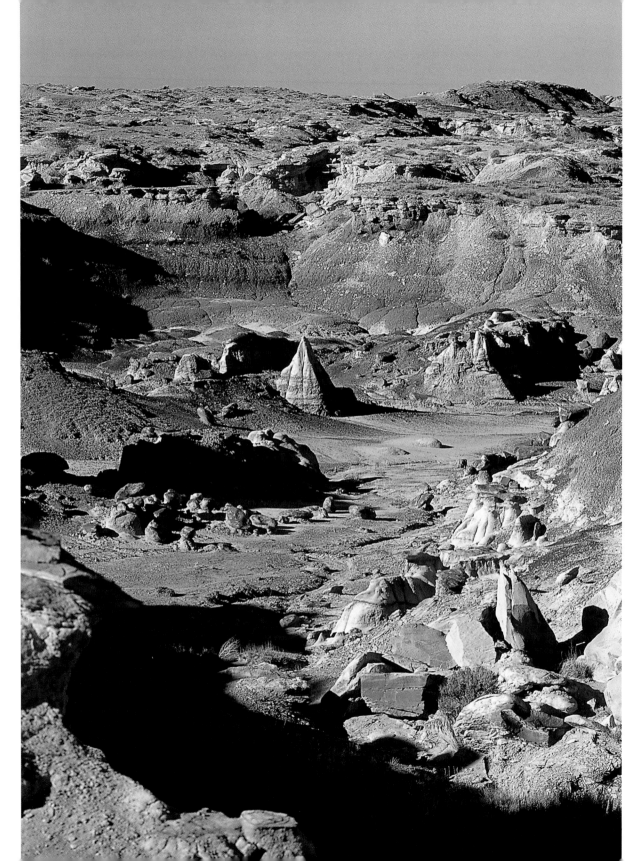

Bisti/De-na-zin Wilderness just northwest of Chaco Canyon has a lunar-type landscape that has been celebrated by artists including Georgia O'Keeffe.

El Malpais National Monument looking west from La Ventana Natural Arch on Route 117.

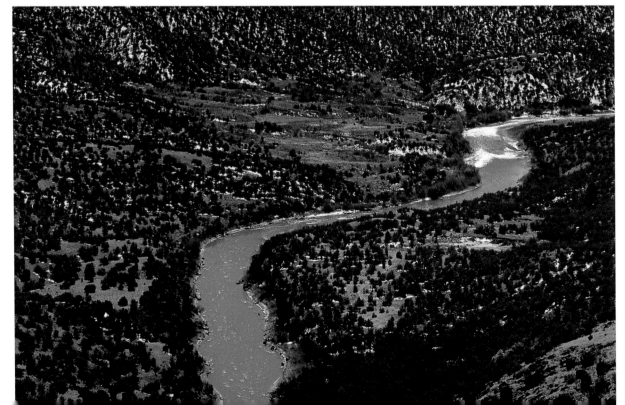

The Rio Grande has been an important north-south corridor for humans and nature for ages. Looking south from the park overlook in White Rock.

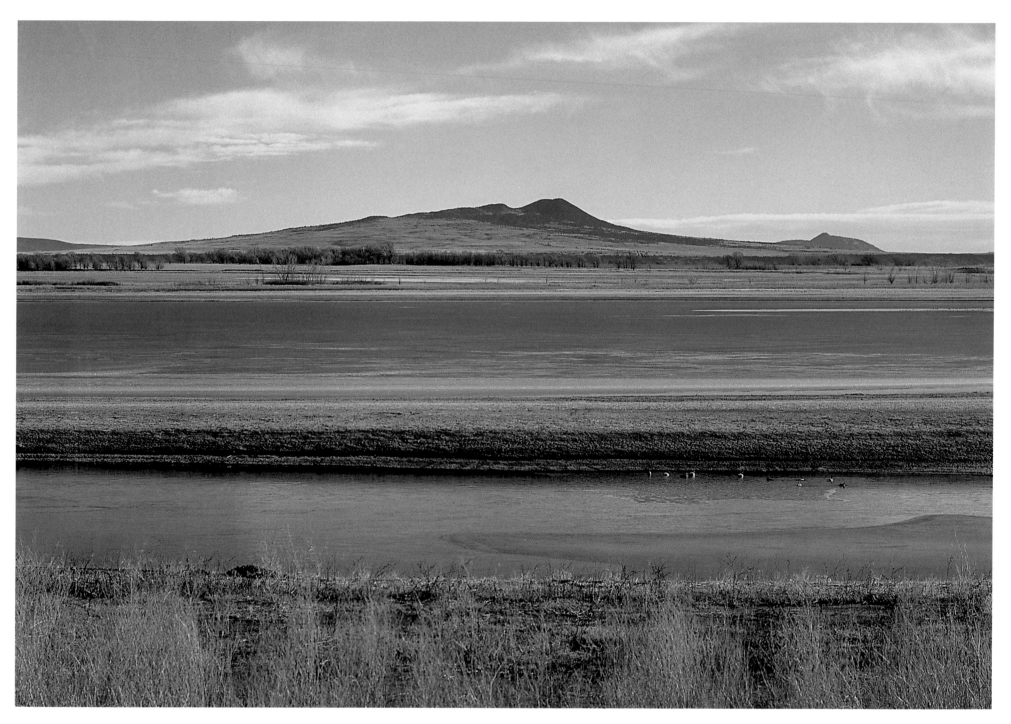

Saltpeter Mountain overlooking the Maxwell National Wildlife Refuge south of Raton.

one of the nation's most colorful and enigmatic states.

What follows is a synthesis of secondary sources, a patchwork of information derived from the most current historical research, and the most readable sources listed in the back of this book.

Land Forms and Nature's Road Map

\mathcal{V}IEWED FROM THE AIR, the state's physical attributes form a series of interconnected natural byways. Almost all of New Mexico's mountains and waterways with some notable variations run in a north-south direction. Each corridor represents an independent physiographic province; that is to say, an area with a distinct pattern of land forms that vary noticeably from the adjoining region. New Mexico's diverse topography is a composite of the southern Rocky Mountains, the Great Plains, and other subordinate plateaus, basins, and ranges. Two splinters of the Rockies intrude into the northern part of the state. The snow-capped San Juan, Jemez, and Nacimiento Mountains make up the western prong, while the towering silhouettes of the Sangre de Cristos make up the eastern prong to form the southernmost tip of the Rocky Mountains. A broad, 140-mile-wide plateau through which the Rio Grande meanders southward from Colorado to gently sculpt the San Luis, Española, and

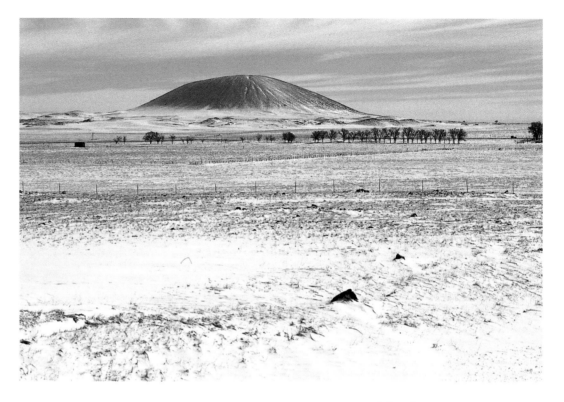

Palo Blanco Mountain from Capulin Volcano National Monument in the winter, near Raton.

Albuquerque-Belen Valleys, separates the two ranges. To the west of the San Juans we encounter the vast, canyon-laden Colorado Plateau and the petroleum-rich San Juan Basin. The elongated Chuska and Zuni Mountains combine with the Cebolleta Range and Mount Taylor, rising to an altitude of 11,300 feet, to define the southern limits of the Colorado Plateau. Southeast of the Sangre de Cristos, volcanic formations deliberately meld into a vast, carpet-like prairie called the Llano Estacado (Staked Plains), which gradually assimilates the remnants of the Canadian Escarpment into some of the flattest surface area on the earth.

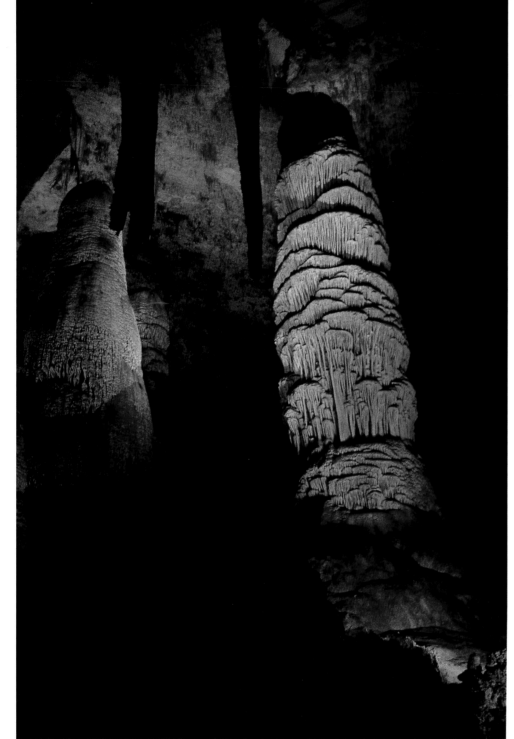

Carlsbad Caverns National Park, located in the southeastern corner of New Mexico. One of its celebrated events is the departure of thousands of bats every evening from the entrance of the caverns.

The vermilion Sandias and the purple-hued Manzanos form a second mountainous corridor that delineates the eastern periphery of the lower Rio Grande Valley. Continuing east beyond the mountains one enters the hospitable environment of the Estancia Valley. As the Rio Grande tumbles south and east toward the Texas border, the Sacramento, San Andres, and San Mateo Ranges make up a third discernible corridor. Positioned between the Sacramentos on the east and the San Andres Range on the west is the Tularosa Basin, an area so desolate that scientists determined it to be the perfect test site for the world's first atomic detonation. Farther west, between the San Andres Mountains and the San Mateos lies a ninety-mile stretch of parched earth between present-day Rincon and San Marcial, so devoid of water that Spanish cartographers named it the Jornada del Muerto (Journey of the Deadman). West of the San Mateos, toward the Mogollon Rim near the New Mexico-Arizona state line, lie the lush grasslands of the Plains of San Agustin. Beyond these plains are the ominous lava flows that form the *malpaís* or badlands near Grants.

Five major rivers—the Rio Grande, Pecos, Canadian, San Juan, Gila—and their tributaries, among which the Rio Chama and the Rio Puerco are the most prominent, provide much-needed nourishment to this astringent land. Its 1,800-mile length makes the serpentine-like Rio Grande the fifth longest river in North America. The so-called "great river" rises near a 14,000-foot summit in the San Luis Valley,

White Sands National
Monument sporting its
perfectly white gypsum.
Formerly known as White
Sands Proving Grounds, this is
the site of the U. S. military's
earliest missile program.

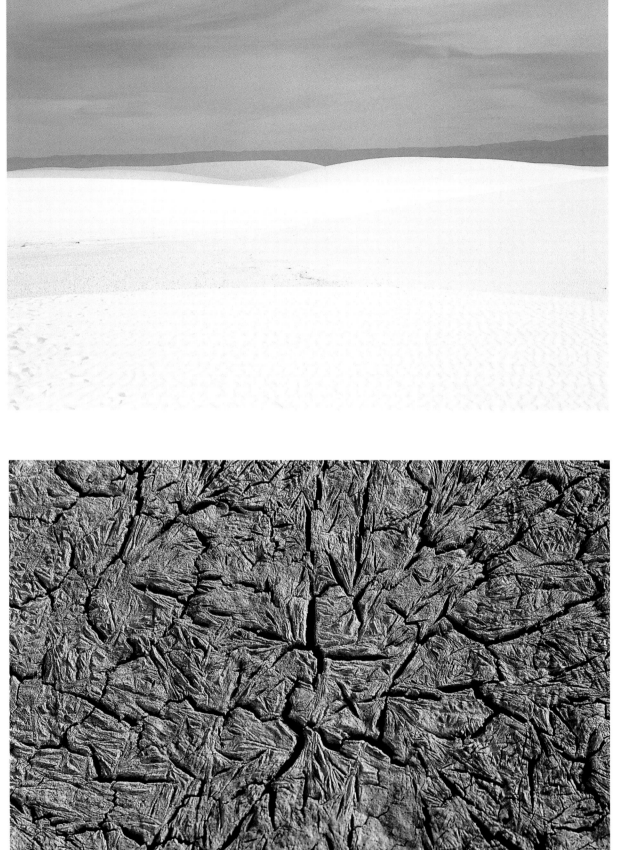

Bisti /De-na-zin Wilderness is a desert
landscape. When the rains come
in July and August water collects in
the soil and as it evaporates
creates patterns in the mud.

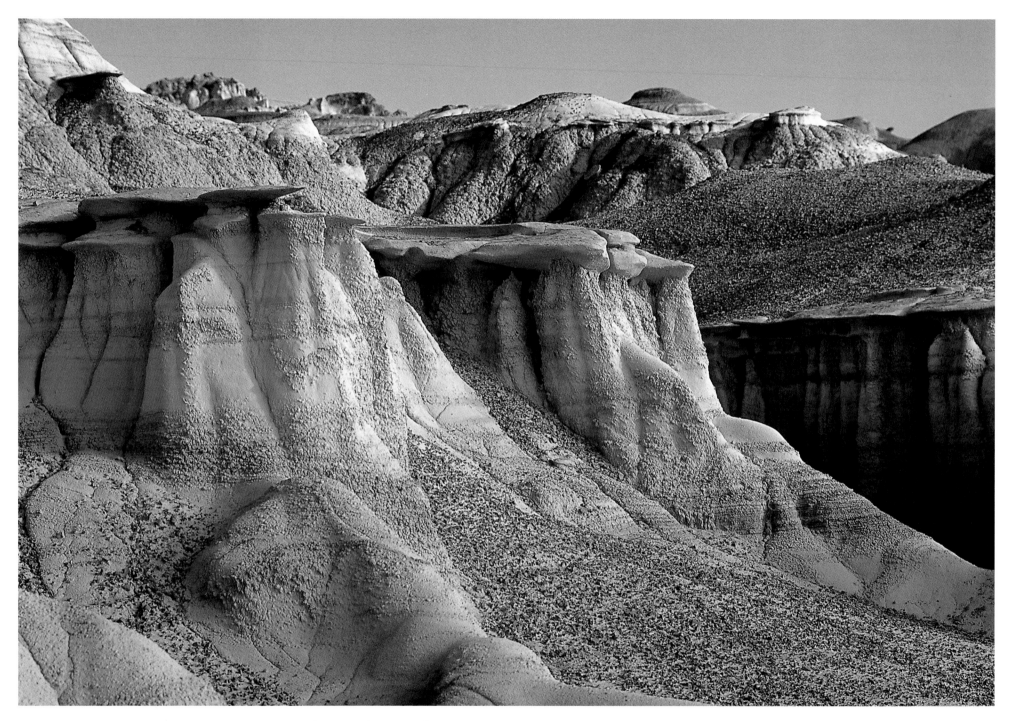

A lunar landscape in the Bisti/De-na-zin Wilderness near Chaco Canyon.

where it draws strength from the snow-clad promontories of the Continental Divide. The high sierra acts like a natural hydrant, spewing forth crystalline waters to inaugurate the Rio Grande's tortuous journey to the Gulf of Mexico. Near the Colorado-New Mexico border, the river has methodically forged a chasm through which it plummets like a raging, white-capped eruption for seventy-five miles before it enters the tranquil Española Valley, where the Chama River generously augments its waters.

At this juncture, the once mighty river slowly etches a natural 800-mile-long corridor to the sea, bisecting New Mexico almost perfectly in half longitudinally. In contrast to its exuberant beginnings, the torrent has been reduced to hardly more than a trickle. Bled thin by recreational, agricultural, and metropolitan use, the Rio Grande ambles its way across the broad, alluvial plain south of Albuquerque toward Elephant Butte Dam 150 miles downstream. When there is normal rainfall, the Rio Grande is again replenished. Beyond the dam, labor-intensive farms in southern New Mexico and densely populated municipalities along the U.S.-Mexico border eagerly anticipate delivery of the region's most vital natural resource.

In 1954, author Paul Horgan penned a Pulitzer Prize-winning book to honor the river's one hundredth anniversary as the international boundary between the United States and Mexico. Using a literal translation from the Spanish, Horgan titled his multi-volume epic *The Great River*. When European explorers ventured into

Red rocks near Ghost Ranch in Abiquiú. The painter Georgia O'Keeffe lived at Ghost Ranch and later had a home in Abiquiú, located northwest of Santa Fe.

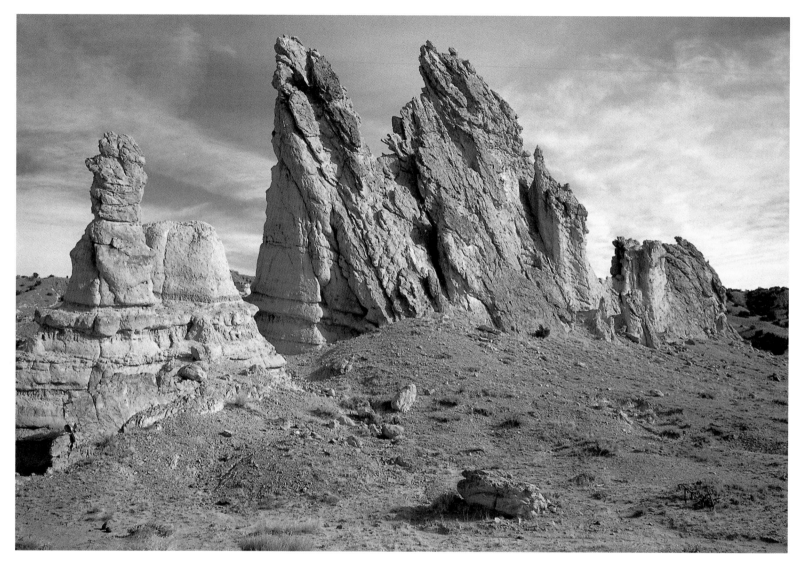

A formation of rocks outside the little-known Plaza Blanca settlement near Abiquiú.

the American Southwest beginning in the mid-1500s, the famous landmark so impressed the Spaniards that they referred to it variously as *El Río de las Palmas*, where the river enters the Gulf of Mexico, and *El Río del Norte*, near the point in west Texas where its roiling waters surge unim-

peded through the corrugated canyons of the Big Bend. Who in the sixteenth century could have imagined the impressive waterway that Spaniards observed near present-day Brownsville, Texas, could possibly have been the same drainage whose headwaters they explored nearly

two thousand miles distant in southern Colorado? With Mexico's independence from Spain in 1821, border residents popularized the name *El Río Bravo del Norte*. The application Rio Grande, however, did not come into common usage before the arrival of the first English-speaking settlers to Texas in the early 1800s. Whatever the designation, the river has for centuries served as an aquatic road map to lure occupants—human and non-human—into the searing environment of the desert Southwest.

Thousands of migratory birds have retraced this route over time as the Rio Grande wends its way toward the Gulf of Mexico. Twice a year, feathered squadrons of sandhill cranes, with outstretched necks as if to point the way, mark the well-worn flight path for others to follow. These creatures seek brief repose among the verdant, reed-covered estuaries of the Rio Grande. In an uncanny display of orderliness, the birds glide effortlessly above the water until they come to rest in the biotic marshlands of the Bosque del Apache National Wildlife Refuge near Socorro. Here, some draw sustenance to complete their exhausting odyssey while many stay for the winter. As ethereal hues of crimson and amber gently broadcast dawn across the placid water, the birds sleep, seemingly undisturbed. Then, as if startled by a gunshot, they ascend in splendid unison to continue the journey or to find food. Surely, this natural drama has been staged repeatedly among the numerous willow thickets that punctuate the Rio Grande along it course. The so-called *bosques* offer protection and brief respite for the birds to complete the annual migration cycle.

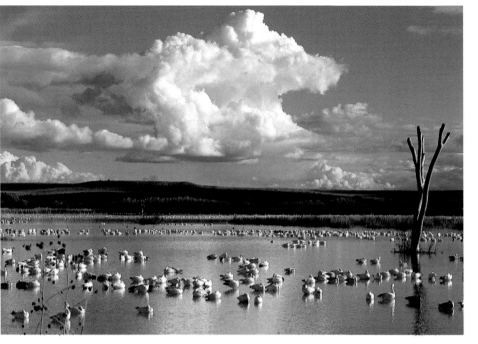

Snow geese, *chen caerulescens,* are a familiar sight under a New Mexican sky from November to April in the Bosque del Apache National Wildlife Refuge.

Water from the Rio Grande floods the Bosque del Apache National Wildlife Refuge plains to create one of the West's best-known wetlands.

No doubt wetlands such as these attracted the region's earliest human migrations as well.

Archaeological evidence, however, suggests that early man may have preferred the treeless, uninterrupted terrain of the open plains to the well-watered valleys of the Rio Grande. Physical evidence—a fluted projectile said to be 11,000 years old—recovered near the Clovis-Portales area of eastern New Mexico suggests that hunters in pursuit of large grazing animals such as mammoth, caribou, musk ox, and big horned

bison were the earliest *homo sapiens* to occupy the area. Climate studies of the late Pleistocene indicate that unlike today, the high plains were much wetter, interspersed with shallow lakes and sufficient plant life to attract animals and birds of every variety. New Mexico's first inhabitants may have enjoyed cooler summers in which to hunt extensively and accumulate a surplus of meat and other foodstuffs to sustain their fragile communities during exceptionally damp winters. Scientists, in fact, have likened New Mexico's climate during the time of Clovis Man similar to that of Puget Sound.

Far removed from Clovis and closer to Clayton in the northwestern corner of the state lies the small ranching community of Folsom, site of the first conclusive physical evidence of human existence in North America. In the summer of 1908, George McJunkin, a former African American slave from Texas employed as a local cow hand, chanced upon a curious collection of bleached animal bones as he coaxed his mount up Wild Horse Gulch. The bones proved to be the remains of an extinct species of bison. Although at the time undetected, finely crafted projectile points were embedded in the ribs of the mighty beast. The points themselves were not recovered until 1925 when amateur archeologist Carl Schwacheim attracted scientific attention to the site. The Colorado Museum of Natural History attributed the so-called Folsom Man points to a society of prehistoric hunters who roamed the plains near the present-day Colorado-New Mexico border. The additional

Gran Quivira, an old Pueblo and Spanish mission in the Salinas Pueblo Missions National Monument, located off Route 60 southeast of Albuquerque.

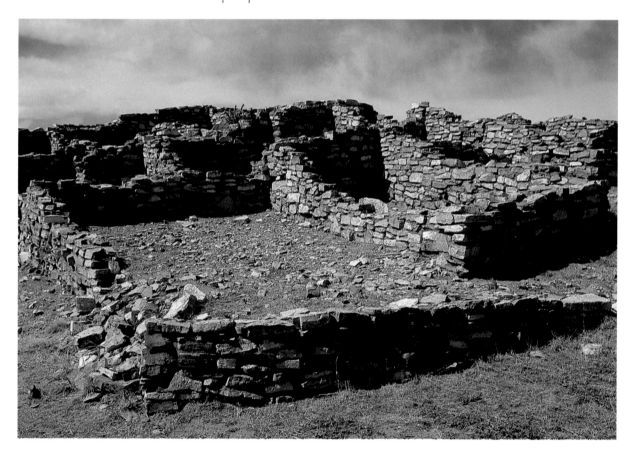

discovery of an "eyed" bone needle suggests that the Folsom people probably fashioned clothing from animal hides as protection against the winter cold. Presumably, these hunters tracked now extinct creatures that were common to the grasslands of the Great Plains and the nearby woodlands 8,000 to 10,000 years ago. While these early habitation sites are some distance from the fertile corridors of the Rio Grande, climatic changes during the late Pleistocene may have forced an inward migration as the high plains became acutely warmer and drier. No doubt the lucid waters of the Rio Grande, combined with its alluvial soil, were a welcome invitation to other prehistoric nomads.

The Pre-Contact Pueblo World

RECENT ARCHAEOLOGY REVEALS that the earliest inhabitants of the Rio Grande Valley may have migrated south from the San Juan Basin as well as east from the red rock canyons near present-day Kayenta in northern Arizona. Sometime around A.D. 1300 people with highly developed skills in architecture, pottery making, and irrigation farming drifted into the upper reaches of the fertile Rio Grande Valley from the Four Corners region. Concurrent with this movement, others gradually populated the lower

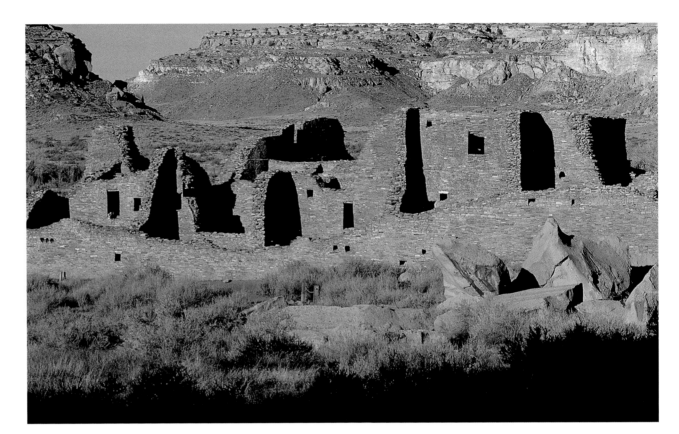

Rio Grande near present-day Socorro, the valleys east of the Manzano Mountains, and the western sector of the state near the Zuni Mountains. Although each of these groups no doubt referred to themselves in their own spoken language, there have been attempts to apply generic names to identify them as a singularly distinct culture. Navajos, who refer to themselves as *Diné*, ascribed the name *anazazi* to these antecedents in the American Southwest. In the sixteenth century, Spaniards who chanced upon their densely clustered communities and

Pueblo del Arroyo. The Ancient Puebloans created a center at Chaco Canyon over 1000 years ago with multi-story stone buildings, straight roads to distant sites, and a widespead cultural influence.

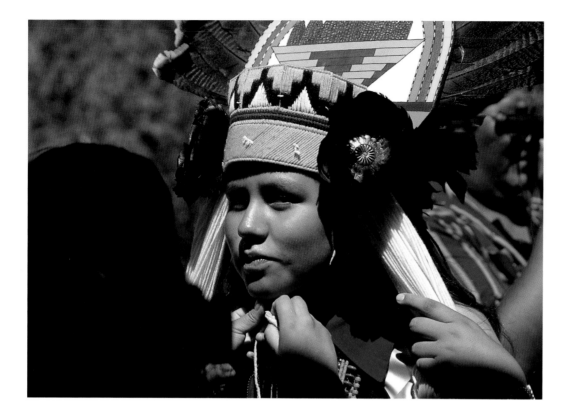

Jemez Pueblo dancer
on July 4th celebration
in Jemez Springs north
of Jemez Pueblo.

tration into New Spain's northern frontier, Pueblo people were well apportioned throughout the region. At the time Columbus landed in the West Indies in 1492, the Pueblo people had long since established communities in the Chama Valley, on the Pajarito Plateau, in the mountains between Picuris and Taos, all through the Galisteo Basin, in the area near present-day Mountainair, and in the Jemez and Pecos River Valleys. The names ascribed to the then-thriving communities appear unfamiliar, because they predate the Spanish arrival and are derived from native languages spoken among the various pueblos even to the present day. From 1540 to 1598, Spaniards listed more than one hundred pueblos including: Yungue, Sapawe, Ponsu, Posi in the Española Valley; Tshirege, Puye, Tyuoni, Tsankawi, and Otowi near present-day Los Alamos; Patokwa, Tovakwa, Wabakwa, and Guisewa in the Jemez Springs area; Tunque, Kuaua, Coofor (Alcanfor), and Puaray in the Tiguex (pronounced Tee-gwesh) region north of present-day Albuquerque; Shé in the Galisteo Basin; Pindi in the vicinity of Santa Fe; Cicuye in the upper Pecos drainage; Chía and Acuco in the west, as well as the Zuni villages of Hawikuh, Matsaki, Halona, Kiakima, Kianawa, and Kwakina. Spanish adventurers, who imagined the latter native communities be the famed mythical Cities of Cíbola, were instantly attracted to the uncharted reaches of the northern frontier.

multi-storied dwellings chose to call them *Pueblos*. Spanish chroniclers, who frequently distinguished tribal as well as linguistic differences among the people they encountered believed the name—meaning "townsmen"—appropriately descriptive. By all accounts, the sight of semi-sedentary Indians concentrated into agrarian-based communities not unlike those dispersed across the valley of Mexico deeply impressed the Spaniards.

Southwestern archaeologists estimate that some time between the years A.D. 1325 and 1540, the year of Coronado's inaugural pene-

While the Pueblos shared many common characteristics with regard to religion, lifestyle, and economy, their relationship to one another

Laughlin Peak covered with winter snow near Raton. It had melted on the grassy plain but remained on the mountain's north side.

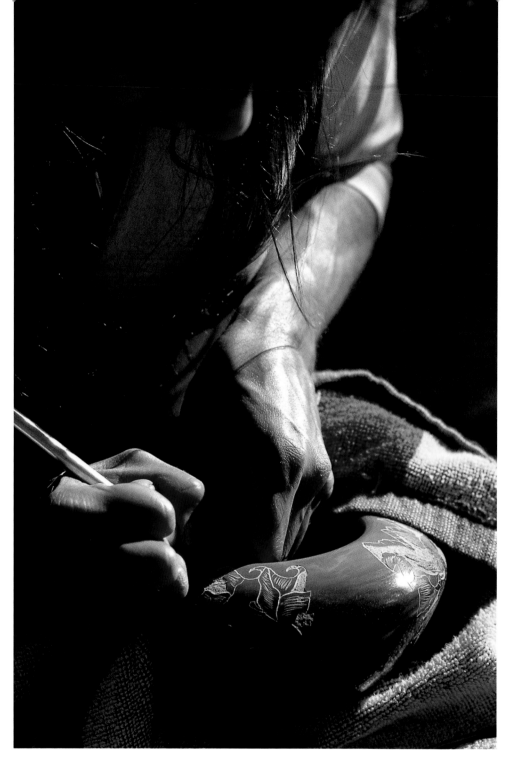

Santa Clara Pueblo potter Gwen Tafoya inscribes one of her pots. Pottery by Native Americans was an essential tool which over the years developed into a treasured art form.

was anything but homogenous. For example, the occupants of one village most likely could not communicate with the inhabitants of a neighboring village. There is no one common language among the Pueblos; each village falls into one of four separate phyllum. Keresan is the predominant language spoken among today's villages immediately north and west of Bernalillo—Santa Ana, Cochiti, Zía, San Felipe, and Santo Domingo—and includes the western Laguna and Acoma. Zunian is still spoken among the people who first occupied the Grants-Gallup vicinity.

By far the most extensive language is Tanoan of which three distinct dialects—*Tiwa, Tewa,* and *Towa*—are still spoken today among the villages from Taos in the north to Isleta in the south. Just as in historic times, the people of Picuris and Taos speak Northern Tiwa. Tewa was then and is now the language commonly heard among the villages—San Juan, San Ildefonso, Santa Clara, Tesuque, Nambé, and Pojoaque—located near the junction of the Rio Chama and Rio Grande. The communities of the Tiguex province, clustered within the broad valleys north and south of Albuquerque, spoke Southern Tiwa. Several communities located east of the Sandia and the Manzano Mountains on the northwestern rim of the Salinas Basin were believed to have also spoken Southern Tiwa.

Towa was the language of the inhabitants of Jemez, where it is still spoken today, and Pecos before that village was depopulated in 1838. Two other variants of the Tanoan language—Piro and Tompiro—were spoken at

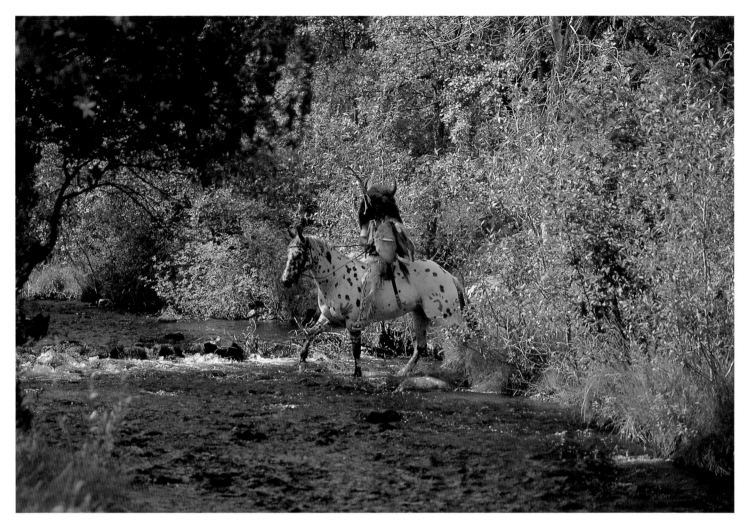

A Nambe warrior opens ceremonies in a traditional manner at the annual Eight Northern Indian Pueblos Arts and Crafts Festival.

the time the Spanish arrived, but ceased to exist as living languages before 1680. These dialects may also have been used in pueblos that were once located near present-day Socorro and extended west toward the abandoned Indian villages of Abó and Gran Quivira in the Salinas Basin. Finally, the Hopi in northwestern Arizona speak a Shoshonean derivative. Linguistic differences instilled a strong sense of independence—not interdependence—among the pre-contact pueblo communities.

Spanish chroniclers provide the only eye-witness accounts of Pueblo life during that time. The semi-sedentary villages reminded latter-day journalists of the cosmopolitan communities they had encountered in Mexico. Every pueblo

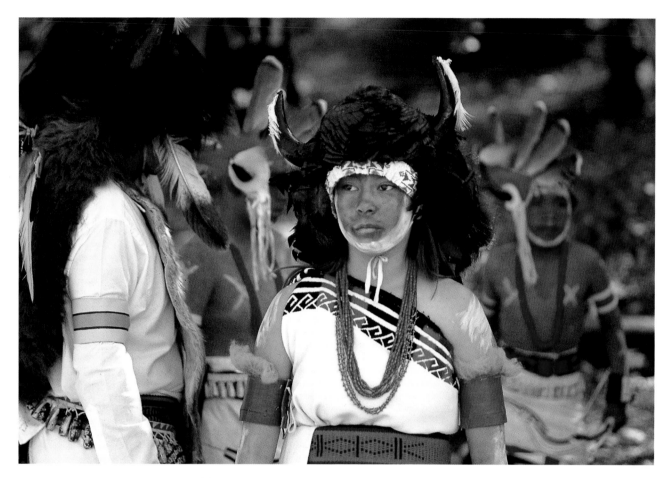

San Juan Pueblo Dancers in Nambé Pueblo preparing to perform at the annual Eight Northern Indian Pueblos Arts and Crafts Festival.

of land. Houses shared common walls and roofs, which minimized the amount of building materials required for construction. To apply the term "apartment" to these structures, however, is somewhat misleading. A modern apartment building has a well-defined outer parameter that encloses smaller cubicles whose size and shape are modified. The pueblo, on the other hand, continuously evolved on the outside as additional rooms were added. The number of independent pueblos sprinkled across New Mexico's landscape suggests that these early builders were mindful of the fragile balance between population density and limited natural resources. The pueblo complex itself had multiple functions. The ground level, for example, had no doors or windows in order to offer protection during times when hostile invaders threatened the community. Houses were clustered around an open *plaza,* thus providing useable space for religious ceremonies and other communal festivities.

Typically, the community teemed with activity. One can almost imagine the myriad sounds and smells that permeated the pueblo atmosphere. You might hear the rasping sound of stone against stone as women ground corn into meal for daily consumption. Within the confines of the plaza there is an audible mixture of turkeys gobbling, dogs barking, and children laughing in playful exuberance. In the background are the muted strains of a solitary flute

contained multi-storied complexes and many were comprised of more than one thousand rooms. Although the overall concentration of inhabitants in the Rio Grande Valley was enormous, Native Americans were distributed among villages of approximately 800 residents. Their box-shaped, earthen structures were practical. Puebloans maximized space by building their dwellings vertically to accommodate a large concentration of people on limited parcels

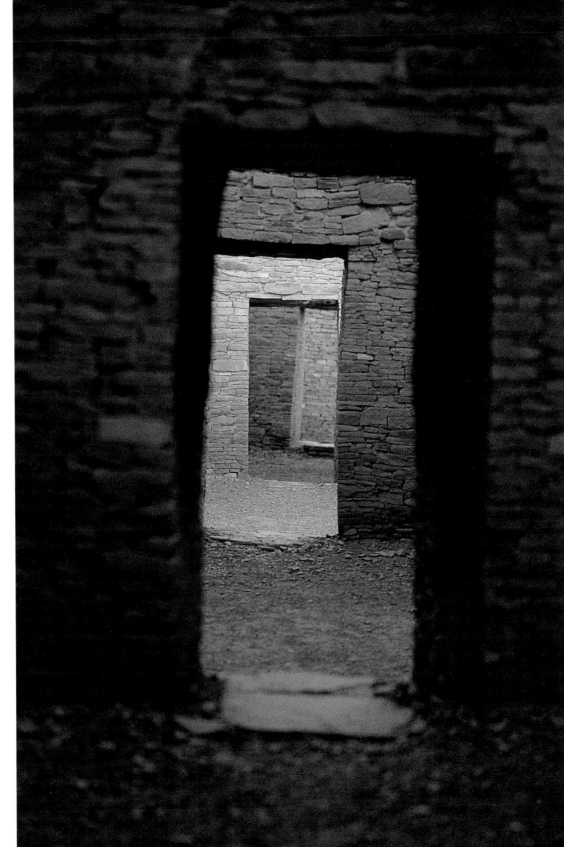

Chaco Canyon ruins in northwestern New Mexico demonstrate extraordinary architectural feats. Built by early Americans over 1000 years ago in an arid desert, Chaco Canyon is recognized as a World Heritage Site. The view here is through doorways in Pueblo Bonito.

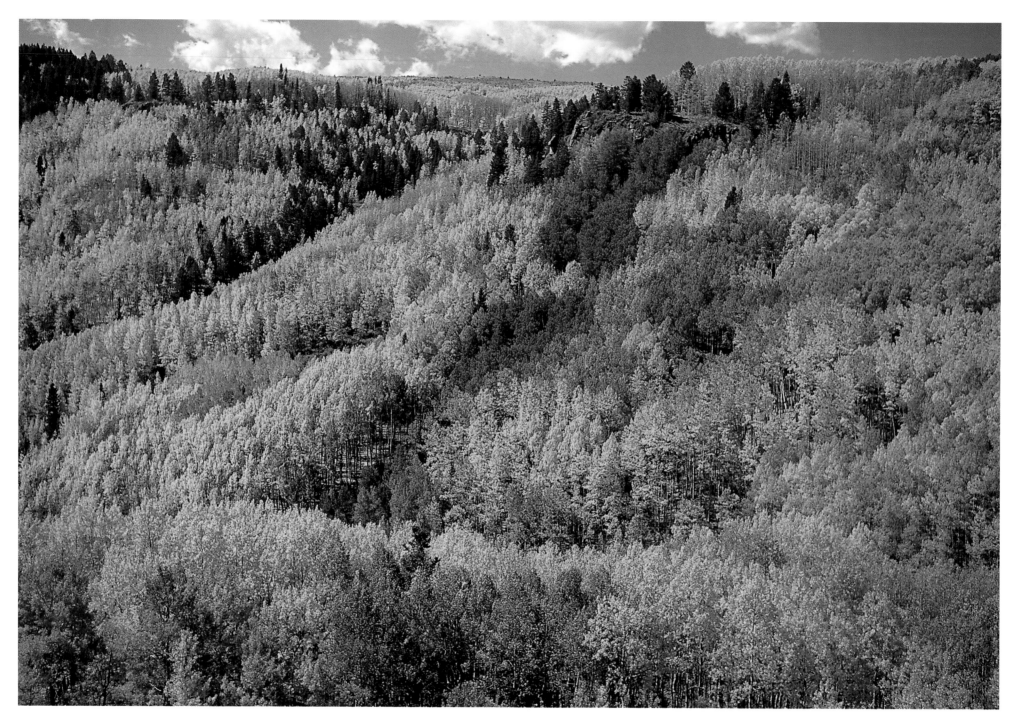

Quaking aspen, *populus tremuloides*, near Chama are one of the West's great spectacles in autumn.

player or an artisan testing the timbre of a ceremonial drum, assembled from the material of a nearby cottonwood. The faint odor of piñon smoke from the morning's fires and the pungent aroma of sage as it is applied to purify living quarters lingers in the air and hangs like a thin veil throughout the pueblo.

There is a well-defined division of labor within each community. The men busily anticipate the hunt, or perhaps having just returned, prepare their kills for evening meals. Older males fashion fine garments out of cotton and turkey feathers, or polish necklaces and inlaid pendants designed from locally mined turquoise, obsidian, and other decorative stones. Meanwhile, some of the older women fire elegant, multi-colored pottery. Younger men use stone tools to form slabs of sandstone into smooth, thin building blocks for use in construction. As room blocks are completed, the younger women prepare a mud plaster, which they apply in thin layers onto the stone walls to offer some protection against violent rain and relentless sun. Sometimes the women prepare a whitewash made from lumps of naturally formed gypsum, baked and ground into a fine powder, then dissolved in hot water. This application provides a finished look to the interior walls.

The Pueblo people were first and foremost agriculturalists. The production of ample food to sustain the community and to create a surplus for winter storage required the full participation of its members. Crucial to their success was the ability to harness limited water resources. When Pueblo ancestors migrated from the citadel-like

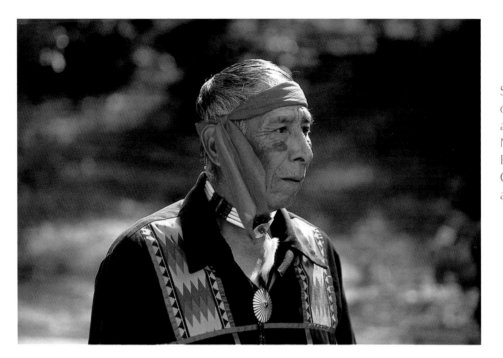

San Juan Pueblo drummer at the annual Eight Northern Indian Pueblos Arts and Crafts Festival held at Nambé Pueblo.

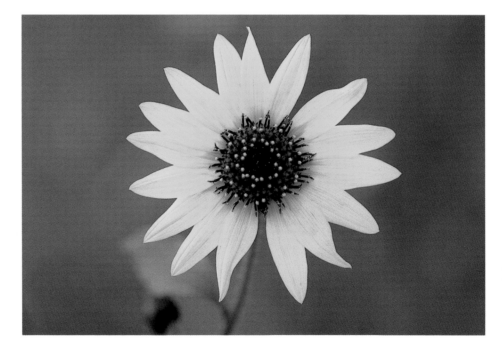

Sunflower east of Apache Creek on the San Agustin Plain, Route 12.

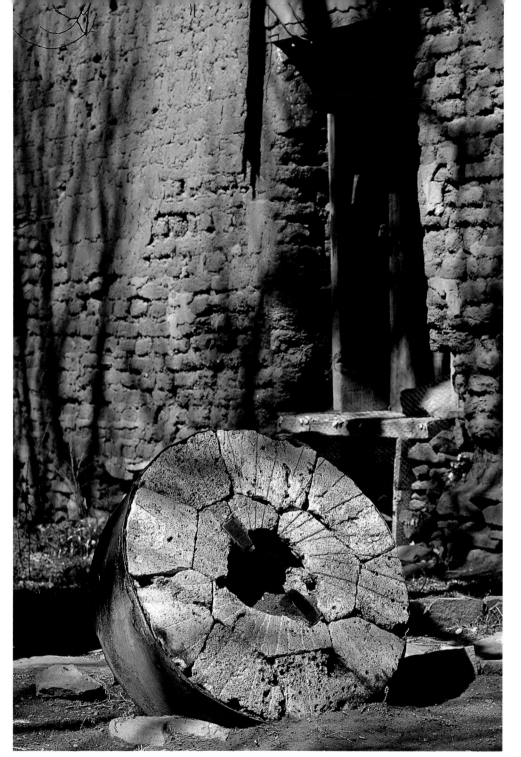

An old grist mill in La Cueva southeast of Mora on Route 442, built by Vicente Romero in the 1870s.

communities of Mesa Verde or the religious centers of Chaco Canyon, they brought with them a tradition of water storage strategies and dryland farming methods. They farmed on contoured terraces, grid-bordered gardens, and in natural flood plains. Initially, they depended on seasonal precipitation and the annual runoff from snow-packed mountains, which they channeled into adjacent fields via an intricate network of diversionary canals and catchment dams. When the Spanish arrived in the Chama Valley in the late 1500s, they observed that native villagers practiced different methods of water harvesting and conservation techniques. Their innovative strategies included installation of gravel-mulched fields adjacent to river bottom lands; gardens of rock-bordered rectangular grids and cobble-stepped terraces located on mesas above the pueblo; stone-lined ditches to channel water from one depression to another; and check dams made of brush and stone used to impound water for diversion to designated planting areas.

Within the man-made fields, the Indians planted corn, their only native grain and principal dietary staple. Squashes and melons of several varieties supplemented their diet. Rabbits, deer, elk, antelope, wild turkeys, and bighorn sheep provided fresh meat. Pinto beans (*frijoles*) were another source of protein. Sometime during the year, the young men of the community might venture onto the high plains to hunt buffalo, or gather salt and other essentials to sustain life. The pueblos cultivated cotton to make blankets and clothing, which

Winter in the Rockies west of Peñasco on Route 75.

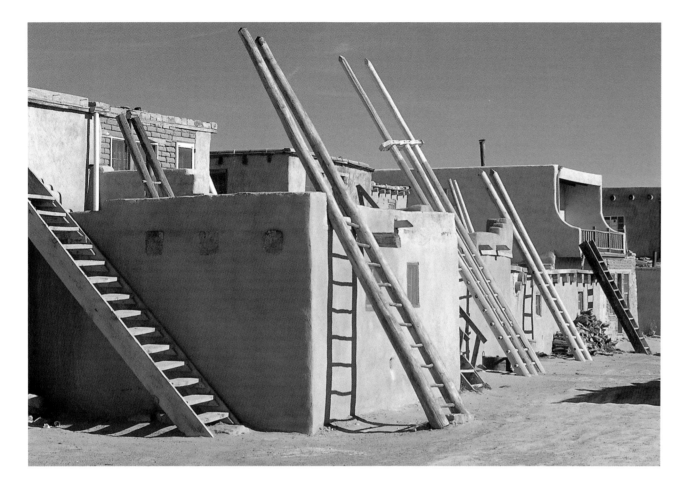

Acoma Pueblo kivas built on a high mesa and lived in continually since the eighth century. Acoma is arguably one of the oldest inhabited communities in the United States. It lies west of Albuquerque.

augmented garments and footwear made from finely tanned deerskin or buffalo hides. Nonedible crops included tobacco and gourds for use in religious ceremonials. They slept on quilts made from turkey feathers and used medicinal herbs gathered in the nearby mountains. The conservation-minded Puebloans took care to produce a surplus of food for storage in the event of unanticipated crop failures.

What native New Mexicans did not produce themselves they acquired through an extensive trade network with the nomadic peoples of the central plains, distant villages on the Pacific coast, or the desert communities of northern Mexico. Evidence of a complex system of widened, rock-lined highways emanating outward from Chaco Canyon in all four directions suggests that trade and communication with outlying communities had existed for centuries. The pueblos of the Rio Grande traded foodstuffs and turquoise for colorful seashells and red coral, prevalent among the Indians of present-day California. Exotic and colorful feathers from Mesoamerica may have reached the Rio Grande Valley through active trading with the Chihuahuan Desert people of Casas Grandes, Mexico. Locally, Taos, Picuris, and Cicuye (Pecos), pueblos on the fringe of the Great Plains, and those that occupied the Salinas Basin established trade relations with Harahey (Pawnee), Cayuga (Kiowa), and Quivira (Wichita) warriors. They exchanged corn and vegetables for bison meat, lard, processed hides, and *bois d'arc* (Osage orange wood) from eastern Texas, which Pueblo men used to fashion sturdy bows and arrow shafts. On the eastern plains, the Jemez traded obsidian in exchange for fibrolite, a highly-prized substance from which they produced axes and other useful implements.

Internally, a strict application of religious traditions governed the Pueblo community and determined its success or failure within the cosmic universe. The subterranean *kiva* appears to be one architectural feature that was common to all of the pueblos. Within its smoke-filled

chamber, ceremonial priests establish contact with *Kachinas*, ancestral spirits who confer moisture, abundance, and good health upon the community. Wearing elaborate masks and costumes, religious leaders often impersonate the pantheon of deities as if to continually remind the villagers of their omnipotent presence. Snake dances, widespread among all pueblos in earlier times but today confined only to the Hopi, regarded poisonous serpents as messengers to the spirit world. After the Spanish arrived, native rituals such as these repelled the missionaries, who made them the object of Catholic preoccupation and religious persecution.

Although life in the pre-contact world appears to have been idyllic, standard defensive applications to pueblo architecture imply that threats from outside the community were not an uncommon occurrence. In part because of their linguistic differences, each pueblo represented an autonomous political unit. Unlike the Iroquois Confederacy on the eastern frontier, there appears to have been no such consolidation among the southwestern pueblos. Territorial rivalries and social incompatibilities often flared into open conflict. The Spanish observed that the Tiguex were constantly at war with the people of Cicuye (Pecos). This may explain the palisade that was said to have encircled the villages near present-day Bernalillo. Coronado's men described a protective wall around the Zuni village of Hawikuh built to keep out Hopi intruders.

More threatening were nomadic invaders such as the Apaches, Utes, and later the

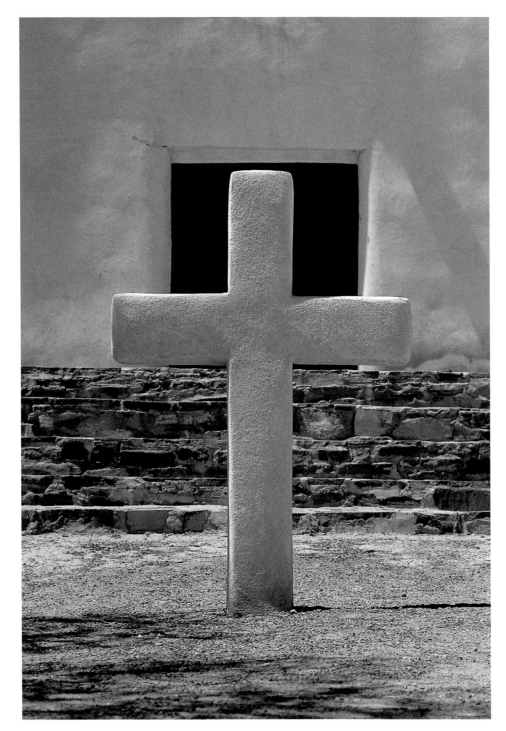

The cross at the Saint Joseph/ San José Mission Church, which stands in Laguna Pueblo west of Albuquerque.

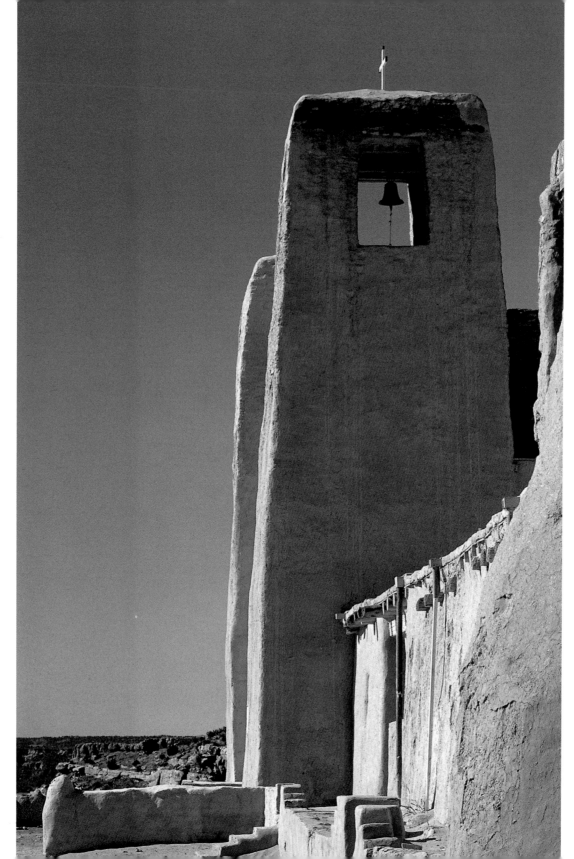

San Esteban del Rey
Mission at Acoma Pueblo.

Navajos, who by A. D. 1400 challenged the Pueblos for the finite resources of the Rio Grande Valley. The *Querechos* (a Spanish application for all Athabaskan-speaking people) were first on the scene. The Jicarilla Apaches had migrated south from Canada across the Sangre de Cristos to range in the mountainous areas north of Taos. Meanwhile, the Mescaleros, Lipanes, and Faraones harassed the pueblos in the lower Rio Grande Valley, the Salinas Basin, and those on the periphery of the eastern plains. The Shoshonean-speaking Utes (*Yutas*) claimed the San Juan River Basin west of Jicarilla territory. Both tribes were buffalo hunters, although the Jicarillas practiced limited forms of agriculture. Their marginal success as farmers depended on the prevailing climatic extremes common to the eastern plains. For this reason, both the Jicarillas and the Utes coveted the abundant stores of nearby pueblo communities. Before the appearance of the horse, these nomads were at best a minor irritant. Once mounted, however, the vaunted equestrians increased hostilities against the pueblos with relentless abandon.

By the early sixteenth century, the pueblo world had assumed an unmistakable defensive posture. Builders sited their housing complexes near the bases of mountains or against natural cliffs for greater protection. They clustered individual units into overcrowded rows, accessing one another through narrow, earthen passageways. Small windows and relatively few door openings were most likely in response to

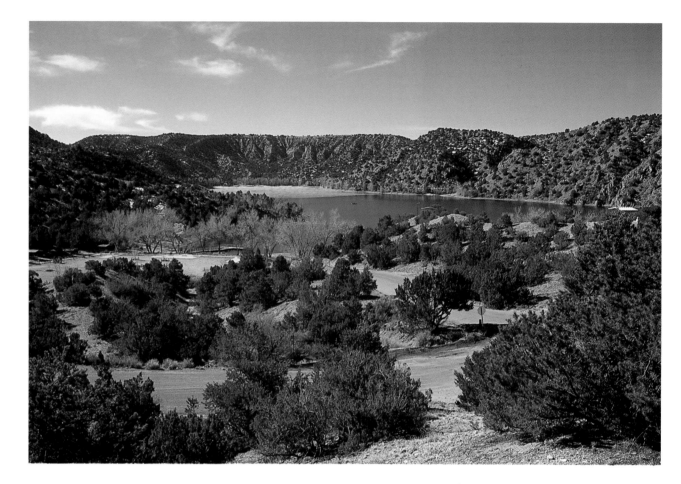

Santa Cruz Lake Recreation Area near Española.

frequent attacks. The use of removable ladders to access upper levels was another defensive feature. Despite episodes of drought and other natural calamities in addition to mounting aggression from all sides, the pueblo communities thrived. Estimates for the indigenous population of New Mexico on the eve of the Spanish *entrada* are as high as 50,000 to 60,000 souls. Their lives, however, would soon be irrevocably transformed.

A solitary tree on the San Agustin Plain on Route 60 near Datil.

Collision of Cultures

SUCH WAS THE PUEBLO world on July 7, 1540, when ominous, armored figures appeared on New Mexico's western horizon. Six months earlier, the exhausted column of troops had set out from the remote Spanish outpost of Compostela in the western province of Nueva Galicia (near present-day Guadalajara, Mexico). Leading the cavalcade was forty-two-year-old Francisco Vásquez de Coronado, the adventurous provincial governor who had paid the handsome sum of fifty thousand pesos ($2 million today) to venture into territories only recently learned about in Mexico City. Naturally intimidated, the Zunis withdrew behind their defensive walls only to be quickly dispatched by the fearsome strangers who possessed the horse, the harquebus, and other formidable weapons. Fortunately, the intruders did not linger among the Zuni, having ascertained that they harbored no treasure comparable to that of the Aztecs and other indigenous tribes of Mexico. After several excursions west into Hopi territory, the Spaniards pressed ahead to the twelve Tiguex villages located in the shadow of the sacred mountain the Puebloans called Oku Pin (Sandia Peak, just north of present-day Albuquerque).

Dismayed that these people possessed no obvious wealth either, Coronado and his men were mollified by the discovery that these villages stored abundant food and blankets to sustain his tattered detachment through the impending winter. Obliged to vacate the downstream village of Alconfor in order to meet the needs of the audacious intruders, the Tiguex protested the imposition and rebelled. They were soundly defeated and severely punished. By the time Coronado's army departed the Rio Grande Valley, en route to Cicuye on the fringe of the eastern plains, it had laid waste to the Tiguex pueblos of Arenal and Moho. More damaging, the soldiers relieved the Tiwa villages of their valued winter surplus.

The Spaniards were not blessed with good fortune, however, as Coronado and his

Hermit Peak dominates the countryside during a summer storm on Route 283 near Las Vegas.

The Rio Chama
south of Abiquiú.

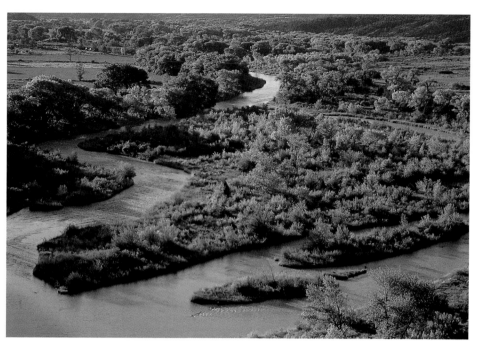

Sunflowers and a
windmill provide a
colorful sight on
Route 117 south
of El Malpais
National Monument.

disheartened entourage found none of the anticipated riches during their year-long trek across the Great Plains. In April 1542, Coronado despondently returned to the provincial capital a failure, where he faced charges for his harsh treatment of the Puebloans and his failure to establish a firm foothold on New Spain's northern periphery. Meanwhile, the traumatized Tiguex people never fully recovered from their portentous first encounter with the invaders. Even though the Spanish would not reappear for another four decades, the Tiguex vacated their shattered province and scattered themselves among neighboring villages along the Rio Grande.

The Coronado expedition set the tone for subsequent incursions into the territory Spanish cartographers called Nuevo Mexico. During the decade 1581 to 1591, Pueblo encounters with Francisco Sanchez Chamuscado (1581), Antonio de Espejo (1582), and to a lesser degree Gaspar Castaño de Sosa (1590), were equally contentious. The latter expedition involved a renegade lieutenant governor of Nuevo León who advanced the first wagon loads of settlers up the Pecos River in an abortive attempt to colonize the region. It seems that the Spaniards proved unable or unwilling to sustain themselves while on the frontier without exacting a tribute of food and clothing from the native population. In time, this practice evolved into a more regularized form of taxation known as the *encomienda*. This institution, a throwback to the Feudal Age, combined with the *repartimiento*, a system of enforced Indian labor, weighed

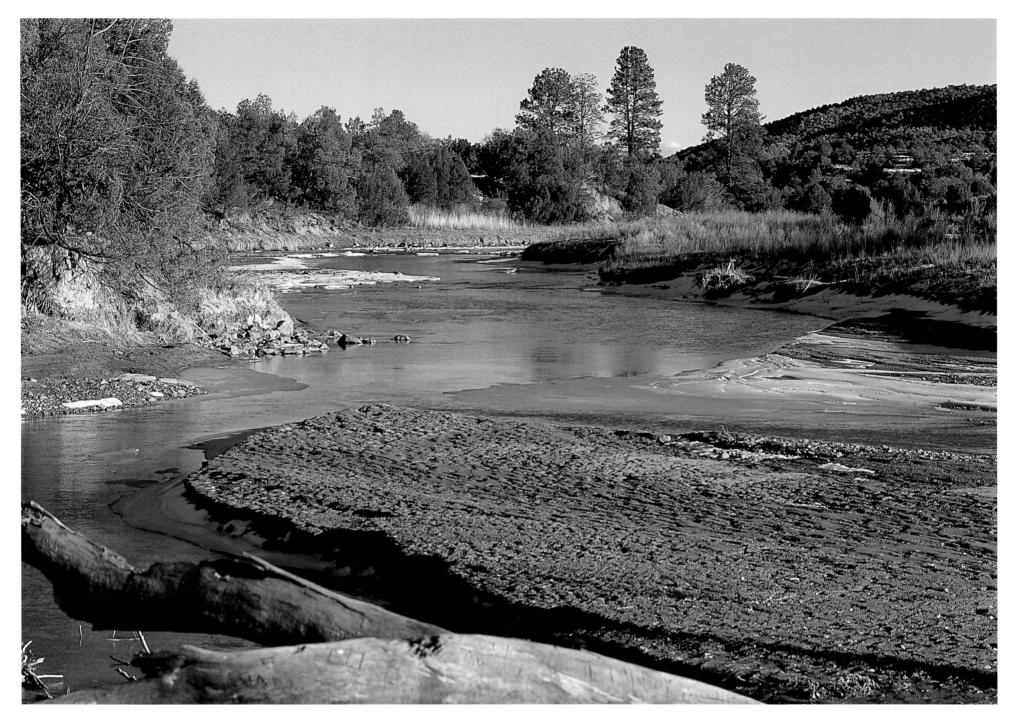

The Rio Chama runs into the Rio Grande near Española.

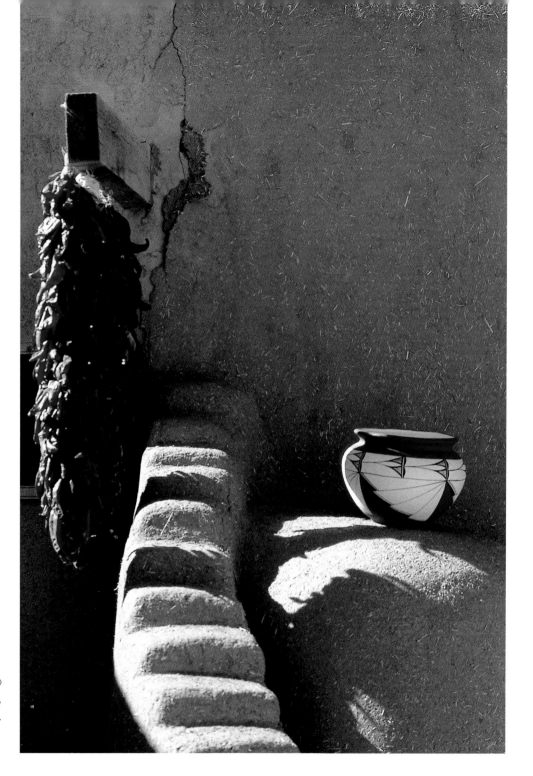

Taos Pueblo
pot, chile *ristra*,
and adobe.

heavily on the indigenous population of the New World during its first century of foreign occupation. Spanish industrialists demanded a steady stream of Indian labor to work in the mines of Zacatecas (1546), Santa Bárbara (1567), and Parral (1631). Unlike the impoverished surroundings of New Mexico, the mountainous regions of Chihuahua in northern Mexico were resplendent with silver and other precious metals. Their discovery inspired a population migration in 1549 unparalleled in North America until the famous California Gold Rush three centuries later.

The appearance of densely populated silver-mining districts in New Spain's northernmost provinces assigned new importance to New Mexico as a defensive buffer against hostile encroachment. Although the explorations of previous decades failed to recover great wealth, they provided Spanish administrators in Mexico City with detailed knowledge of previously unknown territory and its occupants. With each foray into New Mexico, explorers surveyed an extraordinary number of densely populated native communities. Combined, the expeditions of Chamuscado, Espejo, and Castaño de Sosa recorded 75 such villages clustered into distinct provinces, some of which housed 10,000 residents. All nineteen of New Mexico's modern pueblos were included in these early accounts. The prospect of thousands of non-baptized souls gathered into centralized communities awaiting salvation was too much for Spanish missionaries to resist. In response, the Roman Catholic Church asserted its influence on the

viceroy of New Spain to shift emphasis away from the short-term goal of military conquest to a long-range plan for permanent colonization. In the early months of 1598, the honor to carry out this mission fell to don Juan de Oñate, a veteran soldier and heir to the enormous fortune of Cristóbal Oñate, a successful Zacatecan mine owner. Less than sixty years after Coronado ventured into the northern hinterlands, the term "conquest" was legally expunged from the royal lexicon in favor of colonization and evangelization—loftier and less intimidating rhetoric in the Spanish mind.

On September 8, after arduous months of travel up the Rio Grande and across the Jornada del Muerto, the caustic badlands parallel to the river, Oñate, with an estimated 600 soldier-colonists and an assemblage of horses, sheep, pigs, and chickens, beheld the Tewa pueblo of Okeh (present-day San Juan), nestled in the fertile valley near the confluence of the Rio Grande and the Rio Chama. In an unexpected display of hospitality, Pueblo residents invited the bedraggled ensemble to share both food and lodging. Oñate no doubt welcomed the opportunity inasmuch as the snow-laden peaks of the nearby Sangre de Cristos forecasted an early winter. Within weeks of their arrival, the pretentious visitors enlisted fifteen hundred villagers to build a church adjacent to the pueblo, where the Spanish intended to establish the initial colony appropriately named San Juan de los Caballeros. A few months thereafter, Oñate reestablished the colonists farther up the Rio Chama near the unoccupied pueblo of Yunge. There he laid the

A well-known rest stop for weary travelers along the Camino Real and later Route 66, El Rancho de las Golondrinas is now a living museum south of Santa Fe.

foundation for San Gabriel de los Españoles, New Mexico's first capital and Europe's oldest settlement west of the Mississippi. From here, the Spaniards seemed determined to expand their influence. Their first priority, however, was to sustain San Gabriel. The residents of San Juan Pueblo depended primarily on annual rainfall to produce their crops, although previous expeditions had noted limited use of catchment dams and diversion canals (*acequias*). Again, the

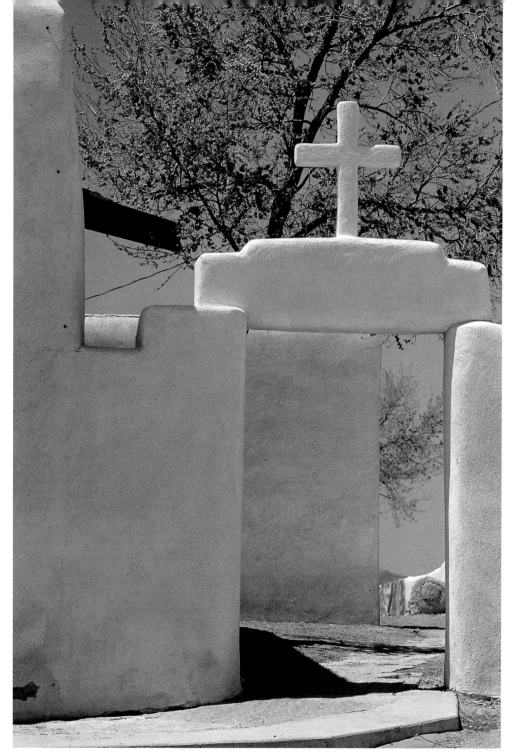

The Catholic
Mission at
Laguna Pueblo.
Laguna was
one of only
a handful of
Pueblos that did
not participate
in the revolt
of 1680.

pretentious newcomers turned to the pueblo to construct a network of ditches in time for spring planting. When it came time to harvest, however, the Spanish found themselves at the mercy of their Indian neighbors. The Europeans arrived well supplied with seeds and livestock to establish an agricultural and pastoral economy. But most of the crops they planted initially failed because the Spaniards were unaccustomed to the mercurial environment. The problem was not in the quality of soil. Rather, persistent aridity combined with exceedingly cold weather produced a climate unfavorable to crops that normally thrived in the more temperate valleys of Mexico. Arable soil, while rich in nutrients, comprised about one percent of the total land area. The Pueblos had most of the irrigable land under cultivation. Spanish law forbade infringement on previously occupied property. Weather patterns, which some scholars liken to a "Little Ice Age," were remarkably colder than today. Extreme temperatures, early frosts, and prolonged winters during which the Rio Grande usually froze solid, resulted in a shorter growing season thus precluding the standard planting techniques most familiar to the Spaniards.

Corn—not wheat—was the revered staple among Pueblo people. In time, Spanish farmers learned to cope with the unpredictable weather to add wheat, barley, cabbage, onions, lettuce, radishes, tomatoes, cantaloupes, watermelons, and chile to the Indians' daily diet. For the present, however, the residents of San Gabriel, consistently plagued with orchards and vineyards that froze prematurely, produced insufficient food

to sustain the colony. As an alternative to starvation, they seized the pueblos' winter surplus for nourishment. Annual assessments of food and blankets from the native communities soon became habitual, which in time evoked deep resentment among the Indians.

Prolonged periods of inattention to crops also contributed to the lackluster success of New Mexico's earliest European colony. Many of the San Gabriel elite still harbored the hope of a mineral bonanza; Oñate seemed obsessed with the idea. How else would the new provincial governor be justly compensated for the estimated one million pesos he personally contributed to establish the miserable colony? The Spaniards persisted in their search for precious metals, and in the process gained detailed knowledge about their surroundings. To the east, they met the Piro-speaking people of the Galisteo and Salinas Basins in addition to encountering the formidable Pueblo stronghold on the upper Pecos drainage. North lay the Tiwa communities of Picuris and Taos. Tewa-speaking cousins of the San Juan people occupied lands along the Rio Grande as far south as the salient promontory the Spaniards called La Bajada. Across the broad alluvial plain leading to Tiguex country, Keres-speaking Indians inhabited Cochiti, Santo Domingo, and San Felipe. Proceeding west, Oñate and his men reconnoitered the provinces of Zía, Jemez, Laguna, Acoma, and Zuni. These latter villages, the unpleasant encounter with Coronado still vivid in their memory, were understandably in no mood to welcome the flamboyant intruders.

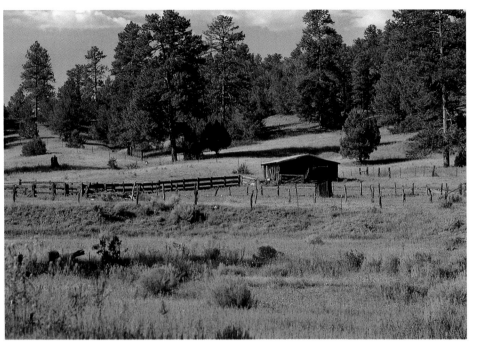

Apache Creek during the monsoon season in late August on Route 12.

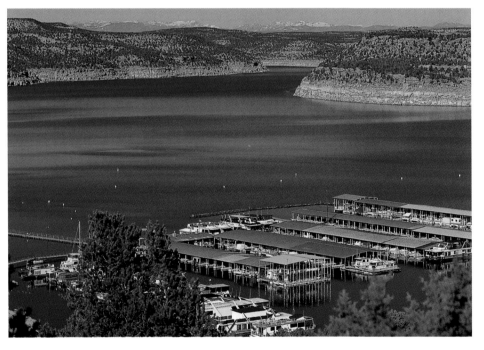

Navajo Lake near the Colorado border in northwestern New Mexico was formed by damming the San Juan River, a vital component of the Navajo Indian Irrigation Project.

Coyote, *canis latrans,* in the Bosque del Apache National Wildlife Refuge.

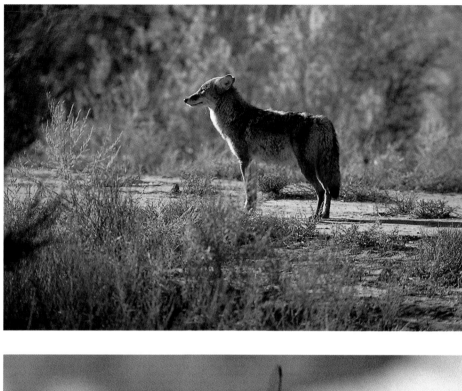

Dragonfly, *odonata,* at the United World College outdoor public spa in Montezuma, just northwest of Las Vegas.

The Acomas, in fact, killed Juan de Zaldívar, the older of the governor's two ambitious nephews, during an attempt to invade their village perched high atop a citadel-like bluff. Enraged at the Pueblo's recalcitrance, Oñate called for punitive retaliation. Following a two-day blood-letting assault, Oñate sentenced two dozen Acoma male captives above the age of twenty-five to be brutally dismembered. Several hundred males twelve to twenty-four and women over twelve years of age faced long-term enslavement. The vicious and vindictive act would come back to haunt the intolerant governor.

Oñate's frequent excursions were welcome relief from mundane administrative routine at San Gabriel. During one such expedition in 1605, which the Spanish administrator recorded for posterity on the sandstone cliffs of present-day El Morro National Monument, several colonists mutinied and left the failing colony to return to Mexico. Unlike Oñate and the Zaldívars, most of the would-be colonists were not aristocrats. They ventured north into unknown terrain with hopes of becoming landed gentry (*hidalgos*). Although the lowest rank of Spanish nobility, the designation carried with it entitlements to land, annual tribute, and access to Indian labor on condition that they remain in New Mexico a minimum of five years and pledge to defend the territory against all threats. As captain general and provincial governor, only Oñate had the authority to compensate the colonists. Preoccupied with notions of personal aggrandizement, he failed to satisfy their needs. Resentment rippled through the

colony. So much so that their discontent reverberated through the halls of municipal government in Mexico City. Disillusioned by his failure to discover great wealth and astonished to learn of the disloyalty of his subjects, Oñate resigned his office. His reputation as an administrator tarnished, he returned to Mexico, where he faced charges not only for the brutal punishment administered to the Acoma insurgents but also for the harsh treatment imposed upon his fellow Spaniards. Despite his shortcomings, the king rewarded the aging conquistador with an appointment as inspector general of mining operations in Spain. Ironically, Oñate, who owed his celebrity and vast wealth to the extractive industry, suffered a fatal stroke in 1626 while inspecting a mine.

Oñate had resigned his office in 1607, the same year British colonists at Jamestown were gaining a tenuous foothold on the North American continent. Later that year, Captain Juan Martínez de Montoya, the genteel, Castilian-born interim governor, reconnoitered a new location for the ill-fated colony. The prospective town site, which lay south of the Chama Valley, appeared to be well-watered and currently unoccupied. The few settlers who moved to the new location named the town Santa Fe (the Holy Faith), perhaps as a reflection of their renewed spirit. As newly appointed Governor Pedro de Peralta assumed office in 1610, the new villa bristled with civic activity. Residents had already begun constructing their houses on the salubrious south bank of the stream that bisected the town. Peralta had little

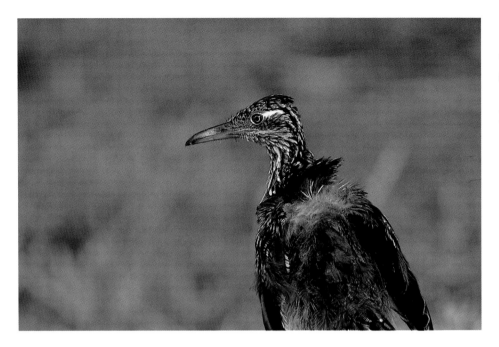

Greater roadrunner, *geococcyx californianus*, in the Bosque del Apache National Wildlife Refuge.

choice but to establish his administrative headquarters on marshier patches of land located on the north bank. Relying on the time-tested blueprint for Spanish town-building, the governor ordered surveys for his personal residence, the church with attached living quarters for the attendant friars, the adobe *casas reales* or town hall, plus ancillary buildings and structures associated with colonial government. All were neatly arranged to form a perimeter around the main plaza. This fundamental template for Spanish colonial municipalities remains well-defined in downtown Santa Fe. Unlike the tentative beginnings of San Juan de los Caballeros and San Gabriel, Santa Fe evolved into the quintessential seat of power for the

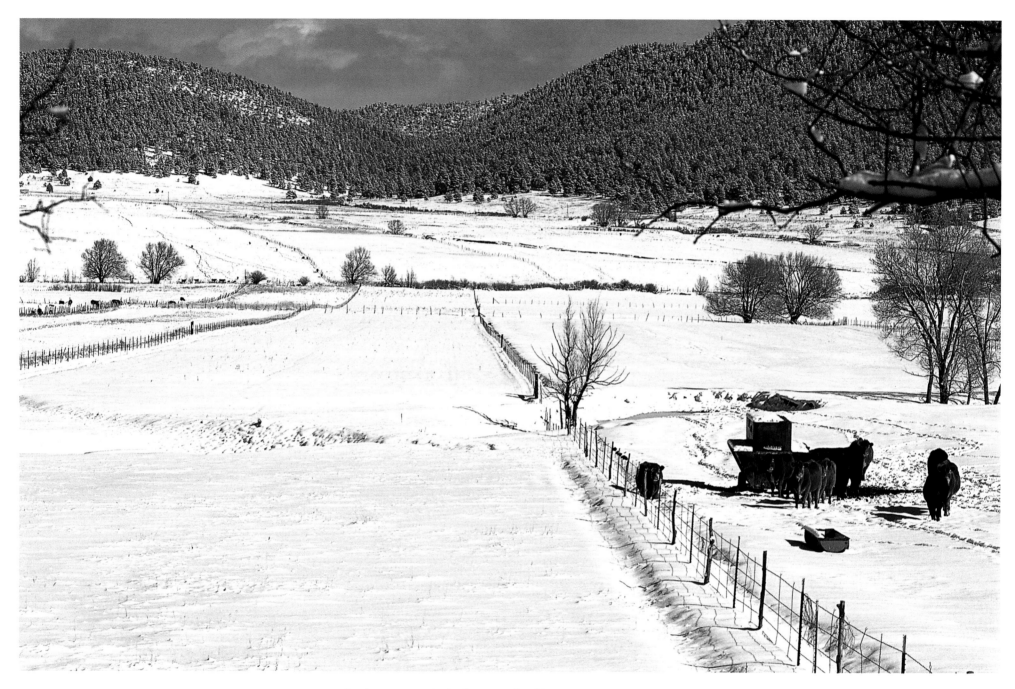

A winter scene in Ledoux north of Las Vegas on Route 94.

next seventy years. From this central location civil and religious authorities—for better or worse—extended the tentacles of regal authority to the remainder of the province.

Virtually from the outset, government officials and church leaders contested one another for the right to dominate the lives of the native population. Unlike the mineral-rich dominions of Mexico and Peru, Spain's newest province appeared to be poverty-ridden, so much so that the viceroy considered abandoning the colony altogether. New Mexico's only exploitable resource, it appeared, were the Pueblo people. Beginning with Oñate, and continuing through the succession of provincial administrators, those who had found favor with the governor were entitled to the property, privileges, and civil appointments afforded them through grants of the *encomienda*. After three decades of Spanish rule, virtually all of New Mexico's limited wealth was concentrated in the hands of thirty-five prominent families. These *encomenderos*—which included the Romero, Gómez Robledo, Anaya, Almazán, Baca, Duran y Chávez, Archuleta, Lucero de Godoy, Montoya, Gonzáles, and Domínguez de Mendoza families—skillfully secured their political and economic influence through strategic marriages and extended familial relationships. Their entitlement allowed them to assess levies in the form of corn and blankets on the local pueblo communities as well as to exact labor and personal services as required to maintain their holdings. In return for their privileged status, the *encomenderos* swore to act as trustees over their Indian subjects, financially support the

church, and render military protection to the province. In theory, Spanish law imposed strict regulations on the amount of tribute to be collected; in practice, abuses prevailed and the system roused deep enmity among the pueblos.

Sometime around 1630, the Spanish crown declared New Mexico a royal colony that was to be entirely subsidized by the treasury. The renewed commitment to bolster the faltering province was neither military nor economically driven. For the next half-century, religion provided the impetus for the financial support of the colony. The Puebloans would soon bear the full weight of Christianity. Although only a handful of Franciscan friars accompanied each *entrada* into New Mexico beginning with Coronado, a cumulative total of 250 members of the mendicant order labored tirelessly to imbue the indigenous populations of the Rio Grande Valley with the spirit of Roman Catholicism. Antithetical to their cause were the *encomenderos,* who monopolized the principal source of labor the missionaries themselves required to build churches and cultivate the land. A relentless feud, during which the power of the Holy Church challenged the authority of the Spanish crown for possession of the Indians' souls, spread like a malignant tumor across the land.

The pueblos could no longer bear the yoke of oppression. Since the Spanish arrival, a series of catastrophes had reduced their population by more than fifty percent (17,000 in 1680). Insatiable demands for food and clothing drove many of the pueblo communities to starvation. Ceaseless labor on behalf of the Church resulted

A small chapel
near Chili on
Route 285.

Indian uprising within the confines of the United States, spelled disaster for the Spanish colonization effort. In its wake, 400 settlers—representing 15 percent of the colony—and twenty-one Franciscans lay dead and mutilated. The surviving Spaniards fled the province in mass hysteria; some never to return, most exiled to El Paso. In August 1692, exactly twelve years after the catastrophic uprising, the vigorous don Diego de Vargas initiated the reconquest of New Mexico. After six months of reconnaissance and renewing strategic alliances with Pecos and other militant pueblos, Vargas returned to El Paso to assemble the colonists. Of the 500-plus families that returned to the province with Vargas, only forty had accompanied Oñate. The governor recruited the additional colonists from the central valley of Mexico and the mining towns near Zacatecas. Spain's momentous return to New Mexico in 1693 promised a new relationship between Pueblos and Hispanos, as both faced new perils from hostile forces beyond their shared border.

in unattended fields at home. These problems were worsened by natural calamities such as droughts that sucked the life out of the soil, rendering it useless, and pestilence for which the Indians had no immunity, that left hundreds of their kind dead. When they turned to traditional deities for salvation, intolerant missionaries smashed religious symbols and incinerated sacred sites. Public humiliation and punishment of religious leaders only deepened Pueblo animosity. One especially vindictive member of San Juan Pueblo, a medicine man named Popé, took up residence in Taos, intent on planting the seeds of insurrection. The ensuing Pueblo Revolt of 1680, recognized in history as the most successful

Communities in Transition

THE INTENSE TWO-DAY BATTLE to wrest the Palace of the Governors from its formidable Tano and Tewa defenders ended on December 28, 1693. The comparatively benign reinstatement of Spanish authority that followed

anticipated a new era of pragmatic accommodation between Indians and Europeans. The Spaniards had learned a humiliating lesson, and with their return to Santa Fe the imperious institution of the *encomienda* was forever abolished. Missionaries exchanged crusading fanaticism for benevolent paternalism that proved more tolerant of traditional religious practices. Archaeological evidence at Pecos suggests the friars may have allowed the Pueblos to return to the kivas. A new breed of colonist—racially mixed, industrious, and family oriented—outnumbered the predisposed aristocracy of earlier *entradas*. In the absence of the *encomienda*, unwieldy estates that once dominated the colony gave way to subsistence farms and ranches whose owners actively engaged in agriculture and animal husbandry. Content to manage their properties independently, the hard-edged, self-reliant newcomers encouraged the Pueblos to return to their own fields. Regular inspection of the local pueblos became standard practice and Indian residents were afforded legal representation against all civil and religious improprieties. In an amazing departure from earlier times, Spanish officials not only permitted the Pueblos to own firearms but also enlisted them to serve alongside Hispano neighbors (*vecinos*) in the local militia. Barter between Hispanos and Pueblos increased during this period. At the same time, government officials encouraged trade among the Plains Indians as well.

Although minor insurrections were unavoidable, the comparatively peaceful coexistence between the two dominant cultures of

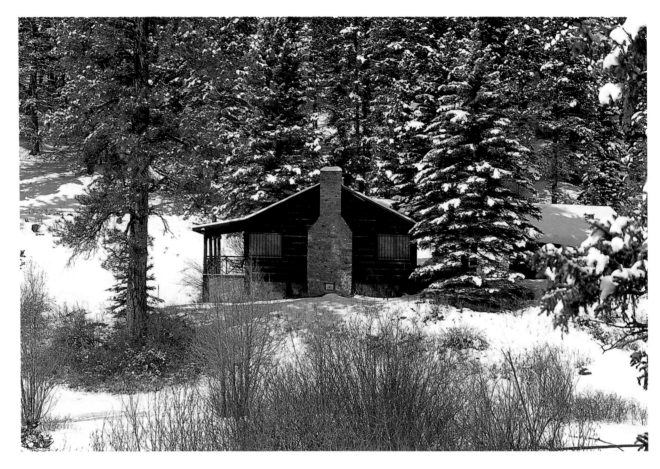

A cabin in winter,
Pecos Wilderness Area.

Nuevo Mexico ushered in an era of unprecedented growth and stability within the once mercurial province. Ritualized kinship through intermarriage and baptism (*compadrazgo*), living in close proximity, and shared use of finite land and water resources hastened cultural coexistence but not at the expense of ethnic singularity. Like ripples in a pond, Hispano settlers emanated outward from Santa Fe, the geographic epicenter. First among the newfound

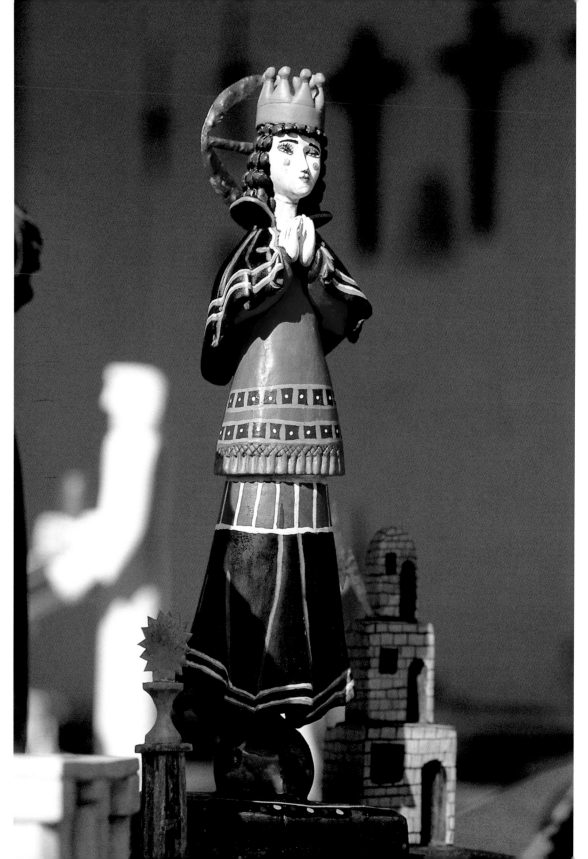

Spanish market
art in Santa Fe.

municipalities, Santa Cruz de la Cañada (1695) (near present-day Española) earned the designation of *villa* when Governor Vargas assigned forty-four families to take up residence there. A decade later, Spanish colonists founded Albuquerque (1706) in the lush Rio Grande Valley, the last of the three *villas* established in New Mexico for the remainder of the colonial period. Next, they founded important outlying villages such as Chimayó (1695), Galisteo (1706), Rancho de Taos (1716), Ojo Caliente (c. 1724), Rancho de Chama (1724), El Embudo (1725), El Rito (c. 1731), Las Trampas (1751), Abiquiú (1754), and San Miguel del Vado

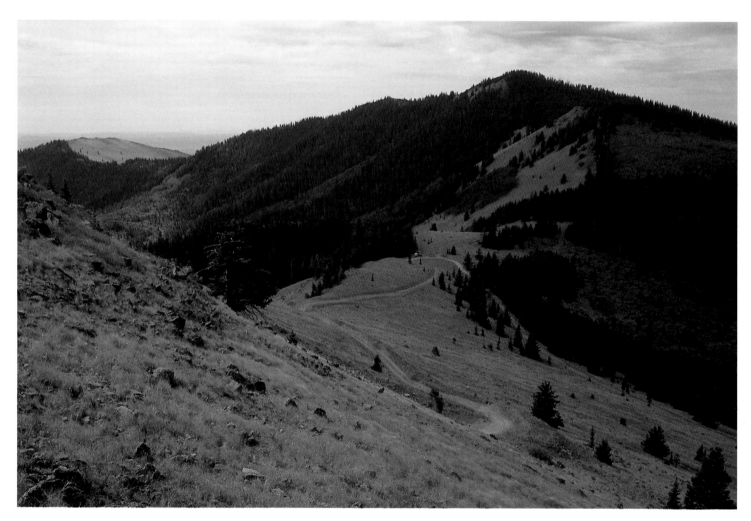

From the crest of Mount Taylor, near Grants, which is sacred to several Native American tribes.

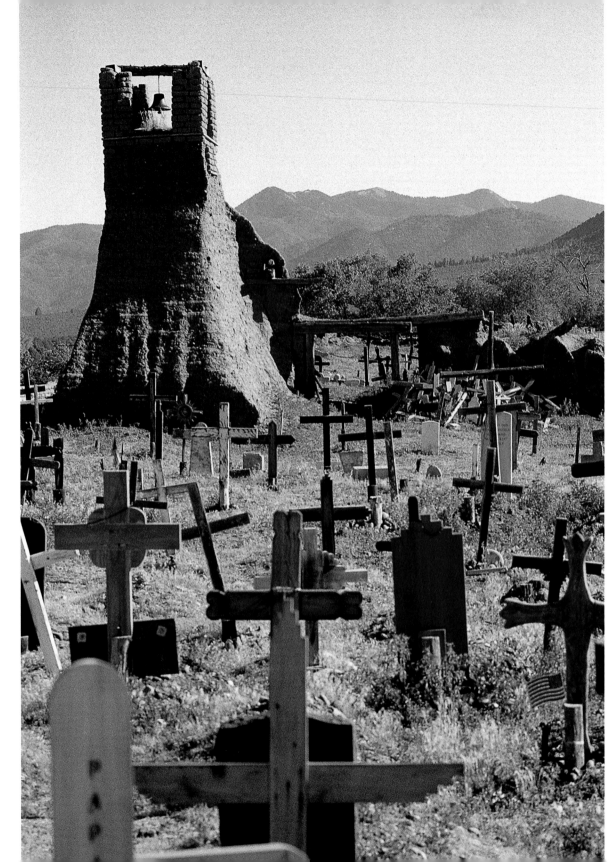

Mission San Geronimo de Taos and burial grounds in the Taos Pueblo. This was the site of the revolt in the New Mexican rebellion of 1847 in which New Mexico landowners rose up against the occupying United States Army during the Mexican-American War.

Barn in Winter
in the Rocky
Mountains on
Route 64 near
Tierra Amarilla.

(1794), all located north of La Bajada, the established point of demarcation between Rio Arriba and Rio Abajo. Near Albuquerque, and continuing south to El Paso past the Manzano and Organos Mountains, lay the reoccupied communities of Bernalillo (pre-1680), Atrisco (1692), Los Chávez (1692), Alameda (1696), Tomé (1739) , and Belén (1740). From these settlements, pioneers inched westward into the pastoral grasslands of the Rio Puerco Valley to populate Cebolleta (1745) in the imposing shadow of Mount Taylor. The census of 1767 verified that the Hispano community (9,580) for the first time nearly equaled the sedentary indigenous population (10,524). More noteworthy was the fact that New Mexico, the oldest province on the rim of Spain's inland empire, had become one of its most populous.

More important, the once troubled colony assumed renewed importance as a buffer between hostile elements and the growth-minded mining communities of northern Mexico.

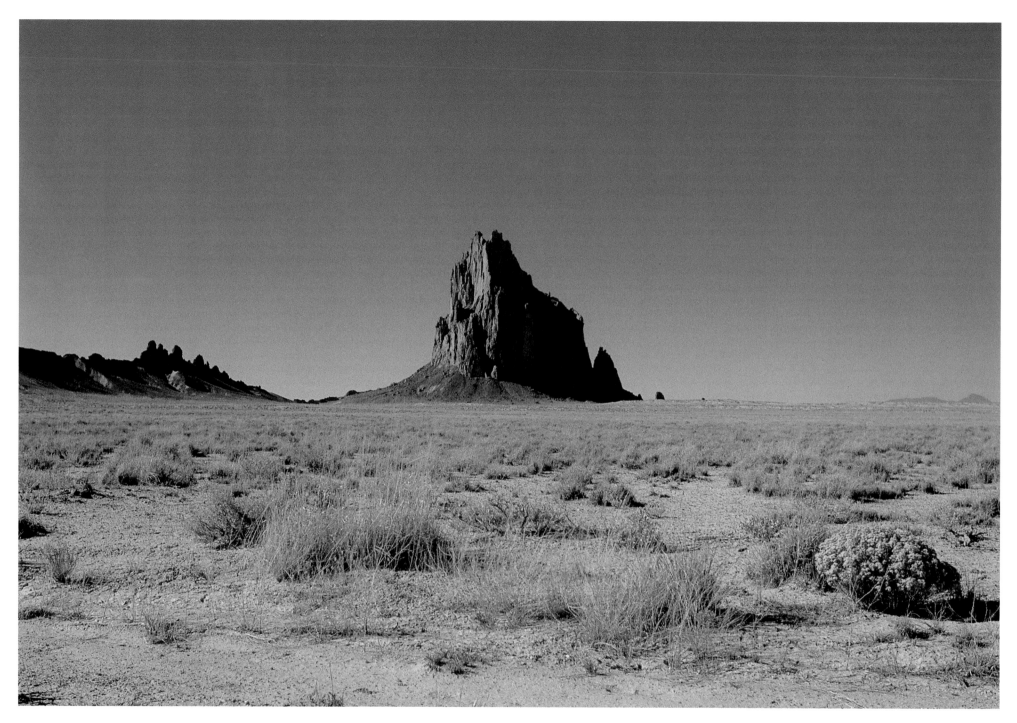

Ship Rock, located in the northwestern corner of New Mexico near the Four Corners monument, is sacred to the Navajos.

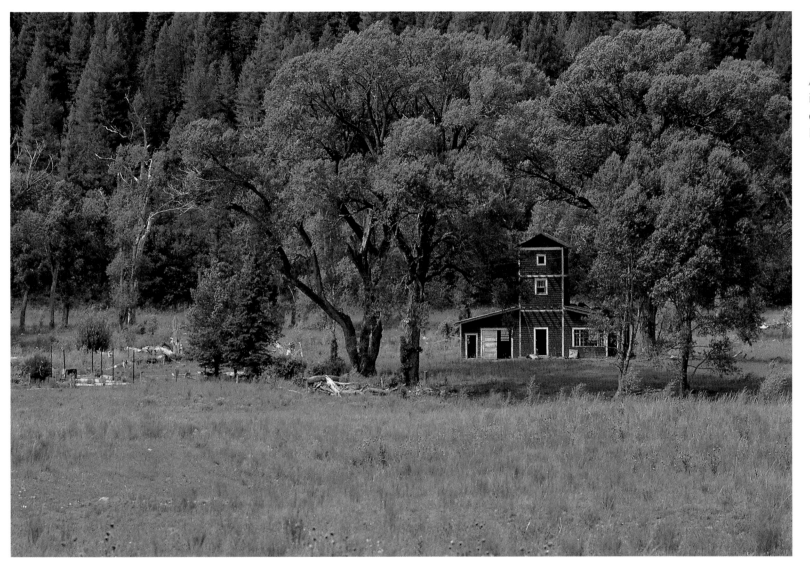

An old farm building in the small town of Gallinas, west of Las Vegas.

Mounted astride stolen Spanish horses, Apache, Ute, Navajo, and Comanche nomads shattered the peaceful ambiance of New Mexico. The latter, the uncontested equestrians of the Great Plains, were the most feared. Comanche warriors swooped out of the San Luis Valley and the Great Plains like a hot, unseasonable wind to ravage frontier settlements. Perfunctorily, a battle-weary garrison of no more than one hundred ill-equipped soldiers rode out to engage them. Always at their side, Pueblo and Hispano recruits to the

Larkspur, *delphinium nelsoni*, in Glenwood, located near the Arizona border in west-central New Mexico.

Pueblo, a seemingly impregnable fortress, routinely offered protection to the harassed *nuevomexicanos*. This pattern of frontier warfare persisted throughout the eighteenth century. Efforts to retaliate frequently vacillated between a policy of the iron fist and one of the velvet glove. The balance between military brinkmanship and frontier diplomacy largely depended on the aptitude of New Mexico's provincial leadership.

No other administrator personified the resilience of New Mexicans in the face of danger more vividly than Governor Juan Bautista de Anza. Unlike his predecessors, most of whom were born in Spain, Anza was a progeny of the New World. The son of a Basque *presidio* officer, Anza's birth in the summer of 1736 no doubt brought a refreshing change to the normally dreary routine at Fronteras, a military outpost in present-day Sonora. An Apache arrow left the young Basque not only fatherless but also hardened like the unrelenting desert that embraced him. Perhaps to avenge his father's death, Anza also chose the military path. Barely sixteen, he volunteered for cadet training at Fronteras, where he was commissioned a lieutenant in the king's army three years later. Anza had just turned twenty-four in 1760—though already a seasoned campaign veteran—when the viceroy appointed him captain of the royal presidio at San Ignacio de Tubac in present-day southern Arizona. In 1772, Anza, a frontiersman of the highest order, established a route between Tubac and Alta California. Four years thereafter, he led the

local militia armed themselves with antiquated weapons in defense of the colony. Their only compensation was individual and communal parcels of land granted by the governor in return for the promise to till the soil and to take up arms when threatened. Too often these citizen-soldiers found themselves isolated on the fringes of the empire only to be hopelessly overrun by calculated Indian attacks. Most often their nearest refuges were the pueblos that a century earlier had been the targets of Hispano avarice and punitive conquest. Taos

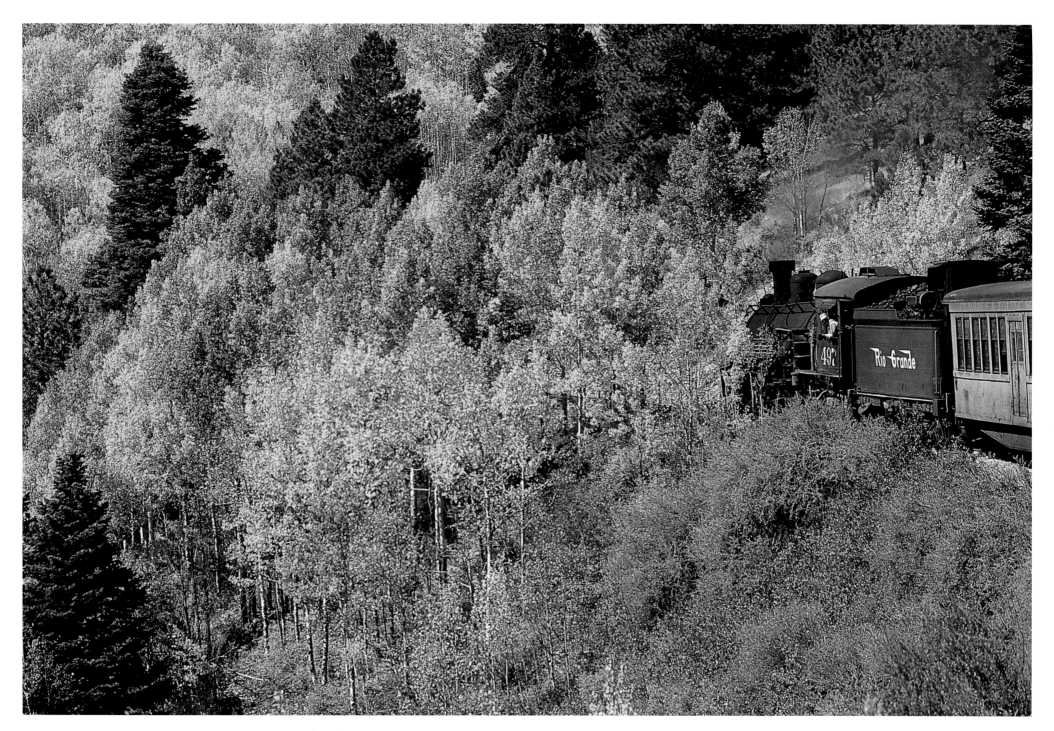

The fall aspen colors give a magical quality to the ride on the Cumbres & Toltec Railroad
traveling through the Rocky Mountains from Antonito, Colorado to Chama, New Mexico.

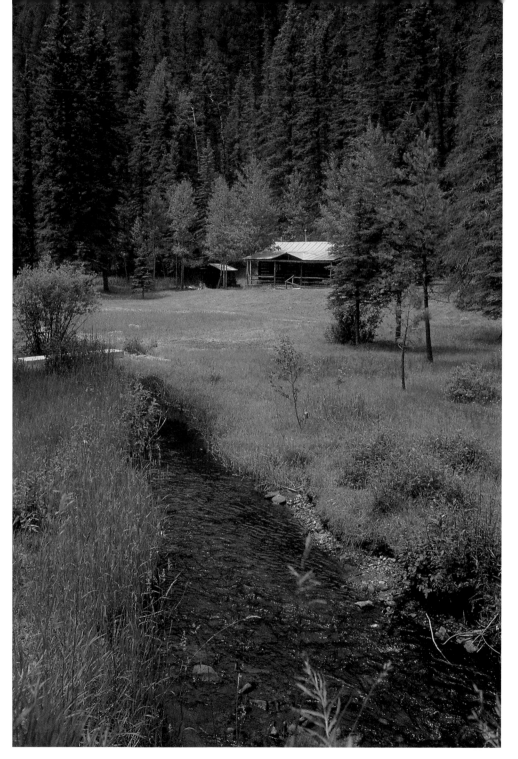

first group of settlers on a 1,200-mile trek across the Mojave Desert to Alta California, Spain's newest and most distant colony. Although Anza's reputation as a proficient leader and a fearless campaigner was irrefutable, a failed campaign against the Yumas in 1775 caused Commandant General Teodoro de Croix to transfer the resilient military officer to New Mexico as the new provincial governor in 1777.

Lieutenant Colonel Anza's reassignment was not without some qualification. Croix, who had reorganized the frontier provinces into a new military commandancy (*Provincias Internas*), needed an experienced and determined administrator to bring peace to New Mexico which was ravaged by uninterrupted warfare. He asked Anza first to subdue the Comanches, then to enter into a strategic alliance with them against the Apaches. The new administrator accomplished his mission with stunning success in the summer of 1779. Anza assembled an army of six hundred professional soldiers, civilian militia, and Pueblo auxiliaries to stage a surprise offensive against the Comanche stronghold on the Arkansas River near present-day Pueblo, Colorado.

The next year, Anza countered his calculated decimation of the Comanche villages with a humanitarian gesture toward the Hopi. With the endorsement of his superiors, Anza rendered aid to drought-stricken Hopi villages, preventing starvation with rations he had transported from Santa Fe. The skillful application of military force combined with humanitarian diplomacy earned Anza the respect and allegiance of the warring nations, especially the Comanches and

the Utes. In time, their conscription to fight other nomadic Indians proved most effective. By the time Anza and his family departed Santa Fe for Arizpe, Sonora in 1787, the indefatigable warrior had exacted promises of peace from the Jicarillas, the Utes, the Comanches, and the Navajos. All pledged to assist the Spanish in their protracted war against the implacable Mescalero Apaches. Fifty-two and in failing health, the veteran frontiersman died in 1788, no doubt dismayed to realize that he had driven the Apaches out of New Mexico only to force them south to menace the Mexican communities of Sonora and Chihuahua.

Anza's ten-year term as governor (1777–1787) not only brought relief but also a measure of prosperity to New Mexico. In the effort to secure peace, Spanish governors sanctioned regularly held trade fairs in Taos, Picuris, Abiquiú, Pecos, and other villages on the plains. Just as they had done before the Spanish arrived, Comanche, Ute, Pawnee, and Kiowa hunters brought buffalo hides, deer and antelope skins, jerked meat, tallow, and salt to trade with the Puebloans and now the Spanish. For their part, the Puebloans exchanged cotton blankets, pottery, maize, and turquoise. Hispano colonists, meanwhile, furnished axes, awls, hoes, knives, and other hardware in addition to gunpowder and firearms. Human exchange was an integral feature of the trade. Plains Indians used this occasion to return pueblo women and children along with captives from other tribes and an occasional Spanish prisoner. These events, held once in the summer and again in the fall, became so valued that they

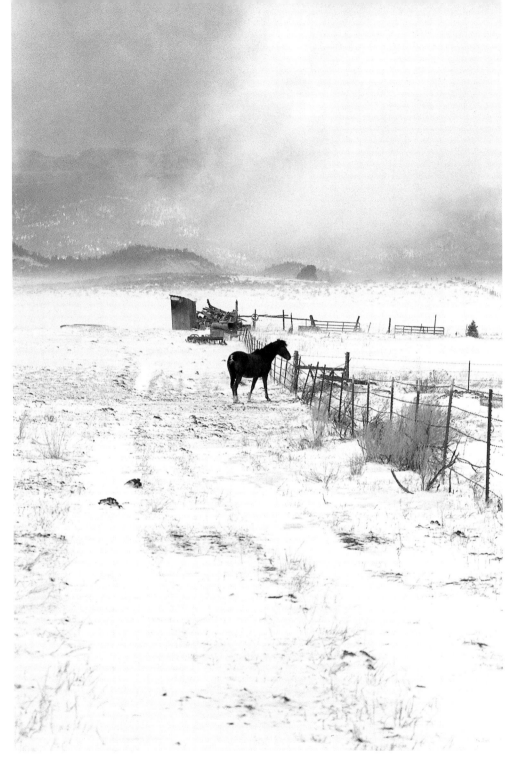

Horse in a snow storm in Tierra Amarilla, site of Spanish land grants that have caused disputes to this day.

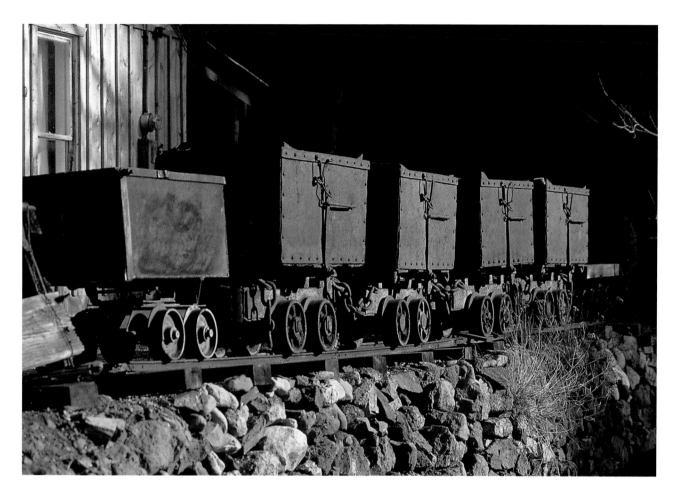

Mogollon is a mining
ghost town in the Mogollon
Mountains. These old mining
cars are on Route 159.

structure in New Mexico. Sixteenth-century colonists were for the most part products of Europe (*penisulares*), not too far removed from the medieval influences of Castile, Galicia, and Estremadura. Those who gravitated to New Mexico hoped to recreate the refined, literate milieu they had savored in Segovia, and more recently, Mexico City. When Vargas reentered Santa Fe in 1693, a new generation of colonists, recruited mostly from the brawling mining towns of northern Mexico, followed in search of a better life in the desert wilderness. Although less rigid, New Mexico society was unmistakably stratified. The governor and his administrators occupied the top rung of the social ladder, along with military and church representatives, most by this time born in the New World (*criollos*). Of the landed gentry (*hacendados*), magistrates, and a nascent merchant class, many were direct descendants of those who arrived with Oñate.

Subsistence farmers, small stockholders, and enlisted soldiers comprised the general population (*vecinos*). They tended the land and as citizen-soldiers defended the realm. Then came the *genízaros*, communities of formerly captive Indians ransomed to the Spanish. They were the marginal class consigned to outposts on the edge of the empire—Abiquiú, Ojo Caliente, San Miguel del Vado, Tomé, Belén, and Sabinal—established to defend the interior provinces. Wage laborers, stockherders, and household servants, some of African descent but mostly various mixed-bloods (*castas*), occupied the bottom rung of society. The census of 1800 revealed a startling reversal in the demographic make-up of the province. At this

were organized to coincide with the annual trade caravans that frequented northern Mexico. The welcome reprieve from hostile raids also revitalized the Pueblo agricultural economy to the extent that the Indian communities routinely supplied Spanish presidios and towns with lettuce, chile, garlic, and other edibles.

Isolation from the centers of power in Mexico City encouraged a more fluid social

time, the Hispano community (24,492) outnumbered the indigenous Pueblo population (8,998) almost three to one.

The dawn of the nineteenth century brought new worries to the Spanish colonial world. Foremost among them was the growing inefficacy and deliberate neglect of the royal government. France's transfer of the Louisiana Territory to the United States in 1803, followed by reckless violations of Spanish sovereignty like those of Zebulon Pike four years later, gave New Mexicans cause for concern. What was the intent of the upstart republic to the east, and how well prepared was the province to protect itself from approaching invasion? These questions among others nagged at the uneasy colonists. Nervousness over Spain's military ineptitude was soon reaffirmed as the empire buckled under the weight of colonial rebellion beginning in 1810. In desperation, Spanish authorities invited delegates from the disaffected colonies to the port city of Cadiz, Spain, to voice their discontent.

New Mexico sent the aging but highly respected Pedro Bautista Pino as its representative. While in Spain, Pino presented a fifty-one-page memorial on the socioeconomic status of the province. First, he admonished the Spanish government for its spiritual neglect. Twenty-two physically spent Franciscans and two secular priests ineffectively ministered to the religious needs of forty thousand Roman Catholics. Worse, the province still had not been declared a diocese. Unscrupulous merchants in Chihuahua, Pino complained, had forced an unfavorable balance of trade in which New Mexico imported far more commodities than it exported.

Consequently, the average, currency-poor New Mexican had no alternative but to pledge crops in advance against daily purchases. Pino criticized military officials for maintaining the main body of regular troops in Sonora and Chihuahua, far removed from daily confrontations on the frontier. Meanwhile, local militia volunteers sometimes sold their clothes and other

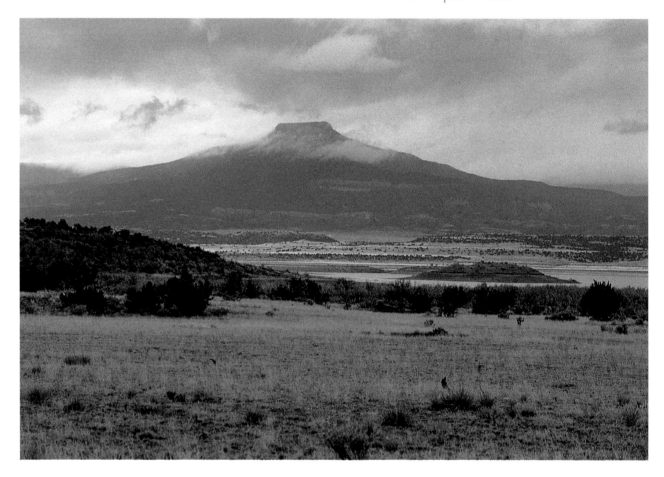

Cerro Pedernal, where the ashes of Georgia O'Keeffe were spread. Ms. O'Keeffe painted the Pedernal many times from her home on Ghost Ranch. Abiquiú Reservoir is visible at the peak's base.

Farm near Vallecitos on Route 111.

personal effects in order to purchase weapons and ammunition to mount a defense. Finally, the province lacked teachers, doctors, manufacturers, and other desperately needed professionals. Unable to assuage the litany of ills enunciated throughout the Americas, Spain relinquished all authority in North America and abandoned her colonies. The former territories of New Spain had little recourse but to declare independence. In 1821, New Mexico came under the jurisdiction of the newly empowered Republic of Mexico.

In the early days of the Mexican Republic, it appeared that the hardscrabble, frontier existence most New Mexicans endured was about to change for the better. Perhaps in anticipation of social and economic reform local citizens celebrated the dawn of a new administration. The grand independence day celebration held on the plaza near the ill-kept Palace of the Governors on September 11, 1821, had barely subsided when once again there were strangers at the gate—this time from the East. Not unlike the Spanish conquistadores who had preceded them into the Southwest in search of untapped wealth, the American interlopers came to New Mexico anticipating an economic conquest of a different nature. Missouri merchants had long dreamed of peddling their manufactured goods in Santa Fe, especially since 1810 when Zebulon Pike published his colorful, eyewitness account lamenting the economic deprivation of the territory. A yard of fine cloth, according to Pike, sold for twenty-five dollars, twice the value of a good horse. New Mexicans, on the other hand, yearned for a new source of trade goods

An old steam engine of the Cumbres & Toltec Railroad in Chama.

because they were constantly at the mercy of the Chihuahuan monopoly, located seven hundred miles distant. The potential for profit was tempting, Pike concluded, and the recent transfer of authority from Spain to Mexico promised unlimited economic opportunity. Even the outgoing Spanish governor, don Facundo Melgares, did not seem disturbed by the appearance of William Becknell and his rag-tag band of Missourians.

Outside of Fenton Lake State Park in the Jemez Mountains on Route 126.

Campground at the City of Rocks State Park near Deming, Route 61.

Long before his appointment as New Mexico's last Spanish administrator, Melgares dreaded the American arrival but appeared resigned to the inevitable. It was he, an inexperienced second lieutenant on temporary duty to El Paso, who intercepted Pike and his weary band during their enforced march to Chihuahua. Reports indicated that Pike, ostensibly in search of the headwaters of the Arkansas River, had "inadvertently" wandered into the San Luis Valley during the winter of 1807. The truth was that President Thomas Jefferson, just one year after Lewis and Clark's triumphant return to St. Louis, had despatched the young first lieutenant into the Arkansas Valley with explicit instructions to infiltrate Spanish domain at every opportunity. Pike and his men were camped at the foot of the Sangre de Cristos near present-day La Jara, Colorado, when the Spaniards seized them. The American captives reached Santa Fe on March 3; Pike appears to have committed his observations to memory. Three days later, Spanish troops escorted the contingent to military headquarters in Chihuahua,

Ranch in the Black Range deep in the Aldo Leopold Wilderness Area.

where they met Melgares en route. Pike and the flamboyant Spaniard spoke frankly about personal as well as military matters. After a month-long interrogation, the Spaniards released the American captives, who returned to St. Louis via New Orleans. Pike's subsequent descriptions of previously unknown Spanish territory circulated widely in St. Louis and other commercial towns on the Mississippi River.

Founded in 1764, St. Louis was the quintessential French community. Situated near the confluence of the Mississippi and Missouri Rivers, the town oozed commercial activity. Although founded by French traders, St. Louis fell under Spanish authority until 1800 when it was repatriated to France. Desperate to fund his military ambitions in Europe, Emperor Napoleon Bonaparte sold St. Louis and other French possessions to the United States in 1803. The city, however, remained French in every other respect. In 1810—the year Pike published his celebrated journal—St. Louis claimed 1,000

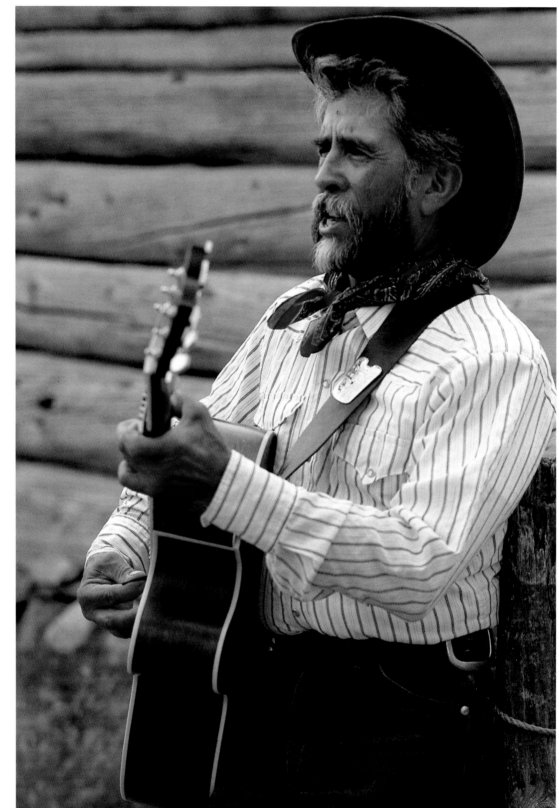

Spanish descendant, Julian Prada, who is also a troubadour and horse trainer.

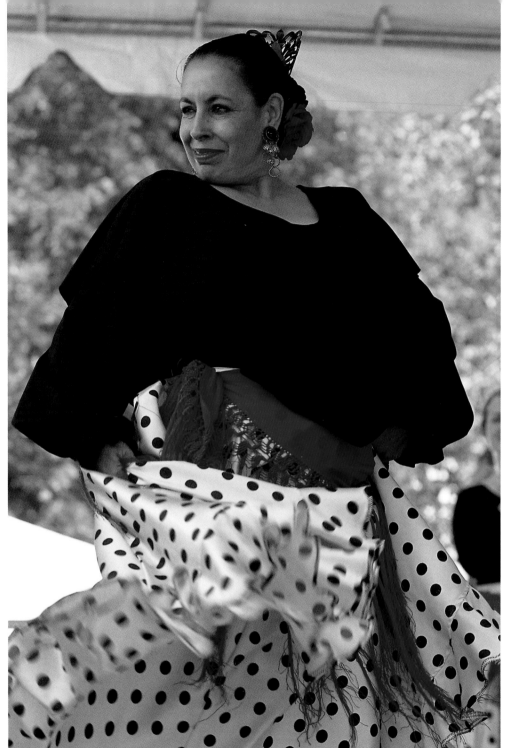

Doris Vigil McBride dances the flamenco at Spanish Market held each summer in Santa Fe.

inhabitants, most of whom resided in rough stone houses coated with limestone plaster.

A decade later, as Becknell and his five associates outfitted their caravan for New Mexico, St. Louis boasted 5,000 citizens, forty commercial buildings, two chartered banks, a brewery, three churches, one post office, and all the trappings of a thriving port city. In stark contrast, Santa Fe, eight hundred miles southwest, had scarcely progressed beyond the unflattering description thirty-six-year-old mission inspector Francisco Antanasio Domínguez rendered in 1776. Santa Fe, he noted in his meticulous report, was an untidy assortment of privately owned subsistence ranches and farms. It bore no semblance of streets, and the mud-covered, flat-roofed houses were scattered about in a disorderly fashion. Although the city housed about 2,000 residents, only the governor, his family, and an assembly of magistrates and city officials lived in the *villa* proper. Frey Juan Augustín Morfi's follow-up report in 1780 echoed Dominguez's dreary assessment. The visiting Franciscan from San Antonio, Texas judged Santa Fe to be appalling and its residents devoid of all refinement.

Clearly not as cosmopolitan as St. Louis, Santa Fe nonetheless found itself inextricably tied to the Missouri trade centers for the next sixty years. Becknell, the former Indian trader and veteran of the War of 1812, had opened the floodgates. The Santa Fe Trail wended its way through the well-watered prairies of Kansas, the snow-laden valleys of Colorado, across the Arkansas River, and entered New

San Felipe de Neri Catholic Church stands on the west side of Old Town Plaza in Albuquerque.

Movie set in the Cerrillos Hills on J. W. Eaves Ranch near Santa Fe. An eighth-century turquoise mine that was worked by Native Americans is nearby.

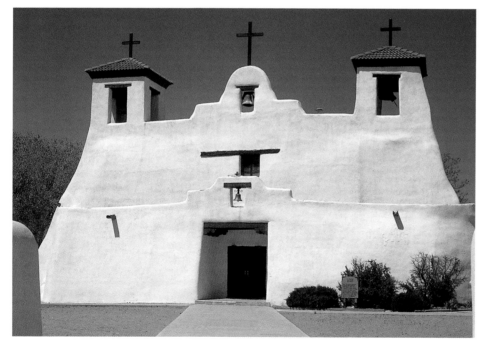

St. Augustine Catholic Church at Isleta Pueblo.

Mexico near the *genízaro* village of San Miguel del Vado. Within months, the profitable venture lured hundreds of get-rich-quick Americans to the trail's end in Santa Fe. Annual gross receipts exceeding $100,000 were not uncommon by the end of the decade.

Within a year, however, Missourians had glutted the market with merchandise. New Mexicans, woefully cash poor, were hard pressed to sustain the momentum of trade. Prices for commodities plummeted, forcing American freighters to move beyond Santa Fe toward more promising opportunities in Chihuahua and Durango. The profit potential of the Santa Fe-Chihuahua trade, combined with fur-trapping opportunities, attracted speculators like Josiah Gregg, Christopher (Kit) Carson, Ceran St. Vrain, Charles Beaubien, William and Charles Bent, Manuel Alvarez, and others destined to share the spotlight in New Mexico's unfolding drama.

The expansion of the Santa Fe trade into northern Mexico gave rise to an Hispano mercantile class that was virtually nonexistent before this time. In the early years, their language skills, knowledge of the territory, and familial ties to the merchants of northern Mexico made them useful to the Americans as middlemen and brokers. By 1835, they had organized their own trade networks and owned a substantial portion of all goods being freighted south from Santa Fe. Whereas American traders specialized in goods manufactured in the East and the Midwest, Hispano merchants dominated the trade in

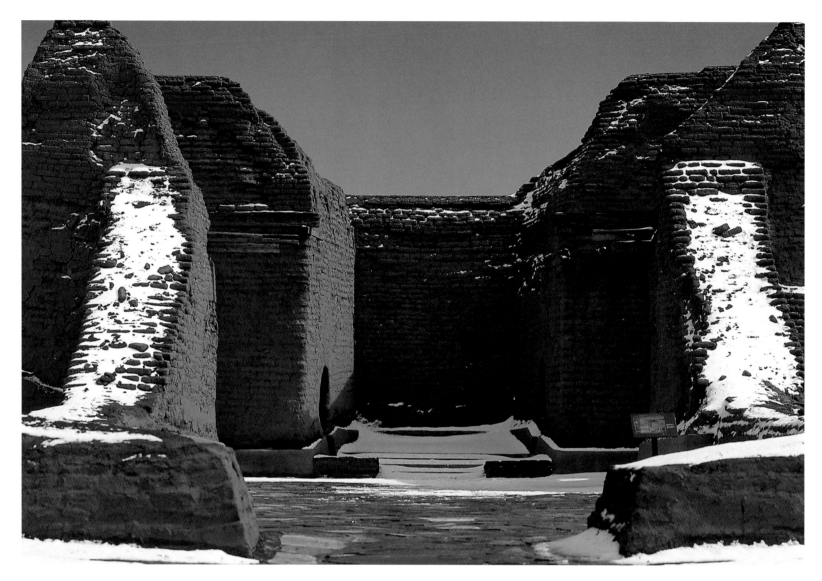

local merchandise (*efectos del país*), a carryover from the well-established colonial trade.

Favored items that Hispano freighters transported included piñon nuts, salt, candles, buffalo hides, deer skins, weavings, and blankets in addition to sheep, an especially valued export.

Boasting a population in excess of 200,000 people (six times that of New Mexico) the mineral-laden, currency-rich, boomtowns of northern Mexico paid cash—or more precisely, silver pesos—for regional and foreign commodities. One advantage Hispano merchants enjoyed

Pecos Pueblo National Monument in winter. As the Pueblo's population decreased, the remaining Native Americans joined Jemez Pueblo, where they remain today.

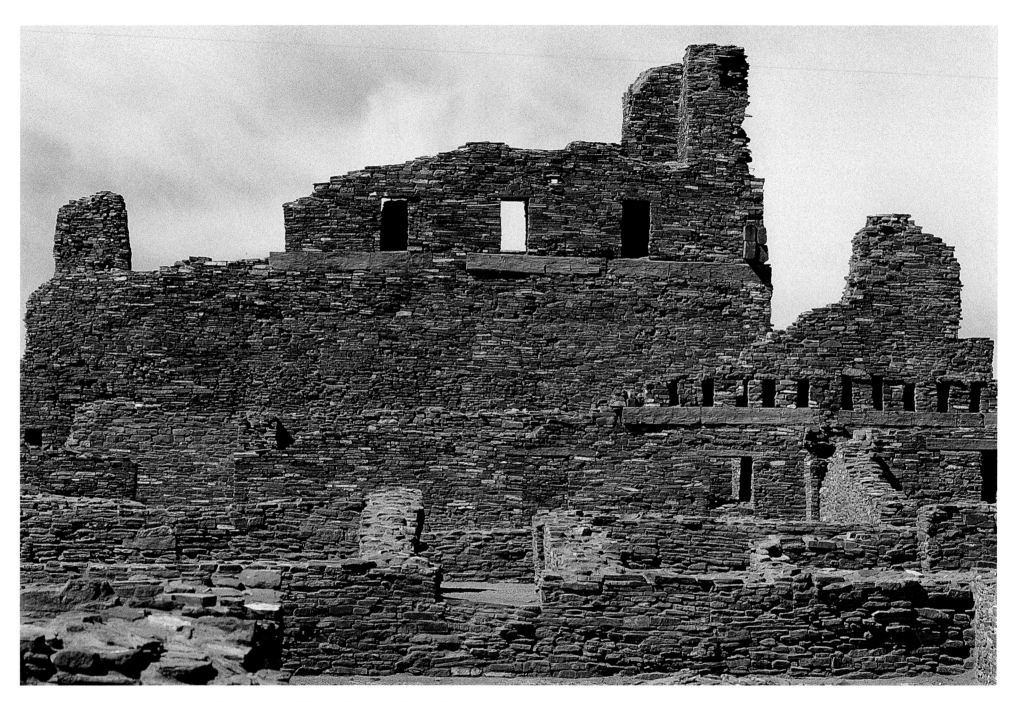

Abó Pueblo, off Route 60, of the Salinas Pueblo Missions National Monument was also a Spanish mission.
The Salinas missions traded with Native American Plains tribes as well as with the Puebloans and other western tribes.

over their American competitors was exemption from all import duties, enabling New Mexicans to reap higher profits on each shipment. Within five years of their entry into the trade, Hispano merchants amassed personal fortunes sufficient to capitalize direct purchases from eastern manufacturers. By the end of the decade, a handful of entrepreneurs—Mariano Cháves y Castillo, Miguel Antonio Otero, Pedro José Perea, Manuel and Pablo Delgado, Vicente Armijo, Antonio Sandoval and others—consolidated their wealth to purchase American-made goods (*efectos extranjeros*) for transport to northern Mexico. Their astounding success made them formidable competitors for the duration of the trade. More important, the financial achievements of New Mexican merchants, who called themselves *capitalistas*, belied the prevailing Anglo stereotype that Hispanos possessed neither the ambition nor the proficiency for business.

In contrast to the positive contributions of the Hispano merchant class, Manuel Armijo, one of the so-called *ricos* who had profited from the Santa Fe trade, left a black mark in the annals of New Mexico history. Both hero and villain, Armijo truly represents a tragic figure in the state's history. His reputation as hero stemmed from his loyalty to the Republic and his eagerness to defend New Mexico against foreign aggression. One of several children born to wealthy Albuquerque landholder don Vicente Armijo, Manuel tended his father's flocks while he dreamed of independent wealth and military greatness. At age

A crucifix in St. Francis Cathedral in Santa Fe. The cathedral was built under the leadership of Archbishop Jean Baptiste Lamy, a well-known figure in New Mexican history.

twenty he had earned minor recognition as a lieutenant in the local militia during the ongoing campaigns against the Apaches. His political career began somewhat unimpressively as mayor (*alcalde*) of Albuquerque, where he established a reputation as the champion of

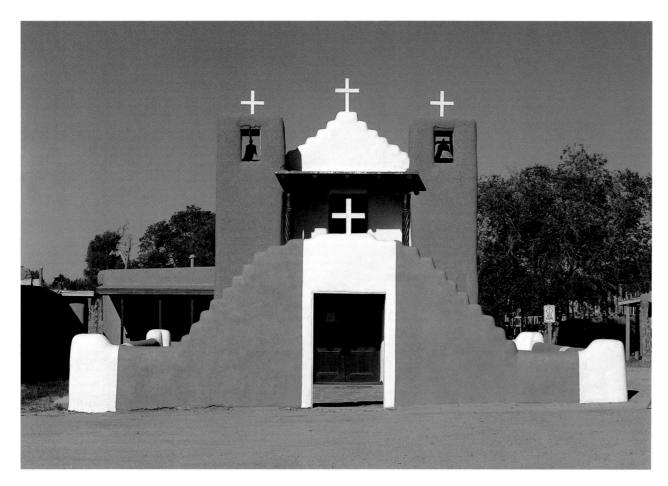

The Chapel of St. Jerome
(San Geronimo) at Taos Pueblo.

In 1837, perhaps inspired by the successful revolt against Antonio López de Santa Anna in Texas the previous year, a coalition of Pueblo—possibly from Nambé—and Hispano farmers from Santa Cruz protested the appointment of the irascible Colonel Albino Pérez as governor. Armijo eventually suppressed the so-called Chimayó Rebellion, but not before the rebels had overrun the governor's office and killed him. A grateful Mexican Republic reappointed Armijo as Perez's successor and made him supreme military commander. Early in his second term, Armijo faced an even stiffer challenge from Texas filibusters in 1841. Claiming that the boundaries of the Texas Republic extended to the headwaters of the Rio Grande, President Mirabeau Lamar pledged to annex New Mexico and usurp the lucrative Santa Fe-Chihuahua trade. Armijo and inhospitable desert terrain foiled Lamar's plans. Thirst-ridden and scattered across the Llano Estacado, the bedraggled Texans were easy prey for the New Mexico militia. Attired in a dazzling uniform accented with a plumed head cover, Armijo routed the intruders and marched them to Mexico for trial. Once again, Armijo's unflinching defense of the Republic made him a national hero.

The governor's personal ambition, manifested in his fraudulent, self-serving behavior while in office, however, made him a villain. His unpardonable crime: the silent surrender of New Mexico territory through reckless parceling of lands to personal friends and political associates. Within a three-year period

the common man. During an uninspired first term as Mexican governor (1827–1829), Armijo lobbied for public schools and military stipends for the local militia. He strenuously enforced taxation of all American trade goods and worked diligently to minimize smuggling. In the intervening years, Armijo amassed a personal fortune in the Santa Fe trade and became increasingly influential in politics and military affairs.

(1841–1844) Armijo, either by direct decree or with his personal knowledge, awarded 9.7 million acres of land—half within a six-week period during the winter of 1843. The Beaubien-Miranda Land Grant (renamed the Maxwell Land Grant) is the most infamous example. Like other immigrants who preceded him to New Mexico, the Canadian-born Beaubien had engaged in the fur trade and the Santa Fe trade with moderate success. His close friendship with Armijo and a business relationship with Guadalupe Miranda, the governor's collector of customs in Santa Fe, had a more lasting influence on the Frenchman's financial good fortune. It was probably Miranda who drafted the terms of the land grant, which included Charles Bent as a silent partner. Within days of receiving the petition, Armijo granted the partners their request, careful not to specify details about the grant's size or its legality.

Sunflowers at the Bosque del Apache National Wildlife Refuge. In July the sunflowers emerge throughout the state in profusion.

Looking down on Mora from Route 94 after a winter storm. The Spanish land grant and subsequent parceling to tenant farmers is discernible.

The practice of compensating New Mexican villagers and militiamen with individual grants of land had been common practice since the Spanish colonial period. Under Mexican authority, municipal land grants extended the limits of settlement into remote corners of the province such as Anton Chico (1822), Tierra Amarilla (1832), and Las Vegas (1835). These grants generously entitled farmers and stock raisers to small parcels of land and unrestricted communal access to water, timber, and pasturage (*ejidos*). The Colonization Law of 1824, which enticed Americans to abandon the Louisiana Territory for new lands in Texas, was legislated to populate less desirable regions of the northern frontier. The law naturally gave preference to Mexican citizens in the distribution of lands and it limited the amount of each entitlement to eleven square leagues (approximately 97,000 acres). No government administrator before Armijo had awarded grants of such extraordinary size. After the successful Texas Revolution in 1836, Mexican law specifically forbade land grants to foreigners.

Carlos Beaubien was by birth a foreigner. But like other new arrivals who married into prominent Hispano families, Beaubien chose the Lobato family of Taos as his passport to becoming a citizen of the Republic. Other former Americans like Ceran St. Vrain married or cohabitated with well-to-do Hispano women and became Mexican citizens. Charles Bent, who derived his income from the famous trading post located on the American side of the Arkansas River, never relinquished his U.S. citizenship. These relationships were not only financially

St. Francis Cathedral in Santa Fe at Christmas.

political activism made Martínez suspicious of all foreigners. Implicated in the farmer-led Chimayó Rebellion of 1837, the Taos cleric attended the execution of the rebels and never lost his disdain for the officious Armijo. Ever the Mexican patriot, Martínez stood in the path of foreign ambition and deeply resented the governor's cavalier disbursement of native soil. Obviously, Martinez's voice went unheard. Beaubien and Miranda received their grant in 1841, and in gratitude transferred one-quarter share each to Manuel Armijo and Charles Bent. The following year, Luz Beaubien married Lucien Bonaparte Maxwell, an Illinois expatriate who had come to New Mexico to engage in the fur trade. Upon his father-in-law's death in 1864, Maxwell diligently assumed sole owner-ship of the grant.

Armijo suffered a final indignity at the very moment his country needed him most. As the winds of war swept across the Southwest, fueled by the United States annexation of Texas in 1845, armed invasion was a certainty. New Mexicans naturally turned to Armijo, the hero of the Chimayó Rebellion and the ill-fated Texas Expedition, to defend them against the "Colossus of the North." Meanwhile, American businessmen Charles and William Bent, long suspected of disloyalty to the Mexican govern-ment, actively undermined the military defense of New Mexico. It is a well-known fact that the two brothers welcomed Brigadier General Stephen Watts Kearny and the Army of the West to Bent's Fort in advance of his march on Santa Fe. It is also common knowledge that the

convenient but also politically advantageous. Armijo's favoritism did not go unchallenged. The most strident objections came from Padre Antonio José Martínez, the fiery parish priest from Taos and defender of the poor.

Born in the *genízaro* village of Abiquiú in 1793, he was ordained as a priest in 1823. Martínez was more than a devout Catholic, he was an ardent nationalist. Profoundly literate, no doubt a skill derived from his training for the ministry, he purchased a printing press from Santa Fe trader Josiah Gregg to publish New Mexico's first newspaper, *El Crepúsculo de la Libertad* (The Dawn of Liberty). A lifetime of

San Francisco de
Asis Catholic Church
in Ranchos de Taos.

An adobe home reflecting the Catholic heritage of its inhabitants, near Cordova.

Bents shamelessly courted Armijo's favor with premium wines and exotic delicacies, which they routinely imported from the East. Not known for certain but often suspected, the Bents, in collusion with U.S. envoy James Magoffin, bribed the governor with cash to abandon his resistance to the invasion. In Armijo's defense, he may have realized the futility of confronting the American army with a seriously outnumbered contingent of untrained, ill-equipped militia. In any event, the anticipated showdown at Cañoncito de Apache never took place. On August 18, 1846, Kearny's Missourians entered Santa Fe unopposed and ceremoniously hoisted the American flag. For the third time in three hundred years, unwelcome visitors made their presence known in New Mexico.

Foreigners in Their Native Land

THE TWO MOST SIGNIFICANT events of the nineteenth century occurred less than fifty years apart. Both had a monumental effect on the state's history. First, the arrival of the American army in 1846 abruptly concluded three centuries of Hispano authority. In July 1848, the Treaty of Guadalupe Hidalgo, ratified as Americans commemorated their own emancipation from colonial rule, guaranteed the rights of U.S. citizenship to all New Mexicans—Indian and

Sacred Heart Catholic Church in Quemado.

Hispano. Second, the coming of the railroad in 1879 served as an agent of incorporation to link the frontier provinces of the former Spanish empire to the industrialized regions of the United States. As the Atchison, Topeka, and Santa Fe Railroad (AT&SF) merged national markets with regional resources, New Mexico invariably became an extractive colony of the East and the Midwest. In the process, the natural landscape, replete with coal, timber, land, and

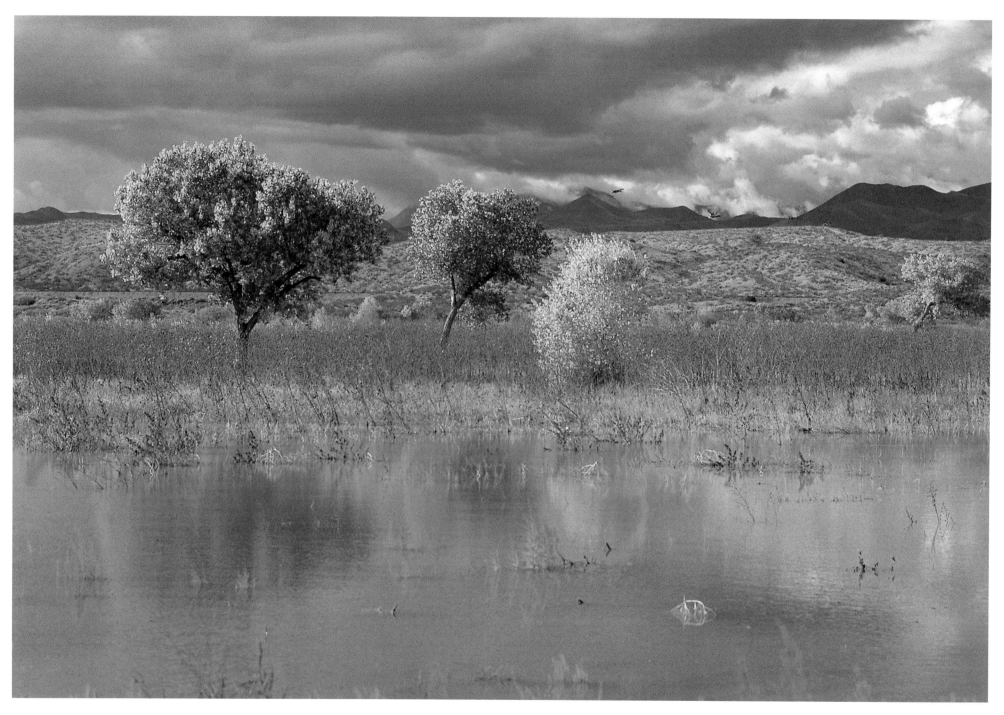

Fall foliage in the Bosque del Apache National Wildlife Refuge.

resources—oil, gas, and uranium—that as yet had no marketable value, was irreversibly altered. Directly in the path of industrial development and regional modernization, Hispano villagers witnessed the demise of independent stock raising and subsistence farming. With the advent of the twentieth century, the vast majority of New Mexico's Spanish-speaking population were no longer land owners; rather, they became consumers and wage earners.

As General Kearny asserted United States authority over its newly acquired territory, he pledged to restore civil government, to defend New Mexico from future hostility, and to ensure the inalienable rights of property and religion to its citizens. To that end, Kearny commissioned the construction of Fort Marcy just north of the colonial plaza in Santa Fe. Within a month of occupation, Colonel Sterling Price arrived from Missouri with additional troops to strengthen the fort. Kearny, meanwhile, appointed Charles Bent the first interim governor, perhaps as compensation for the latter's role in neutralizing Armijo.

In many ways, Bent mirrored the cultural superiority of the newly imposed military regime. Virtually from their first encounter in 1821, the Puritan-minded Americans held a low opinion of Hispano culture. They considered Spanish-speaking people backward, superstitious, lacking ambition, vulgar, corrupt, and cowardly. Americans disparaged New Mexicans for their religious beliefs, their spoken language, and most of all their antiquated agrarian

Christ in the Desert is a Benedictine Monastery near Ghost Ranch in Abuquiú. This statue is in the chapel.

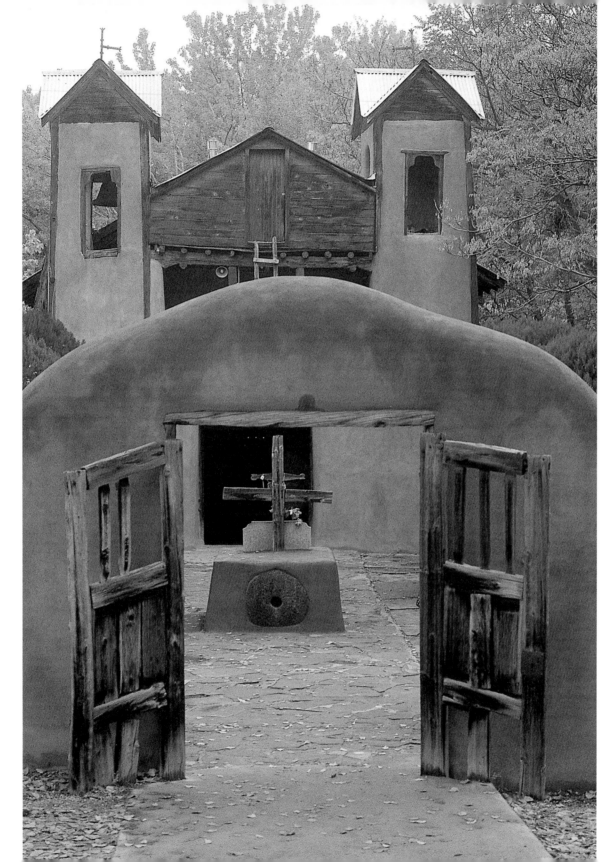

El Santuario de Nuestro Señor
de Esquipulas Catholic Church in
Chimayó is home of reputed healing
powers and is a sacred destination for
many Catholics as well as non-Catholics.

economy. The troops who accompanied Kearny in 1848, and the cadre of lawyers, land speculators, and Protestant missionaries that followed, were no different. Legal conflicts were inevitable in part because of contradicting perceptions regarding land use and property ownership. The Indians, who claimed ancestral inheritance of the land, were overpowered and banished to government-subsidized reservations. Hispanos, whose legal right to the land rested in European law and generations of continuous occupancy, were legally dispossessed of their property and reduced to wage labor. The Anglos, confident in the American tradition of fee simple ownership, water rights, and indiscriminate resource exploitation, judicially wrested more than fifty-two million acres of New Mexico's land from its previous owners and made it available to speculators and homesteaders.

American reluctance to integrate New Mexico into the Union arose in part because of the territory's racial admixture and the presumed dearth of exploitable mineral resources. The United States had annexed California within two years of the first discovery of gold. In similar fashion, Colorado Territory earned statehood in 1861, on the heels of the Rocky Mountain gold rush. In contrast, New Mexico did not become a state until 1912, after sixty-two years as a territory.

Violence was the trademark of the Territorial Period. During the quest for acceptance into the Union, New Mexicans endured episodes of disruptions resulting from internal rebellion, renewed Indian hostilities, economic rivalry, civil war, and ethnic vigilantism. In light

Truchas Cemetery overlooking the Sangre de Cristo Mountains, part of the southern Rocky Mountains.

of this civil unrest, the United States military dominated the economic and political milieu. Its presence offered a ready market for locally produced stock and agricultural products. Its mission promised to hasten long-awaited peace and stability to the frontier. The first affront to that goal came within a year of the army's triumphant entry into the plaza at Santa Fe.

Although the American occupation of New Mexico has been characterized as "bloodless," not

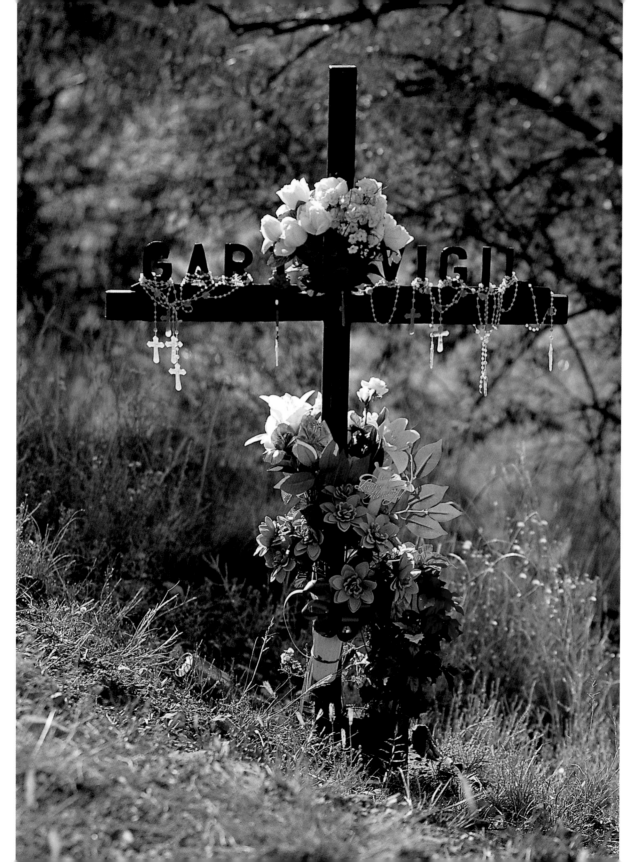

El Pueblo, Route 3. A *descanso* commemorating the death of a comrade along the road. The beer can next to the cross is left half full so that the deceased friend will have something to drink on his journey.

all Hispano citizens welcomed the abrupt governmental transition. Many of the residents of San Miguel de Vado, for example, preferred repatriation to Mexico rather than swear allegiance to the United States. Others voiced resentment through armed insurrection. Early in 1847, a coalition of Pueblo, Hispano, and *genízaro* residents from Taos, Arroyo Hondo, Questa, Las Vegas, and Mora staged an uprising during which they murdered Charles Bent in his home along with Narciso Beaubien. In retaliation, Colonel Price marched an army of 350 soldiers and militia through the snow, encountering token resistence at Santa Cruz and Embudo.

A contingent of Hispano militia was among the ranks under the command of the French trader Ceran St. Vrain, Bent's former business associate and longtime friend. This cadre of troops would in the near future form the basis for a regiment of Spanish-speaking patriots destined to see action during the Civil War. When Price's army arrived in Taos, they learned that the rebels had retreated to the mission church. Undaunted, the federals stormed the fortification, crushed the rebels, and gutted the church. The ill-fated insurrectionists were brought to trial, where they faced a vengeful Carlos Beaubien still in mourning over the loss of his son, Narciso. As the local magistrate, Beaubien's sentence was hardly impartial; he quickly despatched the rebels and ordered their execution.

With the local uprising suppressed, the army next turned to the Indian depredations with equal ferocity. The Navajos were high on the army's list of priorities. By the time New Mexico was declared a territory in 1850, the Navajo had reached the pinnacle of their political and economic power. Their wealth, substantially greater than other tribes of the Southwest, had been derived partly from their success as stock raisers. Curiously, the Spanish first introduced the Navajos to sheep and by extension the sheep industry. As Hispano settlers gravitated west from the settlements in Rio Abajo onto the grasslands of the Rio Puerco Valley, they brought countless flocks of sheep with them. These *pastores* soon established Cebolleta, Cubero, and other villages that together formed a pastoral borderland in the western part of the province. Concurrent with Hispano relocation to the Mount Taylor region, the Navajos had occupied lands on either side of the Lucachuki Mountains and the Cañones del Muerto and de Chelly in present-day northern Arizona. The acquisition of sheep either through trade or by raiding provided Navajos with a renewable resource that stabilized their economy. Many Navajos prospered throughout the eighteenth century, raising flocks that some estimates number in excess of ten thousand sheep.

Their material wealth, however, made the Navajos targets for neighboring tribes. Utes regularly staged raids from their mountainous domain in the San Juan Basin. In the wake of these attacks, Navajos simply raided local Hispano villages to replenish their flocks. This raiding cycle continued unabated into the nineteenth century. Although Spanish and Mexican authorities staged punitive expeditions against the Navajos, they were for the most part ineffective. As the United States Army assumed protective

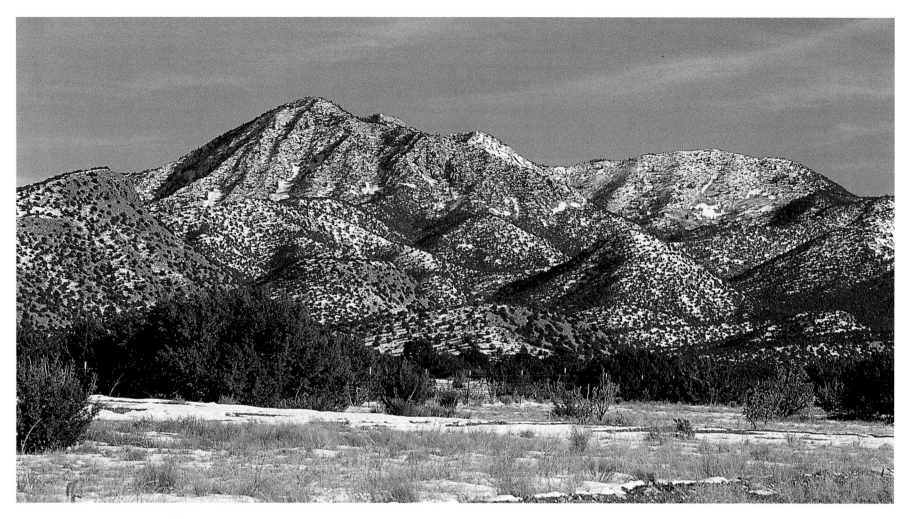

A winter view of the Ortiz Mountains northeast of Albuquerque from Route 22.

responsibility for the new territory, Navajos' ability to raid with seeming impunity encouraged them to escalate hostilities.

The Navajos were no match, however, for the remorseless Americans. In September 1851, the army broadcasted its intent to challenge them when it established a new post—appropriately named Fort Defiance—at the mouth of Cañon Bonito, a known Navajo stronghold. A decade later, soldiers from the windswept outpost would relocate to Fort Wingate (near present-day Gallup), built as a staging area for a ruthless assault on the Navajos. In the army's view, Kit Carson—explorer, mountain man, war hero, merchant, and scout—was the best person to undertake the calculated subjection of the Apaches and the Navajos. The Mescalero Apaches were the first to succumb

to Carson and regiments of the 1st New Mexico Cavalry (the same troops that would fight at Glorieta Pass).

When the battle-weary Apaches surrendered, Carson removed them to a new post called Fort Sumner near Bosque Redondo, where he waited out the winter of 1862. The following spring, Carson advanced his army to Fort Wingate and offered Navajo leaders a choice between peaceful removal to Fort Sumner or all-out war. In the tradition of the Spanish and Mexican military, Carson relied on Ute, Pueblo, and Hopi auxiliaries to extricate the Navajos from their canyon ramparts. The Navajos surrendered in 1863 and their subsequent forced relocation to Bosque Redondo stands out as one of the most tragic incidents in New Mexico history. Remembered in Navajo oral tradition as the "Long Walk," ten thousand men, women, and children began the journey during which 1,500 of their tribesmen died en route. It is a tragic historical irony that less than one hundred years later, New Mexico National Guardsmen of the 200th and the 515th Coast Artillery in the Philippines would suffer similar deprivations at the hands of Japanese captors.

For all of the loss and destruction *nuevo-mexicanos* endured at the hands of the Plains Indians, the systematic expropriation of land experienced at the hands of avaricious lawyers and the American judicial system was in the long run far more damaging. There is no more telling evidence of corruption than the history of the Tierra Amarilla land grant. The coming

Old Model A and gas pump in Mogollon, relics of a thriving mining town past.

Steller's jay, *cyanocitta stelleri,* at the Santa Fe Ski Basin.

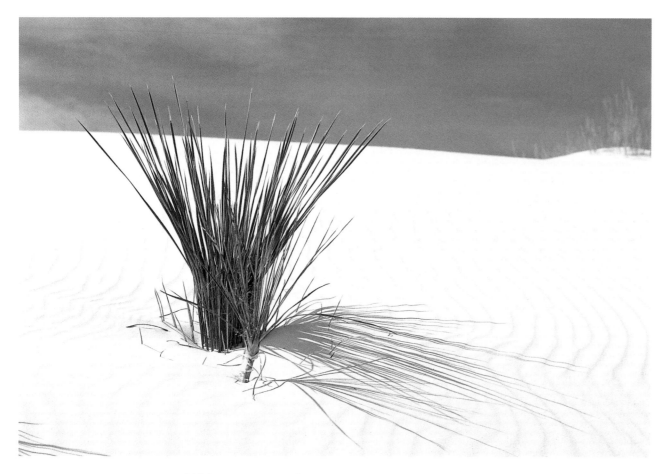

White gypsum sand forms White Sands National Monument.

Santa Fe years in advance of the railroad, he most likely arrived by overland stage. In 1872, officials in Washington appointed Catron U.S. Attorney General for New Mexico. Along with his partner Stanley B. Elkins, Catron built a law practice that specialized in banking, mine speculation, and the adjudication of former Spanish and Mexican land grants. In less than a decade, Catron—with the assistance of a local political machine known as the "Santa Fe Ring"—became one of the territory's largest individual landholders.

In 1832, Governor Armijo awarded the Tierra Amarilla Grant to Francisco Martínez and a handful of Abiquiú sheepmen. By the time Catron reached Santa Fe, Hispano settlers gradually had spread all through the Chama River Valley, where they established pastoral communities like Tierra Amarilla (formerly Nutrias), Los Ojos (renamed Parkview for a time), La Puente, and Placita Blanca (present-day Rutherton). Meanwhile, at the request of local rancher T. D. Burns, the federal government placed a small garrison of troops in the valley to distribute rations to the newly established Jicarilla Apache Reservation near Dulce (1873). It was about this time that Burns, in collusion with Catron and Elkins, and without the knowledge or consent of resident Hispanos, surreptitiously absorbed parcels of the Tierra Amarilla land grant. In one month alone, Burns assumed ownership of 42,000 acres, which he promptly deeded to Catron. Meanwhile, Catron, who legally represented Spanish-speaking clients for a percentage of their lands as payment,

of the railroad in 1879 was at once a blessing and a curse to New Mexico's Hispano citizenry. True, it served to industrialize the territory, thus hastening modernization and statehood. But it also attracted a disreputable element to Santa Fe with an insatiable lust for timber, coal, and other exploitable resources.

Thomas Benton Catron, a lawyer from Lexington, Missouri, was the most nefarious of the robber barons. Because Catron came to

amassed holdings of his own. When the Santa Fe Railroad chugged across Raton Pass toward Las Vegas in 1879, Catron had become sole owner of the grant's 600,000 acres.

In December 1881, Catron conveyed the right-of-way across his land to the Denver & Rio Grande Western Railroad (D&RGW), the staunch rival of the Santa Fe line. The conveyance included a set-aside of fourteen lots destined to become the railroad's principal depot, which the company named Chama. The next year, Catron awarded timber rights valued at $3 million to the D&RGW, and thereafter he incorporated Southwest Lumber and Railway Company to process ties and finished lumber for sale to the railroad. Prominent land owners in New Mexico repeated this pattern of land distribution to corporate entities well into the twentieth century. In 1870, Lucien Maxwell sold most of his holdings to European investors represented by the Catron-Elkins law firm. They in turn sold all of the proven coal reserves to Colorado Fuel & Iron of Pueblo (CF&I) in 1901. In an attempt to de-politicize the land issue, Congress established the Court of Private Claims. Hispano loss of land did not abate; instead, it accelerated. Of the more than thirty-five million acres in claims Hispano grantees brought before the court from 1854 to 1904, slightly more than two million acres were confirmed.

As New Mexico entered the twentieth century, most Hispano residents no longer enjoyed an agricultural base. Moreover, they had no control over the industrial developments that

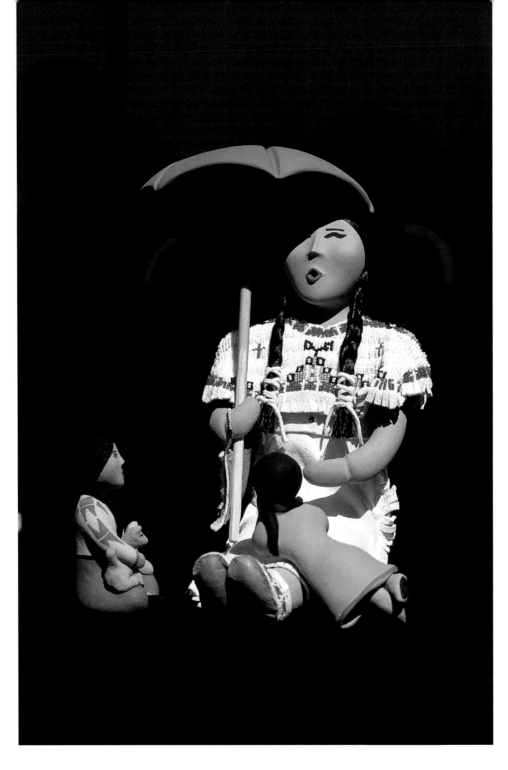

Rose Pecos Sun Rhode's story teller figure at Indian Market in Santa Fe.

Mountain cabin in the Pecos Wilderness Area near El Porvenir.

affected the West in general and the nation's forty-seventh state in particular. Hispano villagers—and to a lesser degree urban dwellers—adopted wage labor and seasonal migration as a strategy for economic survival. From 1900 to 1920, Hispano laborers either worked for local employers or traveled short distances to seek temporary employment. This way, they earned a living while maintaining the traditional family home. Ironically, the very industries that had caused their economic dislocation became outlets for employment.

Although most CF&I holdings were in southern Colorado, the company also held leases in northern New Mexico. The railroad, mining smelters, and steel manufacturers coveted the rich, bituminous seams of coal found in abundance near Raton, Gallup, Madrid, and Carthage (near Socorro). Raton and Gallup coal camps accounted for 90 percent of the state's total output from 1880 to 1940. At its peak, the industry claimed 200 operations that employed more than 5,000 laborers, most of them Hispano.

The D&RGW needed sawmill workers and track crews to extend its rails. As the narrow gauge railroad advanced in a serpentine course through the mountain villages of northern New Mexico and southern Colorado, it devoured virgin stands of ponderosa pine to produce railroad ties. La Madera, Lumberton, Dulce, El Vado, and other active sawmills dotted the landscape in the early 1900s. As companies clear-cut their way from one timber stand to the next, Hispano sawmill workers packed up their families and trailed the natural timber belt into southwestern Colorado. As in the coal industry, the track crews for both the Santa Fe and D&RGW railroads were ninety percent Hispano, Navajo, and Apache. Job assurance depended on the progress of the rails. Like the tentacles of a mechanical octopus, the Santa Fe Railroad extended south to Albuquerque and Socorro, then west to Deming and the New Mexico-Arizona border. The virgin stands of timber in the Gila and Apache National Forests near Silver City satisfied the railroad's voracious appetite. As in the north, Hispano and Anglo lumbermen from Reserve, Mogollon, Luna, and Apache benefitted from years of gainful employment.

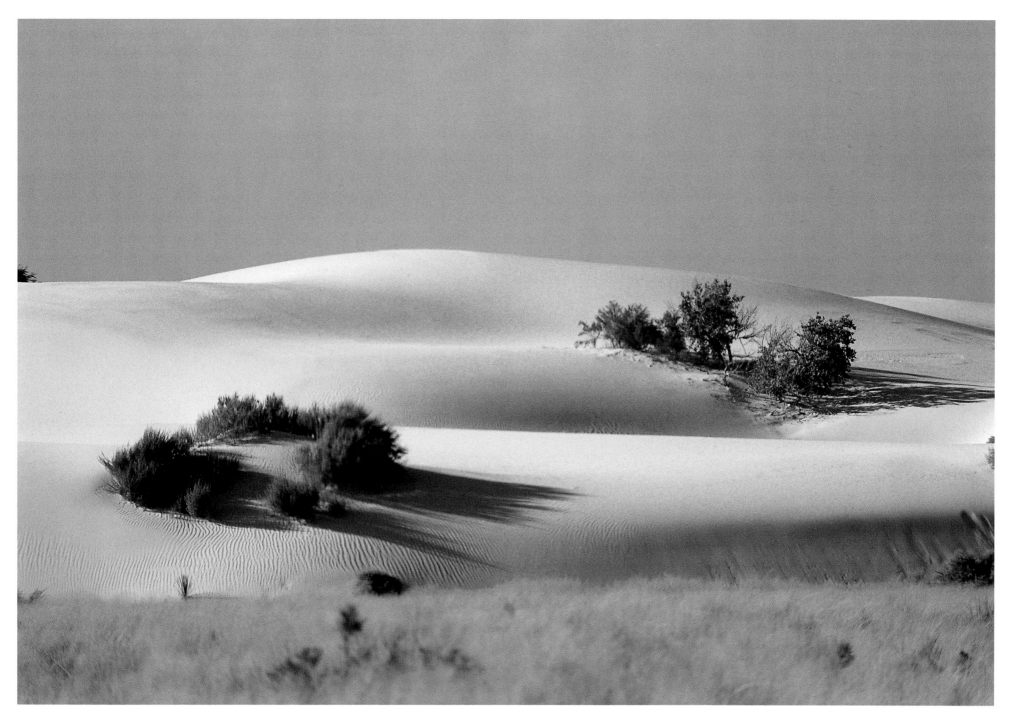

The edge of the gypsum sea, White Sands National Monument.

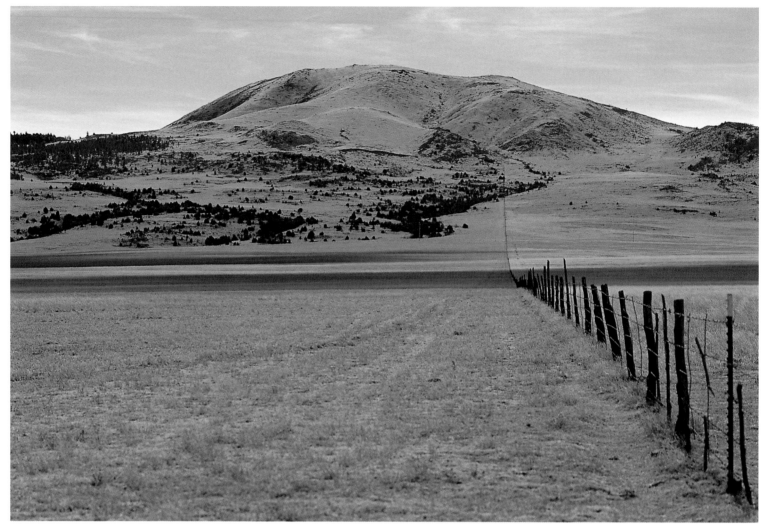

A fence line south of Ocate near Mora looking east to Cerro Pelon on Route 442. One side has been grazed; the other not.

The sugar beet industry provided another outlet for Hispano labor. During the industry's formative years, farm and sugar mills relied on a steady stream of German and Russian immigrants as field hands. As World War I engulfed Europe, America no longer welcomed eastern European immigrants. Instead, the government actively recruited Hispano workers from New Mexico and Arizona to fill the void. Meanwhile, the New Immigration Act of 1917 permitted Great Western Sugar, Holly Sugar, and the American Beet Sugar Company to hire farm

workers from central Mexico. Mexicans, their nation ravaged by an ongoing civil war, responded in overwhelming numbers. Their presence in the industry marked the first time that American-born Hispanos would compete with Mexican labor for limited jobs. This trend would set the tone for economic competition between local *nuevomexicanos* and a new wave of Mexican and Latino laborers that persists to the present day.

During the 1920s and 1930s, however, the sugar beet industry preferred the so-called "hyphenated" Americans because of their bilingual capability and their proximity to the fields. During these years, Colorado produced one quarter of all the beet sugar manufactured in

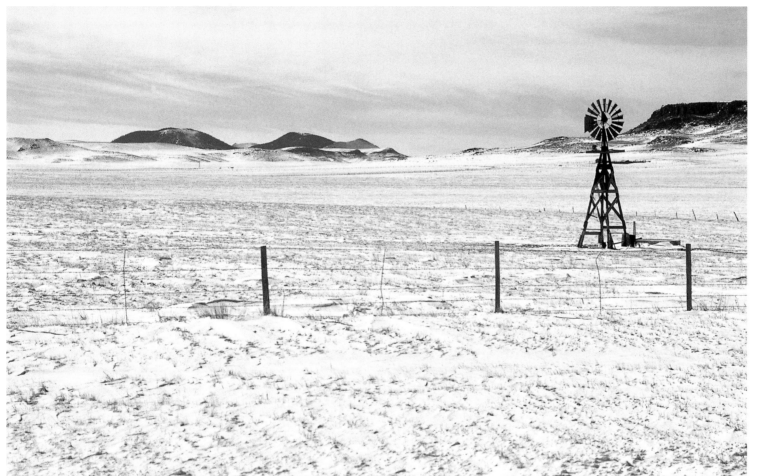

Winter looking at Laughlin Peak from the Capulin Volcano National Monument on Route 64.

A farm in Naranjos, near Mora, on Route 120

A cattle loading chute in San Antonio, near Socorro.

the United States. The state supported ninety-eight factories before World War II. Most were located near the Front Range communities of Greeley and Fort Collins in northern Colorado, but factories in Rocky Ford and Las Animas in southern Colorado were an attractive draw for many New Mexicans. The lure of the sugar beet industry caused the first of several mass migrations from the Spanish-speaking villages of northern New Mexico to adjacent western states.

The government's decision to solicit Hispano labor for a target industry was at the time unprecedented. Federal reliance on the local work force, however, would be repeated many times as New Mexico—and the rest of the nation—plunged deeper into an economic abyss during the 1930s. For the remainder of the twentieth century, New Mexicans exhibited a growing dependency on the federal government to assure their economic livelihood. The massive federal relief programs initiated during the Roosevelt Administration afforded residents of the Southwest a welcome reprieve from the aftershocks of the Great Depression.

Senator Dennis Chavez, the nation's first Hispano ever to hold congressional office, was the state's principal lobbyist for its share of federal relief. Descended from one of the families that returned to New Mexico with Vargas in 1692, Chavez was the epitome of a self-educated, highly motivated local Hispano. From humble origins in the tiny farming community of Los Chávez, Dionisio "Dennis" Chavez ascended to one of the most powerful positions in Congress. As chairman of the

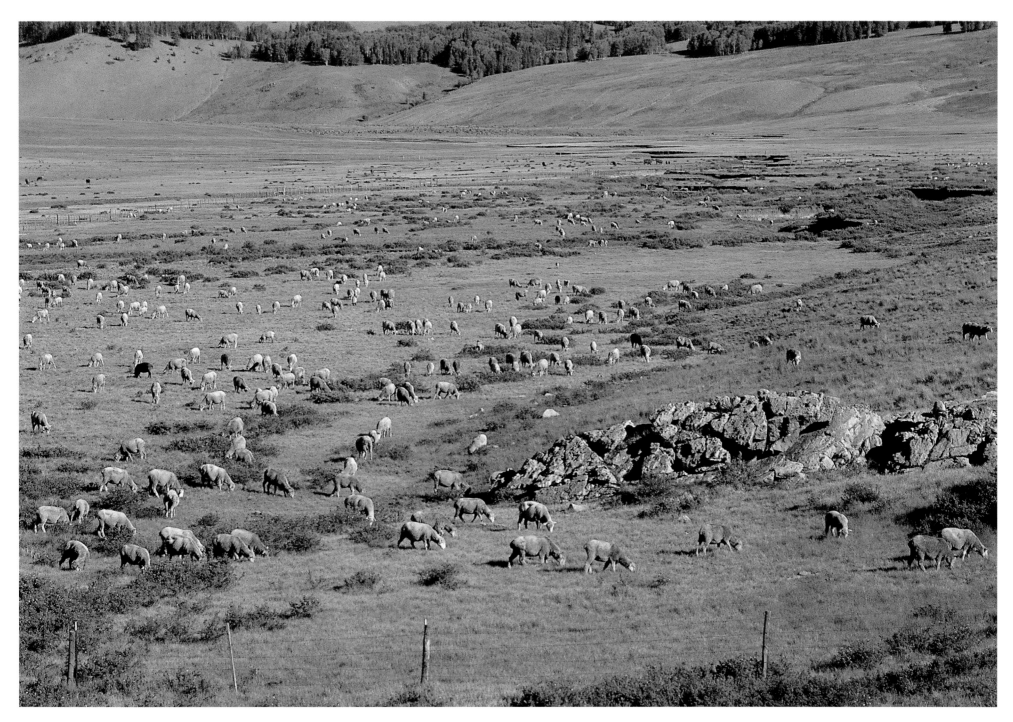

A flock of 850 sheep off Route 64 pasturing near Jawbone Mountain belonging to Autero Valdez, a descendent of Basque sheepherders.

A painted hide by Al Chandler offered at Indian Market, Santa Fe. The image depicts a modern rendition of a vital economic industry between early New Mexicans and Plains Indians.

artists through the revival of traditional arts. He also favored the Civilian Conservation Corps (CCC) because it trained New Mexico's youth in industrial occupations, weaning them away from agricultural work.

During the nadir of the Depression, thousands of federal relief workers built trails, bridges, and roads in Bandelier National Monument (near Los Alamos) and other state and national preserves. New Mexico sponsored other important road building projects. In 1936, the WPA completed the state's portion of U.S. Highway 66, one of only two east-west thoroughfares to traverse the United States at that time. A decade later, Route 66 facilitated the nation's greatest westward migration since the California Gold Rush. Federal relief employees honed their skills as carpenters, masons, and electricians on construction projects such as the National Park Service headquarters building and the municipal public library in Santa Fe. The army supervised both the WPA and the CCC programs, which instilled discipline and encouraged physical fitness along with vocational training. When America entered World War II, these agencies provided the armed forces with a corps of teenage youths who had become accustomed to the rigors of military life.

As the Indian Wars subsided, the southwestern frontier experienced a brief period of military absence. By 1890, the majority of New Mexico's frontier posts were deactivated. The attack on Pearl Harbor in December 1941 inaugurated a new episode in the state's ongoing military dependency. Senator Chavez and a coalition

prestigious public works and defense appropriations subcommittees, "el senador" secured millions in federal dollars and government jobs for his New Mexico constituency. During his early years as senator, he championed the government's work relief programs. Chavez especially supported the Works Progress Administration (WPA) and its attempts to provide employment to Hispano and Indian

of powerful western legislators lured military training bases, naval shipyards, munitions depots, and scientific research facilities to the region. Moderate climate, high altitude, and consistently sunny days made the American Southwest especially attractive to the Army Air Corps.

The Army Corps of Engineers built a chain of air fields in New Mexico: Albuquerque Army Airfield in 1940 (renamed Kirtland), Roswell Army Air Field in 1941 (renamed Walker), Alamogordo Bombing Range and Gunnery in 1942 (renamed Holloman), and Clovis Army Airfield in 1942 (renamed Cannon). Scientific research facilities at Los Alamos and White Sands Proving Grounds complemented the impressive defensive perimeter. Since their appearance, these bases have employed thousands of local residents. With few exceptions, they contributed to every military engagement from World War II through the Persian Gulf War. The persistent military presence in New Mexico since the seventeenth century suggests a strategic importance that has remained an imperative to the present day. Under the George W. Bush Administration, however, the Defense Department has for the first time seriously entertained recommendations for permanent closure of selected bases.

In the twenty-first century, New Mexico is an intricate labyrinth of past and present. Centuries-old pueblos stand in juxtaposition to Las Vegas-style gambling casinos, the panacea for Indian economic self-determination. Modern technology, colorfully featured at the annual Albuquerque Balloon Fiesta, lures throngs of enthusiasts and would-be aviators. In contrast,

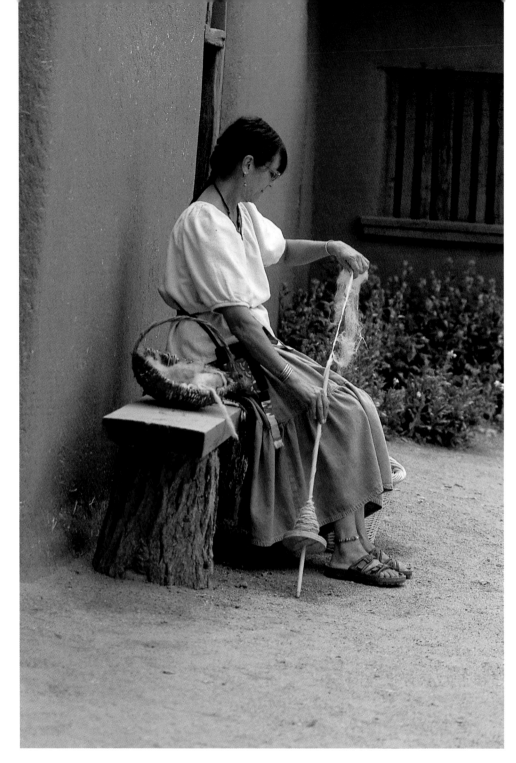

Docent Rebecca Nafey, spinning wool for yarn at El Rancho de las Golondrinas.

A field and barn east of Las Vegas on Route 104.

the eighteenth-century Spanish colonial village replicated at Rancho de las Golondrinas also draws its share of out-of-state admirers. Contemporary art galleries line the streets of Santa Fe, Taos, and Mesilla, where Hispano and Indian artists market recent creations that mirror traditional art forms. Santa Fe's Spanish and Indian Markets, in fact, harken back to the annual trade fairs at Pecos and Taos during the colonial period. New Mexico is musically diverse as well. The gypsy-induced passion of Spanish flamenco complements the structurally orchestrated strains of the *mariachi* and accordion-driven *rancheras* in addition to the familiar "twang" of country and western music. Through it all, the Rio Grande asserts its indomitable influence. Weakened by centuries of multiple use, the relief-giving water that courses through this timeless corridor soothes the parched but compelling land that Spanish adventurers christened Nuevo Mexico.

Rodeos in Galisteo are a favorite event in the state.

OPPOSITE: Baldemar Gonzalez, "Indian Joe," runs a cattle herd in the Pecos Wilderness of the Rocky Mountains at 9000 feet.

Corridors

Fall in Chama on Route 17.

Structure in Mountainair, which sits east of the Manzano Mountains on Route 60.

Spiritual Corridors

THE EVANGELICAL CONQUEST of New Mexico rightfully begins with Coronado. On his inaugural entry into Spain's northern frontier in 1540, Coronado enlisted the services of six Franciscan friars. The spiritual entourage included Fray Marcos de Niza, the self-centered ecclesiastic who just three years earlier brought back exaggerated accounts of gilded cities among the Indians of the Southwest, accompanied the expedition as a guide. Beginning with Coronado's excursion and continuing through Oñate's colonization effort, expectant missionaries were always included. Their official dispersal among the Pueblo communities, however, dates to the 1598 expedition. En route to the Chama Valley, Oñate summoned all Pueblo leaders to Santo Domingo, where he outlined his intent to divide the province among the eight Franciscan friars who accompanied him. Commencing with a lengthy monologue in which the pretentious Spaniard demanded Puebloan obedience to the Christian god and

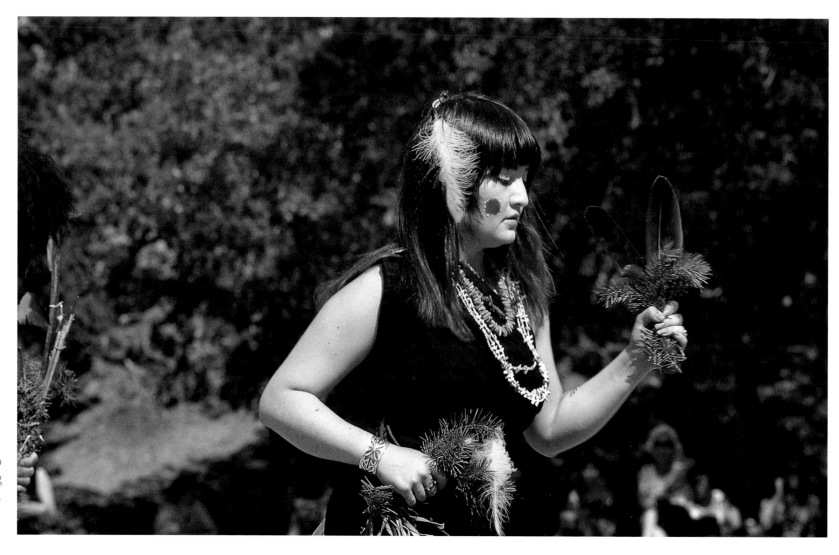

A Nambé Pueblo woman dancing the Buffalo Dance.

vassalage to the Spanish king, he proclaimed the *Conversión de San Pablo de la Provincia de Nuevo México* in honor of the renowned evangelist, St. Paul. Oñate proceeded with assignments of two or more pueblos located on the upper end of the Rio Grande (*Río Arriba*) to each of the friars.

Some appointments also included the more distant villages in the Salinas Basin as well as the Hopi communities to the west.

From this ceremonious beginning, the Spanish hoped to minister the Holy Faith to the indigenous population. In 1610, the same

year Governor Peralta relocated the capital to Santa Fe, the nascent missionary effort became more formalized. The elderly but robust Franciscan superior, Fray Alonso Peinado, who had accompanied Peralta to New Mexico with a supplement of eight additional friars to expand the missionary field, established his ecclesiastic headquarters at Santo Domingo. From this central location, Peinado and his enthusiastic subordinates spread the gospel to the Tano communities of the Galisteo Basin as well as the Tiwa pueblos on the lower Rio Grande (*Río Abajo*). Within a decade, the diligent friars advanced the Spanish missionary effort from an embryonic program to a finely orchestrated institution. The transfer in 1626 of the ebullient Fray Alonso de Benavides from Mexico City to Santo Domingo as superior of the custody (*custos*) further energized the Franciscan effort.

No one embodied the missionary ideals of the Franciscan Order more than Benavides. His energy was boundless and his devotion to the church unshakable. A native of the Azores, a Portugese protectorate and important island way-station en route to the New World, Benavides took the vows of the Franciscan Order in Mexico City. Soon thereafter, he and several of his brethren joined the supply caravan that journeyed up the royal highway (*Camino Real*) once every three years to supply the missions of New Mexico. An ardent missionary, Benavides was perhaps the first friar to sermonize, albeit unsuccessfully, among the Apaches and the Navajos. His most enduring contribution to the

missionary cause, however, came after his brief tenure as *custos*, during which time the tireless superior personally oversaw the establishment of ten new missions.

The year 1630 found Benavides back in Spain, where he published his detailed *Memorial* on the state of the Franciscan program in New Mexico. His pious but overstated testimonial won the admiration of the Vatican. Somewhat inflated figures claiming 30,000 baptisms among the

Quarter horse resting after a roundup in October prior to the coming of snow in the Jemez Mountains.

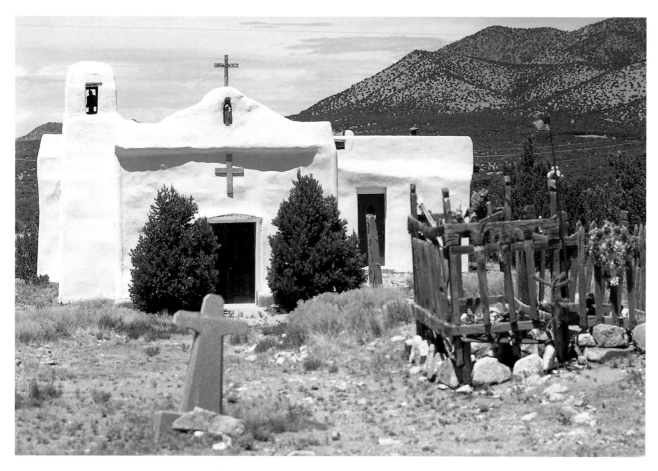

San Francisco
de Asis Chapel in
Golden on Route 14.

suggestion, Benavides' report confirmed the importance of Spain's first and only religious colony. Deemed worthy of continued annual subsidizing but sorely in need of additional clergy, New Mexico accelerated its missionary campaign.

Over a period of about seventy years, an estimated cumulative total of 250 clergy trained and educated in Mexico established forty missions from which to spread the gospel among the indigenous Pueblos. From 1610 to 1680, Spain spared no expense to sustain the friars in this monumental effort. The crown exhausted millions in Spanish silver to train new prelates and supply the missions with their daily necessities. Beginning with the baptism of pueblo residents and the enlistment of their assistance to build the church along with living quarters for one or two friars (*convento*), the Franciscans designated the community an Indian parish (*doctrina*). They listed chapels without benefit of a resident friar as *visitas*. The latter looked to the nearest doctrina for spiritual guidance.

The Franciscans organized pueblo daily life around morning and evening prayers, religious instruction, choir practice, vocational training, and physical labor. The objective: conversion to the Catholic faith, and acceptance into Hispano society. When not building churches and convents, the Pueblos maintained adjacent fields or tended sheep, goats, and cattle. In this manner, the Franciscans created insular communities, virtually independent of civil government, in which they exercised a spiritual

Pueblos impressed not only the Pope but, more importantly, King Felipe IV. The conversions defined a new purpose for Spain's troubled and most remote colony. Unyielding in his commitment to bring salvation to the Indians, Benavides even advanced the notion of recruiting English-speaking Irish priests to New Mexico as a hedge against looming outside influence from the nascent British colonies on the Atlantic shore. Although the king may have winced at the latter

monopoly over the Indians. Among the few remaining vestiges from that great church-building era, the massive stone remains of *San Gregorio de Abó* (1629) and *Nuestra Señora de la Purisima Concepción de Quarai* (1628) in the Salinas Basin, or the hulking adobe framework of the second church at Pecos, *Nuestra Señora de los Angeles de Porcuincula de los Pecos* (rebuilt in 1696), and the virtually unaltered *San Esteban del Rey* at Acoma, (1629–1640) are by far the most impressive.

The Pueblo Revolt of 1680 dramatically curtailed the dizzying pace of Spain's inaugural missionary effort. The Franciscans, in response, learned a hard lesson in humility. Although it appeared the Pueblos had embraced Christianity, the stunning success of the rebellion was testimony to their resolve not to abandon traditional religious beliefs. While Indian neophytes tacitly accepted church sacraments, images of Jesus and the saints, or perhaps even delighted in pompous ritualism and ceremonious processions, they tenaciously preserved their pantheon of *kachinas*. The last rumblings of Indian insurrection subsided in 1696. Although the Franciscans had returned to their task, they did so with considerably less enthusiasm and crusading resolve. Vargas, upon his reoccupation of the province in 1693, left the Pueblo kivas intact. This signaled an era of pragmatic accommodation between the two opposing cultures. As the 1600s faded into distant memory, the Franciscans never again regained the spiritual momentum of earlier times. The dawn of the new century ushered in a period of missionary

Crop being irrigated east of Portales.

decline as spiritual conquest gave way to more pressing military considerations. In 1763, for example, royal support for the entire missionary program in New Mexico totaled about 11,000 pesos, one-third the amount allocated to the Santa Fe garrison that same year.

The Franciscans lost ground during the eighteenth century. The Salinas churches were never reopened, nor did the Hopis invite the missionaries to return. The Zuni, Tano, and

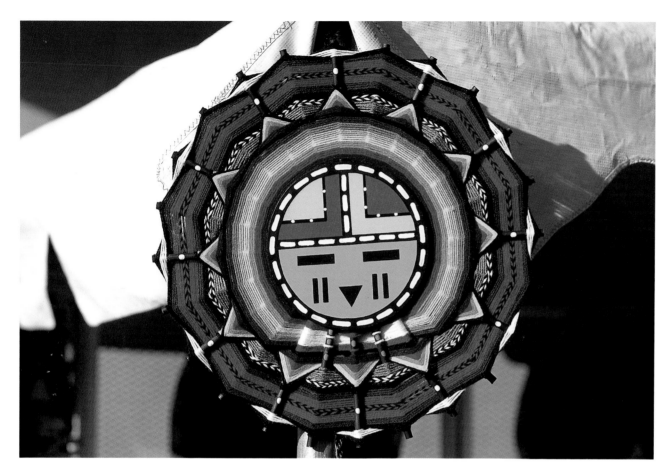

Indian Market, held in Santa Fe each August, is an event that attracts an international crowd.

Jemez mission fields were reduced to about one pueblo each from as many as a dozen before the 1680 revolt. The missions that survived were badly in need of repair and in time succumbed to lengthy periods of neglect. A shocking corollary to the decreasing number of Pueblo villages was the decline of the Indian population from 50,000 to fewer than 14,000 by the end of the seventeenth century. Unchecked nomadic depredations, natural calamities, and devastating illnesses—especially the smallpox epidemic that ravaged the Pueblos in 1781—

reduced their numbers further to about 8,000 inhabitants by 1800.

With fewer missions to support, the central government drastically reduced the number of supply caravans, which for centuries had been the missionaries' lifeline. As authority shifted from Spain to Mexico in 1821, the luckless Franciscans enjoyed no measurable improvement in their deplorable condition. Under Mexican rule, Hispano villages, encouraged by the government's liberal allocation of communal lands, pushed the limits of expansion to mountain sanctuaries and the wide open plains. From now on, rural churches, less imposing and more rustic, vied for the attention of the aging friars. In 1848, the year New Mexico came under United States jurisdiction, Fray Mariano de Jesús López—the last remaining Franciscan in the province—died at Isleta. His passing left Hispano Catholics virtually devoid of formal religious services.

The prolonged absence of clergy in New Mexico caused villagers to turn to the lay brotherhoods for spiritual comfort. *La Fraternidad Piados de Nuestro Padre Jesús Nazareno*, commonly called the Penitente Brotherhood, was believed to have existed in the days of Oñate. Whether he himself was a practicing Penitente is not certain, but early records indicate that he tolerated their activities. Fray Domínguez noted Penitente-like practices at Abiquiú in 1776, but made no mention of a formal organization. The earliest specific reference to the brotherhood in New Mexico appeared in the reports of Bishop José

Windmill with well, Punta de Agua near Mountainair on Route 55.

Kawliga's store just north of Silver City on Route 15.

Elephant Butte Lake shoreline. Created by the damming of the Rio Grande River, it regulates the flow of water for farmers in the Rio Grande Valley and as far south as Mexico. It is also a popular recreational spot.

Antonio Laureano de Zubiría, who inspected New Mexico's churches in 1833, 1845, and 1850. On his first visit, Zubiría noted the emergence of the so-called Penitentes and denounced their self-inflicted corporal punishment. In the absence of local priests, the brotherhoods (*hermanos*) busied themselves tending to the sick and offering consolation to bereaved families through prayer services and wakes (*velorios*).

Disturbed by the Penitentes' expiation of sin through self-flagellation, Zubiría publicly censured them. On one of his many visits from 1834 to 1840, Josiah Gregg, author of *Commerce of the Prairies*, a popular eyewitness account of daily life in New Mexico, may have been the first non-Hispano to witness Penitente activities firsthand in the lower Rio Grande village of Tomé.

In defiance of Bishop Zubiría's proclamation, the *hermanos* proliferated. At first, they performed public ceremonies within the numerous local churches. Ecclesiastical intolerance increased, however, when Santa Fe became a diocese under the auspices of the Archbishop of St. Louis. From this point forward, the Penitentes established their own independent places of worship (*moradas*). The morada—austere, windowless, and always unassuming—were the meeting houses where Penitentes and their followers gathered to worship in solitude. The morada appears to have been especially widespread by 1870. Penitente organizations (*cofradías*) tended to be strongest in the extremely isolated,

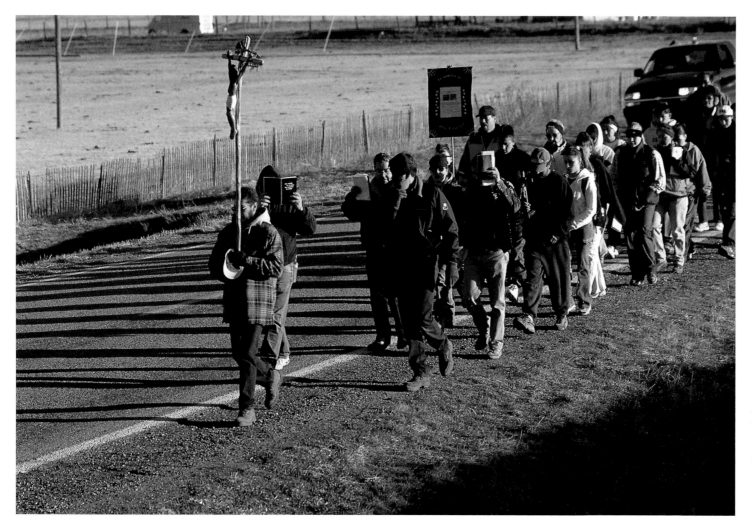

Penitentes on a pilgrimage on Easter Saturday near Mora. A native offshoot of the Catholic Church provides a local culture that is embraced by many New Mexicans.

predominantly Hispano villages of northern New Mexico. The morada consists of fifteen men selected to administer to the local hispano population, twelve of whom are "apostles" and three "novitiates." Chapters in the Chama Valley, Taos Valley, Embudo Watershed, Mora Valley, and the Upper Pecos Watershed, were traditionally—and remain to the present day—strongholds of the Penitentes. Since the 1920s, Penitente influence has expanded to remote communities east of the Sandia and Manzano Mountains, in the valleys of the San Mateo and Cebolleta Mountains, and into the San Luis Valley of southern Colorado. Fewer have been documented in Lincoln and Doña Ana counties in the southern part of the state.

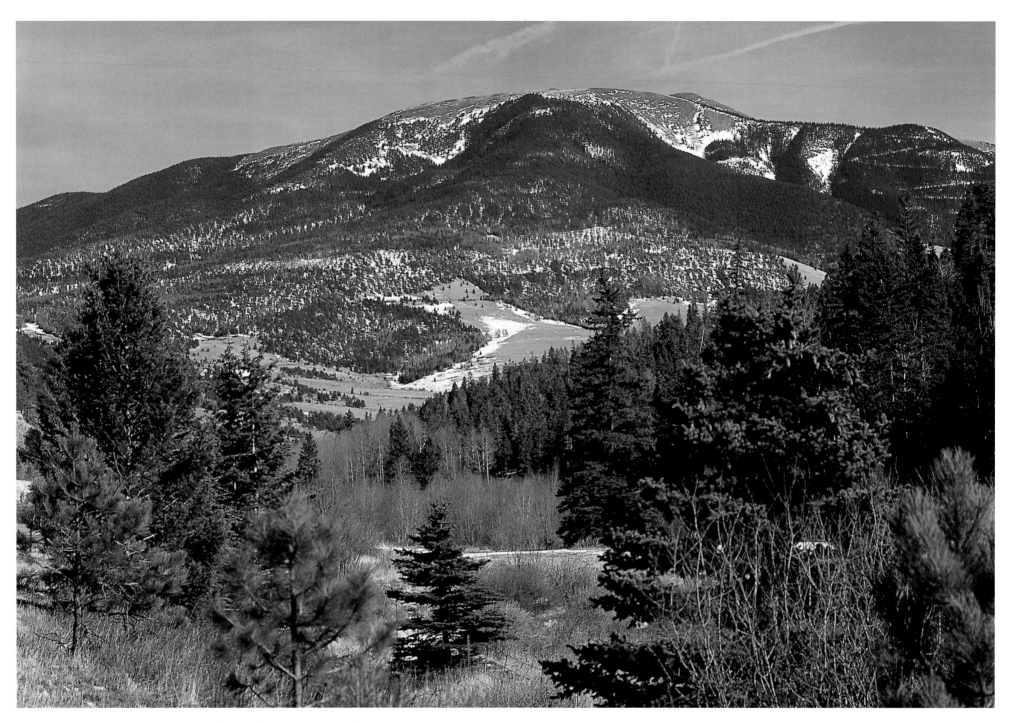

Baldy Peak east of the Rocky Mountains can be reached through Bobcat Pass from Red River on Route 38.

In many respects, the morada symbolized Hispano defiance against foreign domination. Especially loathsome to New Mexicans was the French ascendence within the Catholic church epitomized by Bishop Jean Baptiste Lamy. Lamy, appointed Santa Fe's first bishop in 1853 and elevated to the office of archbishop in 1875, was everything Hispanos resented about foreigners. It was not enough that he was quintessentially French, but the dour church leader openly patronized Hispano parishioners for their "superstitious" beliefs. The austerity of the rural churches repulsed him and the defiant attitude of local Spanish-speaking priests—especially the firebrand José Antonio Martínez—infuriated him. Martínez's implication in the Taos Rebellion of 1847, climaxed by the murders of Governor Bent and Narciso Beaubien, further antagonized the French prelate. When the anti-foreign *nuevomexicano* voiced support for the Penitentes, Lamy held him in even greater contempt. Martínez's political activities so angered the archbishop that he excommunicated the outspoken Taoseño in the spring of 1858. Although his parishioners remained loyal, Martínez died in 1867, never reinstated to the priesthood.

Appropriately, hundreds of *hermanos* from virtually every village in northern New Mexico presided at the funeral. Despite his deep-seated antipathy to the Hispano population, it is to Archbishop Lamy's credit that he advanced public education among New Mexicans through the recruitment of Jesuit priests and the Sisters of Loretto from France. One of his most enduring contributions to education in New Mexico has been the prestigious St. Michael's Catholic school in Santa Fe.

Having lost their voice in the church, the Penitentes moved their pious observances deeper underground. The influx of English-speaking Anglo Protestants who arrived with the railroad in 1879 further undermined the Penitentes' strength and influence. Some of the *hermanos* in fact defected to Protestantism. Most favored the Pentecostal Church, which

A corral near the Canadian River east of Roy.

Claret cup cactus
at White Sands
National Monument.

promoted the use of Spanish in its services. Others joined the Presbyterian Church. The Penitente brotherhood reached its zenith in the 1920s. Their decline coincided with a significant out-migration of Hispano villagers to more industrialized communities like Denver, Pueblo, Albuquerque, El Paso, and Los Angeles. Many Penitentes migrated to the beet fields near La Junta and Rocky Ford in southern Colorado. Still others preferred the Front Range municipalities of Fort Collins and Greeley. Even today it is possible to detect a morada nestled among the ethnic neighborhoods of these northern Colorado communities. Those who remained in northern New Mexico followed the railroad as it crept into

the coal camps near Raton and Clayton or the sawmill towns of La Madera, El Vado, and Chama.

Writing in the 1920s, author Mary Austin exaggerated the strength of the Penitentes, suggesting that ninety-five percent of all Spanish-speaking males in New Mexico were active members. Conversely, estimates from the early 1950s offer a much too conservative total of less than one thousand enrollees. A more realistic number, derived from actual membership rolls in 1960, counted only two to three thousand members out of 428,895 Hispanos (not all males) living in Colorado and New Mexico at the time. Today, the cofradías of northern New Mexico appear to be experiencing somewhat of a revival. Not only have the numbers increased, but the membership reflects a healthy balance between younger and older Hispano males. In recent years, some Penitente organizations have willingly invited the public to witness their annual spiritual gatherings during Easter time.

To conclude that the Spanish goal of spiritual conquest failed in New Mexico would be a gross misconception of the ethnic community today. The pervading Catholicism demonstrated throughout the state is testimony to the enduring legacy of the missionary effort. The Pueblos appeased the Franciscans through a process of selective accommodation, embracing only those Catholic rituals and teachings that were compatible with time-tested traditional practices. The Franciscans in New Mexico—unlike those of Texas and California—never owned the mission outright. When the missions were secularized in

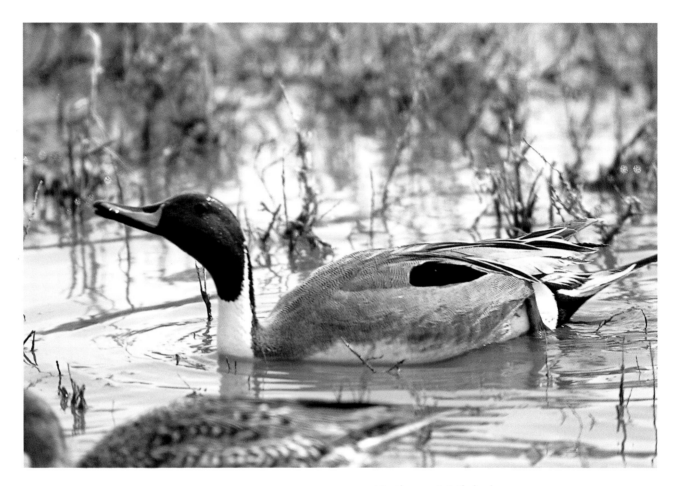

Northern pintail duck, *anas acuta,* in the Bosque del Apache National Wildlife Refuge.

1821, the churches reverted to the Pueblos, which maintain and preserve them to the present day. Each August, hundreds of enthusiasts attend the corn dance at Santo Domingo. In the presence of a Catholic priest and various images of the saints, Santo Domingo residents exit the kiva to perform rituals that predate the Spanish arrival to New Mexico by more than a century.

Similarly, during Easter week, New Mexicans of all ages and ethnic backgrounds—

Quemado Lake Recreation Area, part of the Gila National Forest.

some bearing a replication of the cross—make the annual pilgrimage to the Santuario at Chimayó. Hundreds of crutches, leg braces, and various offerings (*milagros*) grace the interior of the venerated church in silent testimony to the unwavering devotion of the faithful. And all along the state's highways, colorfully decorated crosses (*descansos*) mark the scene of a recent traffic fatality—modern reminders that tragedy and hardship are the inevitable companions of all who challenge this unpretentious but sometimes unforgiving land.

Defensive Corridors

\mathcal{A}LONE AT HIS DESK, in the musty, dimly lit surroundings of the Palace of the Governors, Fermin de Mendinueta issued a plea to Viceroy Antonio María de Bucareli in Mexico City. The battle-weary administrator, plagued by incessant Apache hostilities since his arrival to New Mexico, requested that the 120-man garrison at Santa Fe be bolstered with two additional presidios. The governor suggested that one be placed in the north at Taos, and the other at the opposite extreme near the abandoned pueblo ruins at Senecú (near present-day Socorro).

Not unexpectedly, tight-fisted bureaucrats in Mexico City casually ignored the governor's request. The tendency on the part of the central government to save money at the expense of proper fortification of the northern frontier had by now become standard practice. Had not the viceroyalty denied fray Francisco de Ayeta's request for additional military protection a century earlier? Sensing that dissension was fermenting among the Pueblos in 1677, the young friar convinced the royal treasury to subsidize fifty convict soldiers with arquebuses, swords, horses, saddles, and supplies to accompany the mission caravan on its routine journey to New Mexico. The military escort, undependable though it may have been, offered token protection not only to precious supplies, but also to the newly appointed governor don Antonio de Otermín. In September 1678, the indefatigable Franciscan *custos* returned

to Mexico City. This time Ayeta requested that a full-fledged presidio, such as those authorized in Sinaloa and Nueva Vizcaya (present-day Chihuahua), be constructed in Santa Fe. While officials bickered over Ayeta's petition, the tyrannized Pueblos launched a "war of purification" in the summer of 1680 that routed the Otermín government and sent horrified refugees in retreat to El Paso. Bureaucratic procrastination—certainly in this instance—had cost the Spaniards dearly.

After the twelve-year exile, royal officials, perhaps mindful of their disastrous indecision, appropriated twelve thousand pesos to outfit a one hundred-man garrison and 550 families to reoccupy New Mexico. On October 4, 1693, the feast of St. Francis of Assisi, Vargas and the unwieldy assembly of soldiers and settlers left El Paso determined to retake Santa Fe. Snow fell as

El Vado Lake State Park, southwest of Tierra Amarilla, once the heart of a thriving lumber and timber industry.

Winter cold creates
icicles at Soda Dam
north of Jemez Springs.

the shivering ensemble ascended La Bajada and approached the wintery capital. A furious, two-day battle ensued, during which time Vargas enlisted one hundred fifty warriors from Pecos Pueblo to engage the Tanos and Tewas who had fortified the former governor's residence. First, pounded by ice and wind that claimed twenty-two of their party, and followed thereafter by a hail of Indian arrows that further reduced their numbers, the victorious allied army retook possession of Santa Fe on December 28. In gratitude for their loyal support during the remainder of the campaign, Vargas visited Pecos in the spring of 1694 to reinstate the annual trade fair. At the governor's invitation, a band of eastern plains Apaches, anticipating the resumption of trade with the Pueblos, greeted Vargas as he entered the village. Symbolically, the Apache emissaries spread processed buffalo robes and elk skins at the governor's feet in acknowledgment of the renewed economic bond.

Vargas's recruitment of Indian auxiliary soldiers to defend the empire was not a novel idea. In 1521, Hernando Cortez successfully enlisted the Tlascalans to help defeat the formidable Aztec empire. Several of the Nahuatl-speaking Indians embraced Christianity and accompanied the Spaniards to New Mexico. Included in the first wave of colonists to relocate from San Juan de los Caballeros to Santa Fe in 1610, Tlascalan auxiliaries gathered into a small community they called the Barrio de Analco on the southern bank of the Santa Fe River. Throughout the eighteenth century, the Mexico-born Indians joined Pueblo warriors in a consolidated effort to rid the colony

A well-attired woman at Indian Market in Santa Fe.

of nomadic intruders. During the eighteenth century, Juan Bautista de Anza allied Spanish forces with the Comanches to drive the Apaches farther south into Texas and the northern Mexican frontier. Anza's subsequent compacts with the Utes helped to neutralize the Navajo threat, causing the latter to withdraw to present-day northern Arizona.

While the Spanish enlistment of Indian allies proved to be an effective policy, the primary burden for frontier defense rested squarely on the shoulders of the king's army and the local militia. The prototype Spanish trooper was a *mestizo* (an admixture of Spanish and Indian), most likely born in the New World. Typically, he signed on for a ten-year enlistment, during which time he earned a paltry 400 to 450 pesos annually. Out of his meager salary, the presidial soldier furnished his own protective leather jacket (*cuera*), musket and sword, and a string (*caballada*) of no fewer than seven horses. When in a generous mood, the government sometimes issued each soldier a lone pack mule. With the remainder of his salary, the soldier fed, clothed, and sheltered his family who often accompanied him to the post. From April to September, the garrison soldier stood ready to take up arms against frequent Indian attacks, to escort the annual supply caravans to and from Chihuahua, and to maintain vigilance along the frontier's perimeter. During the winter months, he endured monotonous assignments of guard duty. Of primary concern to his superiors were the thousands of animals the army foraged in the fertile Galisteo Basin, far removed from the protective umbrella

of the presidio. The presence of these herds was in itself an inducement for Indian attack. The army's obsession in maintaining an adequate supply of fresh mounts, however, speaks not only to the extensive territory it patrolled, but also to the inordinate number of hours each soldier spent in the saddle.

The civilian militia represented the backbone of colonial defense. Unlike the regularized army, the soldier-farmers lived in exposed communities and not within the walled presidio compound. Their sole compensation for the defense of empire were the small parcels of well-watered bottom lands the governor distributed as payment. A strip of land one hundred and fifty *varas* (a *vara* equals about thirty-three inches) adjacent to the nearest irrigation source was the eminent domain of the civilian soldier. Several parcels clustered together formed a defensive perimeter around an open plaza, which offered the farmers refuge in the event of an attack. If overrun, the settlers temporarily abandoned the village to seek protection within the nearest pueblo or other more populated communities. As hostilities intensified during the late eighteenth and early nineteenth centuries, peripheral settlements such as Abiquiú, Ojo Caliente, Nutrias, Los Ojos, Chimayó, Mora, Las Vegas, San Miguel del Vado, Tomé, and Belén were valued protective buffers for interior settlements. Historical documents routinely detail civilian participation in punitive campaigns against the Apaches, Comanches, Navajos, and Utes.

Except for a brief period of fiscal conservatism resulting from Brigadier General Pedro de Rivera's comprehensive military inspection

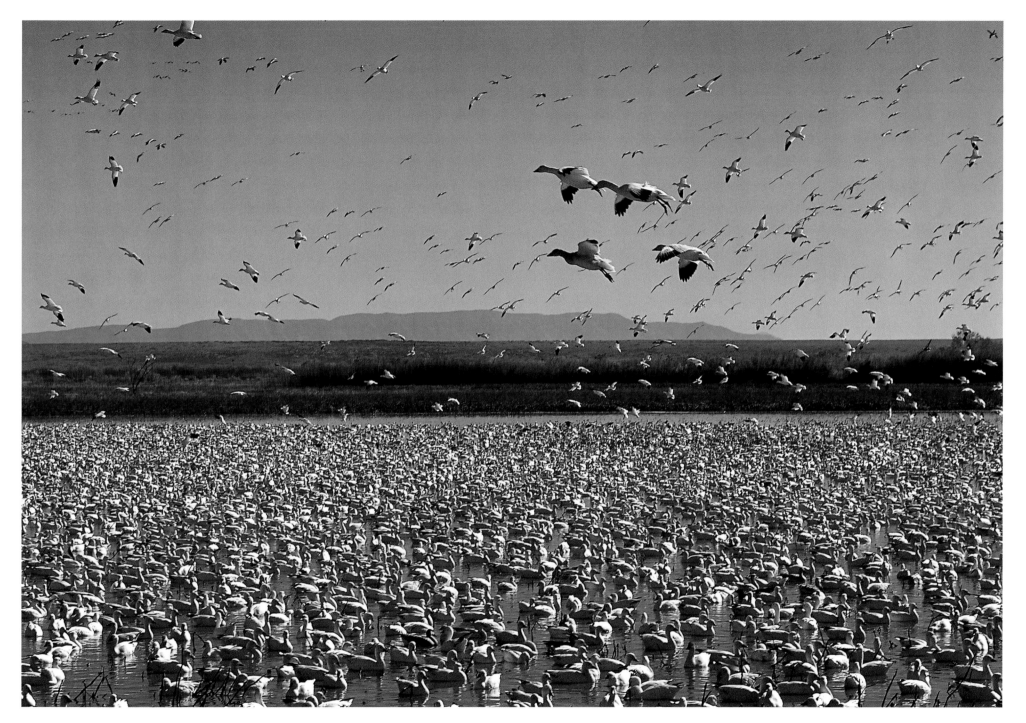

Snow geese lift off at the Bosque del Apache National Wildlife Refuge with four leading the way.

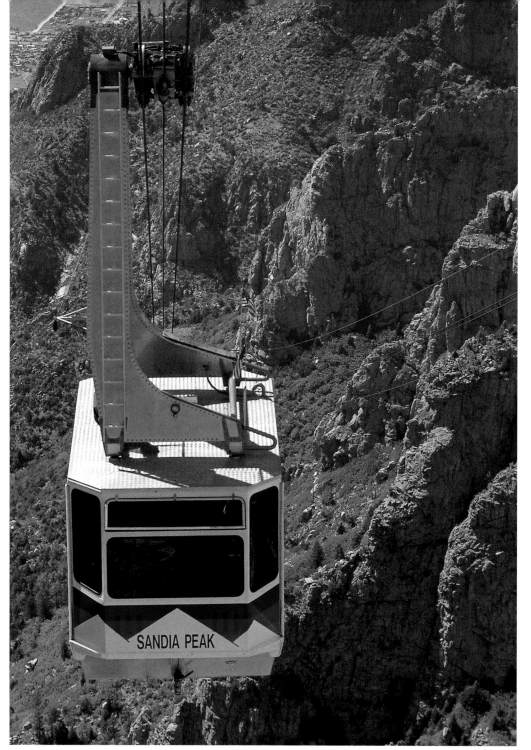

Sandia Peak
Tramway in
Albuquerque is
one of the longest
in the world.

(1724–1728), the Santa Fe presidio maintained a force of 100 to 120 royal troops plus 100 Indian auxiliaries. A frontier-wide military reorganization initiated four decades after Rivera's inspection assigned new importance to the Santa Fe garrison. After an exhaustive 7,500-mile inspection of the northern frontier in 1766, the reform-minded Marqués de Rubí proposed a cordon of royal presidios along an east-west axis from the Gulf of Mexico to the Gulf of California. Two exceptions to the proposed fifteen-post alignment were the Presidio of Béxar in San Antonio and the Presidio of Santa Fe. Each would function independently as north-south salients at the edge of the frontier. Rubí's inspection team included Royal Engineer Nicolás de Lafora, who produced the most informative map of Spain's interior provinces to date. In many respects, the proposed new military alignment anticipated the inevitable threat to New Mexico from British colonies on the eastern seaboard ten years before their political separation from England.

The stunning defeat of the British Empire, followed by the nascent republic's acquisition of the Louisiana Territory in 1803, soon brought land-hungry Americans to New Mexico's doorstep. Accordingly, Spanish military priorities shifted from interior campaigns against recalcitrant Indians to border defense in anticipation of an impending foreign invasion. No colonial administrator more acutely understood American expansionist goals than New Mexico's governor Facundo Melgares. After all, he was one of only a handful of Spaniards who had come face to face with the aggressive foreigners. As the Americans

drew closer, Melgares no doubt recalled his early encounter with Zebulon Pike. The viceroy appointed Lieutenant Colonel Melgares temporary governor of New Mexico in July 1818. A month later, Mexico City made the appointment permanent and assigned him two objectives: subdue the Navajos, whose raids badgered northern villages, and intensify surveillance along the northern periphery as a precaution against the anticipated American invasion. An ardent royalist, Melgares assumed his charge with grim resolve, vowing to drive the Navajos into the California desert. He organized a punitive expedition in Taos comprised of presidio regulars, local militia, and the ubiquitous Pueblo auxiliaries. Typically short of weapons, the diehard Melgares ordered local priests to donate one bell each from the church to be melted down and cast into munitions.

Melgares addressed his second task with even greater fervor. He fortified the outlying communities of Taos, El Vado, Las Truchas, and Ojo Caliente as a hedge against a surprise attack. Next, he despatched Second Lieutenant Juan María de Arce on a reconnaissance mission that led the weary officer into the Yellowstone River Valley before returning to Santa Fe. Upon receipt of a cryptic note intercepted in New Orleans that warned of an impending invasion from the north, Melgares fortified La Veta Pass (north of Taos), a vulnerable entry point into New Mexico. Having determined that standard fortifications were too costly, the ingenious military administrator conceived the idea of portable fortifications that were more inexpensive and readily deployed where needed. The governor submitted detailed

drawings to royal engineers in Mexico City, who promptly rejected his proposal as "unsuitable to the terrain." Despite the alarmist posture in Mexico City, the anticipated military invasion never materialized.

For all of his vigorous tactics and innovative strategies, Melgares could not prevent the Americans from coming. It is a sad irony that he was the person to invite Becknell and his Missouri kinsmen into Santa Fe in 1821. Melgares was a royalist in transition. As a soldier, he defended the political ideals of the crown, but as governor he well understood the economic dilemma of the province. It was not within his power to alter the course of a decaying monarchy. To his credit, Melgares, on the eve of Imperial collapse, decreed

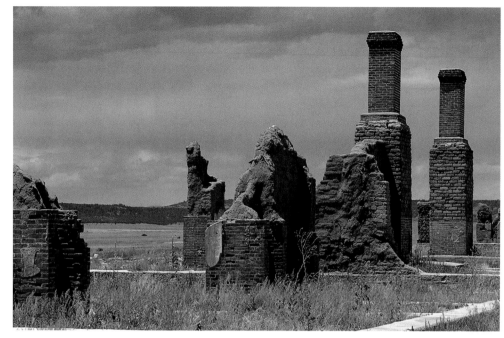

Fort Union (now a national monument), was established in 1851 to protect the Santa Fe Trail. During its forty-year history and three incarnations, it functioned as a military garrison, arsenal, and supply depot.

Fort Seldon (now a state monument), was established north of Las Cruces in 1865 to protect settlers from Apache Indians. It housed one infantry and one cavalry unit, including black Buffalo Soldiers.

all Pueblo Indians citizens of New Spain with full entitlements including the right to vote. When Melgares left Santa Fe for Mexico City in 1822, most of the Pueblos functioned as independent municipal governments.

A quarter of a century after Melgares's departure from New Mexico, as the Treaty of Guadalupe Hidalgo (1848) brought an end to Mexican rule, Lieutenant Colonel Edwin Sumner devised his own regional defense plan for the newly-ceded territories. Not unlike his Spanish antecedents, Sumner, too, envisioned a cordon of military installations. His alignment, however, would be oriented north-south, parallel to all the corridors that penetrated New Mexico. At the time, however, no one could have foreseen the effect that streams of gold seekers migrating from the East to California would have on these early strategies. Within two years of Sumner's proposition, the 9th Military Department fielded more than one thousand army regulars distributed more or less equally from Taos to El Paso and Las Vegas to Cebolleta. Fort Marcy (1846) anchored the alignment in the north, while Fort Bliss (1849, reactivated in 1853) bolstered the opposite extreme. From 1850 to 1870, the War Department established sixty separate military installations in New Mexico of varied size and importance. Key forts—Bayard (1866), Craig (1854), Cummings (1863), Selden (1865), Stanton (1855), Sumner (1862), Union (1851), and Wingate (1860)—collectively played a part in the territory's rich but turbulent military history.

The ongoing confrontation with nomadic Indians—Navajos, Apaches, and to a lesser

degree, Utes—continued unabated from 1860 to 1880. Yet, despite the loss of life and livestock during those decades, perhaps no threat caused greater uncertainty to New Mexicans than the attempted Confederate takeover during the Civil War. As the conflict between North and South escalated, the War Department transferred significant numbers of federal troops from western outposts to the eastern front. By the summer of 1861, New Mexico was vulnerable not only to escalated Indian attacks but more ominously to a Confederate military invasion from Texas.

Brigadier General Henry Hopkins Sibley, who had defected to the Confederate cause from New Mexico, hatched a plan to invade the territory. He perceived New Mexico as a gateway to the Colorado goldfields and the coveted natural harbors of the Pacific Coast. Hopkins had no trouble convincing Confederate President Jefferson Davis to endorse the plan. A former U.S. secretary of war, Davis had long appreciated the strategic importance of the Southwest. Dangerously unprepared to meet the impending threat, New Mexico—as it had done so many times during the colonial period—turned to its civilian militia. As the invasion neared, territorial officials mustered five infantry regiments of the New Mexico Volunteers under the joint command of Kit Carson and Ceran St. Vrain.

Although not well-versed in modern battlefield tactics, the militia were battle-hardened from years of frontier combat. *Nuevomexicanos* from the mountain villages in the north and the ranching communities near Las Placitas (present-day Lincoln) and Carrizozo represented half of the

Derelict truck near Villaneuva, southwest of Las Vegas.

enlisted ranks. Sprinkled throughout the regiment were a cadre of Hispano infantry and cavalry officers: Rafael Chacón, Juan Sarracino, José Valdez, Julian Solano, Francisco Abreau, Manuel Chaves, Andres Tapia, and licensed physician J. Francisco Chaves. The latter, the son of the renowned merchant and livestock owner Mariano Chaves y Costillo, gave up the comforts he enjoyed from the profitable sheep trade to join the militia in defense against yet another foreign invasion.

The volunteers were put to their first test at Valverde on February 21, 1862. The battlefield lay

Orlando's Café in El Prado just north of Taos.

fare well. While Carson praised his troops for bravery in the face of the enemy, the cursory training they had received at Fort Union proved insufficient during the pitched battle. Consequently, Sibley's forces advanced north to capture Albuquerque and Santa Fe. On March 26–28, the volunteers had the opportunity to redeem themselves.

Reinforced by federal troops from Fort Union (near present-day Watrous), and a motley collection of hard-rock miners calling themselves the Colorado Volunteers, the Hispano militiamen engaged the Texan-dominated rebel army. Colorado militiamen, who had slogged over snow-covered Raton Pass to get to the fight, also performed valiantly. Unlike Valverde, Glorieta Pass was home ground to the New Mexicans, who knew the terrain intimately. When instructed to lead Colonel John Chivington on a daring flanking maneuver across Rowe Mesa to the Confederate supply line at Cañoncito de Apache, Lieutenant Colonel Manuel Chaves eagerly complied. The volunteer forces overpowered the unsuspecting rear guard and burned the supply wagons, effectively routing the Confederates, forcing them into a chaotic retreat to El Paso. Just as they had foiled the Santa Fe Expedition in 1841, the local militia again drove the much-despised Texans out of New Mexico.

Their participation in this short but significant engagement between Union and Confederate forces on the western battlefield exemplified the *nuevomexicanos'* military allegiance. As frontiersmen, civilian militia had time and again proven themselves willing to defend the

a few short miles north of Fort Craig (near present-day San Marcial) on the upper end of the dreaded Jornada del Muerto. Positioned on the old Camino Real, Fort Craig in its heyday was an intermediate supply depot for materials despatched from Fort Union and redistributed to posts located along the southern perimeter. The ensuing clash at Valverde proved to be the largest and bloodiest Civil War encounter in the western territories. The New Mexico Volunteers did not

province against Indian assault. The Civil War afforded Spanish-speaking volunteers from Las Vegas, Taos, Anton Chico, Mora, and Las Placitas the first opportunity to prove their loyalty as Americans. Of the estimated 2,800 New Mexicans who comprised the regiment, more than half were former citizens of the Mexican Republic. New Mexico's Hispano population repeated this pattern of volunteerism in 1898 when Teddy Roosevelt recruited southwestern cowboys to fight in Cuba with his celebrated "Rough Riders" during the Spanish-American War. When President Woodrow Wilson committed American troops to Europe in 1917, sixty-five percent of the state's enlisted were Hispano. Chimayó, with a total population of 500 residents at the time, sent forty-one Hispano teenagers to fight the *Wehrmacht* in France.

When Japanese fighter pilots dropped the first torpedoes on the unsuspecting Pacific Fleet anchored at Pearl Harbor on December 7, 1941, the United States claimed approximately 2.5 million citizens of Spanish and Mexican decent. Eighty-five percent of that number resided in the five southwestern states of New Mexico, Texas, Arizona, Colorado, and California. In advance of President Roosevelt's declaration of war, New Mexico Hispanos were among the first to respond. Prior to Japan's attack on Hawaii, the War Department anticipated an invasion of the Philippines. Desperate for fighting men in the summer of 1941, the army recruited members of the New Mexico National Guard to support Texas and Arizona guardsmen previously despatched to defend Manila.

The Old Capitol in Santa Fe at sunset under a brooding sky and brilliant sun—the combination creating a rainbow. Named the Bataan Building to honor New Mexican POWs.

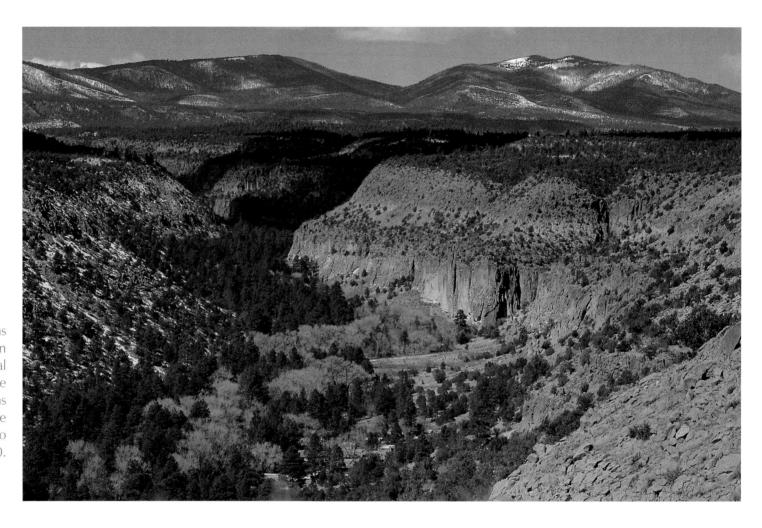

Jemez Mountains looking down on Bandelier National Monument, the home of ancient Puebloans and also the site of the devastating Cerro Grand Fire in 2000.

On December 8, Japan struck the Philippines with unrelenting fury, forcing elements of the 200th and 515th Coastal Artillery to withdraw south to the Bataan peninsula. Rations diminished, ammunition exhausted, and most of his American and Filipino troops near starvation, Major General Edward P. King surrendered 36,000 men to the Japanese in April 1942. What lay ahead for the demoralized American and Filipino prisoners was worse than the military humiliation. The Japanese subjected them to an enforced march through the jungle under extreme cruelty and hardship. During what became known as the "Bataan Death March," thousands of captives perished. Those who survived endured years of privation and torture as prisoners of war.

Today, an elite corps of Bataan veterans sing *corridos* (ballads) to honor the memory of their fallen comrades who never returned to their beloved Southwest.

Other *nuevomexicanos* fought with distinction during the Second World War and subsequent conflicts. Of the seventeen Hispano Medal of Honor recipients in World War II, three were from New Mexico. José Martínez of Taos is believed to have been the first person of Hispano-Mexican descent ever to receive the nation's highest honor. The two other recipients were José Valdez of Gobernador and Alejandro Ruíz of Loving.

New Mexico's contribution to national defense and global security was not restricted to combatants. Scientific technology eclipsed all other wartime contributions. The road to developing the world's first nuclear weapon began innocuously with the construction of a top secret laboratory on the Pajarito Plateau in October 1943. J. Robert Oppenheimer, an esteemed University of California physicist, had spent his summers backpacking on the isolated tableland. He recommended that the War Department purchase 54,000 acres of Forest Service land to initiate the so-called Manhattan Project. From 1943 to 1945, the world's most renowned scientists—Edward Teller, Enrico Fermi, Hans Bethe, Neils Bohr, Otto Frisch, and others—converged on the wind-swept citadel of Los Alamos to secretly assemble the world's first atomic device. The scientific team successfully detonated the prototype—nicknamed the "gadget"—at the Trinity Site in the astringent Tularosa Basin. In August 1945, B-29 bombers deployed to the South Pacific from Roswell Army Air Base, dropped bombs on Hiroshima and Nagasaki, which hastened Japan's unconditional surrender and the end of global war.

Meanwhile, fascinating but lesser-known scientific research was underway at Alamogordo. The barren surroundings of the Tularosa Basin have consistently offered the perfect environment for scientific experimentation. In the 1930s, Roswell-based physicist Dr. Robert Goddard used the vast, sparsely populated basin to perfect the first known liquid-fueled, gyro-controlled rocket prototypes. When American intelligence officers

San Juan Pueblo dancer's headdress at Nambé Pueblo.

Truchas on the high road from Santa Fe to Taos, Route 76. Robert Redford set the movie *Milagro Beanfield War* here.

interrogated Werner von Braun and his German colleagues in the spring of 1945 to ascertain how they had developed the dreaded V-1 and V-2 rockets, they cited Goddard's pioneering work.

As Russian and American soldiers advanced on Berlin in May 1945, von Braun and his fellow German scientists, hidden deep within the recesses of the subterranean rocket facility at nearby Nordhausen, debated the advantages of surrender to U.S. troops as opposed to those of General Zhukov. After intense deliberation, German engineers delivered fourteen tons of research, drawings, scientific instrumentation, and rocket prototypes used in the V-1, V-2, and the more advanced A-4 rocketry program into the hands of the Third Armored Division. Within weeks of his personal surrender to the Allied Forces, the War Department flew von Braun to Fort Bliss in El Paso, Texas, where he thoroughly briefed American officers on the latest German advances in rocket science.

Under the code name "Operation Paperclip," military intelligence identified 150 of Germany's top civilian scientists and technicians. The Army offered the scientists five-year contracts to work at the recently established White Sands Proving Grounds near Alamogordo and the promise to transport their families from occupied Germany. Operation Paperclip came to a fitting conclusion in November 1954 with the naturalization of more than 50 of the German scientists, including von Braun. From 1946 to 1960, German and American scientists worked side by side to develop the nascent space program that within a decade culminated with the Apollo lunar landing.

Trade and Transport Corridors

*I*N 1601, CARTOGRAPHER Enrico Martínez produced the first map of New Mexico, depicting all of the pueblos along the Rio Grande. Also detectable was the faint delineation of El Camino Real de Tierra Adentro, a subsidized interior highway that linked the remote province to the mining districts of northern Mexico and ultimately Mexico City. Extreme dislocation from the population centers of New Spain left the inhabitants of New Mexico few alternatives for economic subsistence. Their links to the outside world were paramount. Technically, the road was opened with the ill-fated entrada of Rodríguez and Chamuscado (1581), who extended the highway north from the mining districts of Zacatecas and Nueva Vizcaya. Oñate's expedition in 1598, however, legitimized the route as the official royal highway into the interior provinces. From that point forward, the Camino Real was the economic and cultural lifeline linking the colonists of New Mexico to the administrative capital 1,200 miles to the south. More important, the highway was a conduit for the transference of culture that with time became increasingly distinct from that of the Iberian motherland.

By the eighteenth century, the colonists of New Mexico had solidified their love-hate relationship with the Plains Indians. When not locked in mortal combat, the two cultures

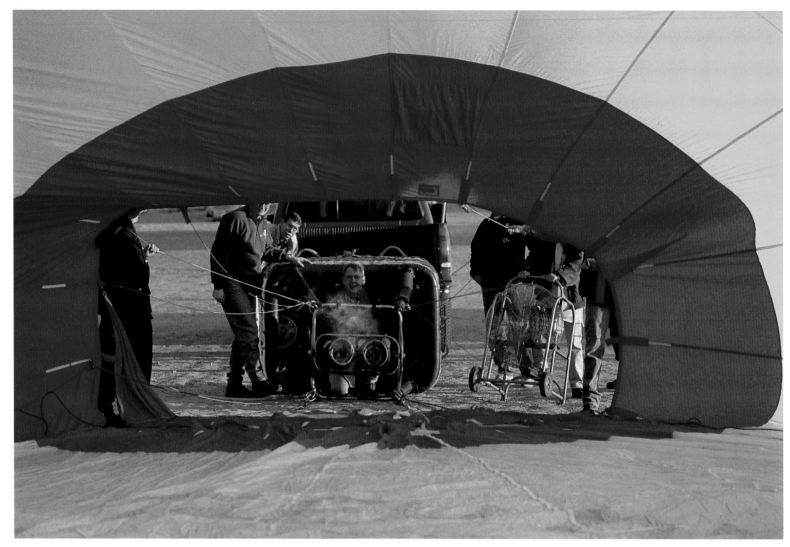

Inside an inflating balloon. Albuquerque Balloon Fiesta is held every year the first week in October.

engaged in lucrative trade. The processed buffalo robes that Apache warriors offered as a gesture of good will to Vargas in 1693 under-scored the importance of resuming the cen-turies-old trade between pueblo and plains.

The prolonged *pax fronteriza* Anza secured with the Comanches in 1787, and that Governor Fernando de la Concha sustained after Anza's departure, hastened New Mexico's transforma-tion from a barter system to a cash economy.

Spanish-speaking plainsmen known as *ciboleros* became an integral feature of the trade in assuming the role as middleman between Plains Indians and Hispano colonists.

Pueblo and Hispano villages located on the apron of the eastern plains were especially active in the burgeoning robe trade. Twice a year, genízaro villagers from San Miguel del Vado assembled hunting parties—sometimes in conjunction with residents from Pecos and other pueblos—either to kill buffalo or to engage in trade with the Comanches, Kiowas, and Pawnees for processed robes. Among the latter tribes, men hunted and women processed the hides. The ciboleros took carts (*carretas*) laden with vegetables, metal axes, knives, woolen blankets–the coveted "Rio Grande" blankets were especially valued among the Indians—horses, tobacco (*punche*), and occasionally firearms for exchange. The optimum trade season was November to March when buffalo coats were thick and most desirable.

With the arrival of the American traders in New Mexico in 1821 and the opening of the Santa Fe Trail, Hispano merchants cultivated a new and sizable market for the robe trade. Within a decade, the emergence of the fur trade added yet another marketable commodity for St. Louis-bound freighters. Meanwhile, the luxury-poor mining districts of northern Chihuahua and Sonora lusted for trade goods from any source. By the mid-nineteenth century, the fur trade was defunct and the buffalo robe trade in serious decline. American competitors such as Bent's Old Fort (near La Junta,

Spanish Market in Santa Fe brings out aspiring flamenco dancer Manuella Perrier.

Colorado) squeezed the ciboleros out of the trade. In due time the Bents and others like them monopolized trade relations with the northern plains Indians—Cheyenne, Arapahos, and Utes—as a viable alternative to their continued dependence on Hispano ciboleros. Of greater consequence, the once seemingly inexhaustible herds of buffalo were rapidly depleted. Cows and calves provided the most desirable hides for tanning. As both groups—

Europe by the fifteenth century. However, the spindle-legged, shaggy-coated little creatures with their wild array of horns possessed an unusual stamina that enabled them to thrive in the harsh, semi-arid environment of the Southwest. Thrive they did. Numbering scarcely more than 5,000 when they arrived with Oñate's colonists to the Chama Valley, their numbers multiplied to an estimated quarter of a million animals by the 1830s. In contrast with the impressive numbers of sheep at that time, New Mexicans maintained only an estimated 5,000 cattle, used almost exclusively as draft animals for agriculture. It appears that the sheepmen of the Rio Abajo dominated the industry.

One important development attributed to the success of the sheep industry in New Mexico was the adoption of a feudal institution known as the *partido*. Introduced in central Mexico as a means of exchange for services rendered, the system had been modified as a means to use sheep for lending capital at interest by the time the system arrived in New Mexico. The owner of the flock turned over a predetermined number of ewes to the *partidario*, the individual who accepted responsibility to care for them. The latter, in turn, promised to make annual payments of lambs and wool to the original owner. At the end of a three- to five-year written contract the benefactor returned the original number of ewes to the owner plus any unpaid balances. The owner routinely realized twenty to thirty-five percent interest on his original investment of livestock. The partido

Hispano and Indian—drastically reduced the animals most vital to reproduction, the herds diminished accordingly and the robe trade ceased altogether.

Sheep, especially the hardy churro introduced to the New World from southern Spain and highly prized for its savory meat and long staple wool, proved to be a more enduring commodity than buffalo hides. Almost comical when compared to the revered Spanish Merino, churro sheep had become virtual outcasts throughout Spain and much of northern

system played a pivotal role in stimulating New Mexico's sheep-dominated economy for the next two hundred years.

Increased use of partidarios during the eighteenth and nineteenth centuries not only resulted in a significant increase in livestock, but also gave rise to a class of wealthy, politically powerful *nuevomexicanos* (ricos). Moguls like Miguel Antonio Otero (whose son eventually became one of New Mexico's territorial governors), Pedro José Perea, and patriarchs of the Ortiz, Sandoval, Chaves y Castillo, and the Basque-born Yrissaris families monopolized the industry. As multiplying flocks increased the management responsibilities of their owners, *partido* provided both a useful source of labor as well as a substitute for wage payments in an economy virtually devoid of cash. Not unlike the sharecropping system introduced in the postwar South during Reconstruction, however, the inherent danger of the partido was to create debts that were virtually impossible to repay. Debt peonage of the partidario and his family to the sheep owner was not an uncommon occurrence.

Each year prominent New Mexico stock owners assembled their flocks at La Joya de Sevilleta (today's Sevilleta), the last settlement north of the Jornada del Muerto. Local drovers trailed the bleating ensemble down El Camino Real to the mining towns of Parral, Santa Bárbara, Zacatecas, and Chihuahua before proceeding to Durango, Mexico City, and eventually Cuernavaca. In 1829, Antonio Armijo, brother of the ill-fated provincial

Hooded merganser, *lophodytes cucullatus,* in the Bosque del Apache National Wildlife Refuge.

governor, pioneered a second commercial trail to the Pacific Coast. Today, we refer to the route as the Old Spanish Trail, a memorial to the combined effort of friars Francisco Antonasio Domínguez and Francisco Silvestre Vélez de Escalante and their failed attempt in 1776 to link New Mexico with California. Following the trace of a well-worn Indian trade route, the adventurous padres documented their journey from Santa Fe via Abiquiú and the Animas River Valley (near present-day Durango, Colorado) to the red-rimmed canyon country of southeastern Utah.

Armijo extended the route across Utah into the Virgin River Valley of Nevada, finally

The Ore House on
the Plaza in Santa Fe.

traders regularly herded mules—especially valued in Missouri—back to New Mexico for use in the Santa Fe-Chihuahua trade. Thus the famed "Missouri" mule touted throughout American folklore was in reality of Mexican California origin.

The sheep industry remained New Mexico's principal economic enterprise until just prior to the Civil War. The successful entry of Anglo merchants—Christopher "Kit" Carson and Richard "Uncle Dick" Wooton, among others—into the trade beginning in 1850 resulted in unwelcome competition within the once Hispano-dominated industry. The Americans also introduced new breeds of sheep—Spanish Merino and French Rambouillet—in a calculated effort to displace the churro as the dominant commodity in California. Not surprisingly, these loftier breeds, while touted for their size and quality of wool, proved unable to survive the arduous drive to market. Although the churro still reigned supreme in New Mexico, Anglo and Hispano herders unwittingly saturated the Pacific Coast market. By 1860, California's sheep inventory exceeded two million animals, making the Golden State a formidable competitor of New Mexico for an increasingly shrinking market. As the door for New Mexico-bred mutton abruptly slammed shut, a growing demand from emerging post-Civil War textile industrialists for wool appeared on the horizon to rescue the New Mexico sheep industry from total collapse.

The Santa Fe-Chihuahua trade, meanwhile, remained an important outlet for Hispano and

reaching the mission of San Gabriel (near Los Angeles). From the Mexican era until well into the American period, Hispano sheepmen herded a wooly tide numbering in the thousands to the thriving bilingual communities of southern California. The discovery of gold in 1848 and the subsequent onslaught of mineral-hungry immigrants bound for the far West increased the regional appetite for New Mexico mutton. In exchange for their flocks, Hispano

Indian stockmen. Many New Mexicans hired on as drovers to transport animals to market. Specialized laborers such as outfitters, muleteers, and men daring enough to mount unbroken horses were in high demand. Less valued but no less necessary to every trade caravan were the scouts, hunters, blacksmiths, wheelwrights, woodcutters, and cooks. These wage earners honed their skills on the Santa Fe-Chihuahua Trail. During the final decades of the trade (1860–1880), *nuevomexicanos* looked to a nascent cattle industry for work. Prior to the Civil War, the Bent family, Sam Watrous, and other prominent Anglo businessmen tried their hands at the cattle trade. Their reliance on Hispano cowhands (*vaqueros*) to tend the herds and break wild horses is well documented. With an affordable labor source at hand, and rangeland that Lucien Maxwell made available to them near present-day Cimarron, New Mexico cattlemen anticipated a dependable outlet for their product.

Although Spanish colonists had introduced Black Andalusian stock to New Mexico after the Pueblo Revolt of 1680, cattle raising clearly remained subservient to the sheep industry as the principal economic endeavor. This was in sharp contrast to other Spanish-held territories such as California and Texas, where cattle were especially valued among the numerous Franciscan-managed missions. As the distinctive black strain of cattle from southern Spain gradually disappeared from the New Mexican frontier, a new breed whose origin harkened to the thorny, cactus-filled surroundings near San

Quaking aspen in the winter at Jack's Creek, Pecos Wilderness, in the Sangre de Cristo Mountains.

American white pelicans, *pelecanus erythrorhynchos*, gather at Bluewater Lake State Park near Grants.

made application of supply and demand encouraged an illicit trade between would-be cattle barons in New Mexico, who purchased stolen Texas cattle from the Comanches and Kiowas to augment their herds. In 1866, visionaries like Charles Goodnight and Oliver Loving forged a cattle trail across the Llano Estacado to Fort Sumner to market their beef among the Navajo prisoners still incarcerated at the time. Similarly, John Chisum, a former associate of Goodnight, established a baronial cattle empire near Roswell, where it is said that he employed a hundred cowboys—mostly vaqueros—to herd an estimated 80,000 head of cattle.

New Mexico's cattle industry reached its zenith in 1875. Locally, mining boomtowns sprang up overnight to create new markets while burgeoning cities like Chicago and Kansas City reportedly consumed 50,000 Chisum-bred cattle in one year. Chisum's personal good fortune notwithstanding, the New Mexico cattle industry could not compete with the annual cattle transactions registered in Texas, Colorado, and Wyoming during the late nineteenth century. William H. Bonney, alias Billy the Kid, is unquestionably New Mexico's most famous persona to emerge out of the turbulent cattle era—a period too often marked by unrestrained violence. Born Henry McCarty to New York City Irish immigrants in 1859, the uneducated, bilingual renegade somehow ascended to the mythic status of an American Robin Hood for his part as a paid assassin in the bloody range conflagration known as the Lincoln County War.

Antonio, Texas, took its place. Described in 1880 simply as a wild breed with enormously long horns, these so-called "Texan" cattle had become a familiar sight on New Mexico's central and southern plains.

Cattle did not become a cash commodity in the West until after the Civil War and the return of the United States Army to the region. The beef-dependent army requisitioned meat on a routine basis. Feral cattle were available by the millions in nearby west Texas. The ready-

Balloons lift off during the annual Albuquerque Balloon Fiesta in October.
Eight hundred fifty balloon crews and pilots convene to fly the thermals of the Sandia Mountains.

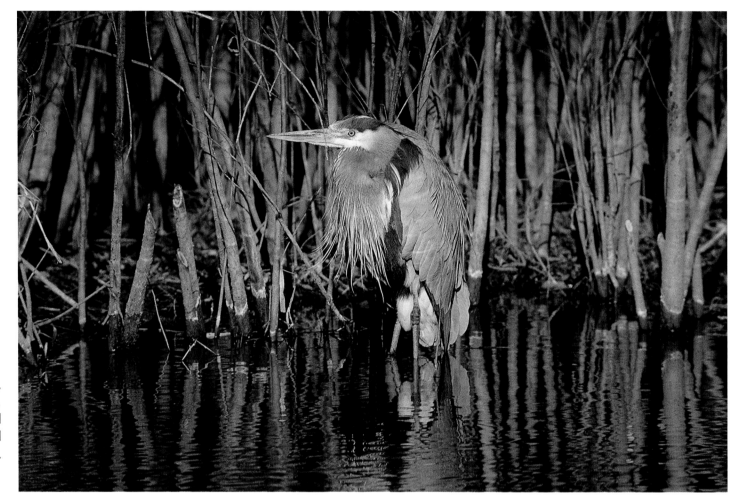

Great blue heron,
ardea herodius,
Bosque del
Apache National
Wildlife Refuge.

Remarkably, the U.S. Census of 1900 and 1910 described a society not too dissimilar from that of the previous century. New Mexico's total population numbered only 141,282 inhabitants, 50 percent of whom were of Hispano/Mexican descent. Ten years later, the population had more than doubled to 327,296 New Mexicans, still predominantly Spanish-speaking, one-third of whom were listed as illiterate in both Spanish and English. Stock raising, agriculture, and mining were the principal occupations of day.

Although the sheep industry continued to dominate the local economy, a decade of severe droughts caused a steady reduction in the numbers of sheep from an all-time high of five

million in 1882–1883. Decreasing demands for mutton nationwide coupled with precipitating prices for raw wool in favor of synthetic fibers throughout the textile industry adversely affected sheep exportation by 1910. New Mexico's link to the broader national community on the eve of the twentieth century would, however, radically transform the post-colonial territory into a pre-industrial state.

The arrival of the railroad mated western resources to eastern markets and in the process modernized New Mexico. If ever a conduit for the transference of culture existed, the railroad was it. It expedited a massive infusion of immigrants from the overcrowded East to the vast, unoccupied spaces of the West. It quickly transformed the American perception of New Mexico territory from an ungainly frontier of predominately Spanish-speaking, technologically-deprived agriculturalists to that of a racially balanced society of would-be industrialists and reform-minded progressives. As New Mexico aspired further to "acceptability," it was at long last admitted to the Union in 1912.

The railroad also encouraged an unrestrained cash economy in which mining, timber production, stock raising, and—in conjunction with reclamation marvels such as Elephant Butte Dam—large-scale agriculture were the immediate by-products. Industry in turn gave rise to new, enterprising locales such as Las Cruces, Mesilla, Deming, Silver City, Lordsburg, Alamogordo, Portales, Roswell, and Hobbs. Las Cruces farmers, who founded the town in 1849 to provision the nearby army encampment located at Radium

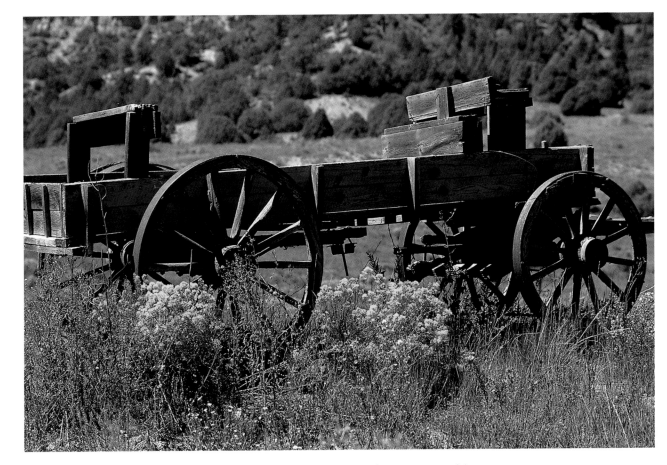

A wagon near Monero, east of Dulce on Route 64.

Springs, especially benefited in 1916 from the Bureau of Reclamation's distribution of irrigation water to the Mesilla Valley. A seemingly unlimited supply of water coupled with intensive cultivation of previously untested commercial crops such as chile, pecans, cotton, peanuts, and sorghum stimulated a viable agricultural economy in southern New Mexico that in time eclipsed that of Albuquerque, Santa Fe, and other long-standing northern municipalities.

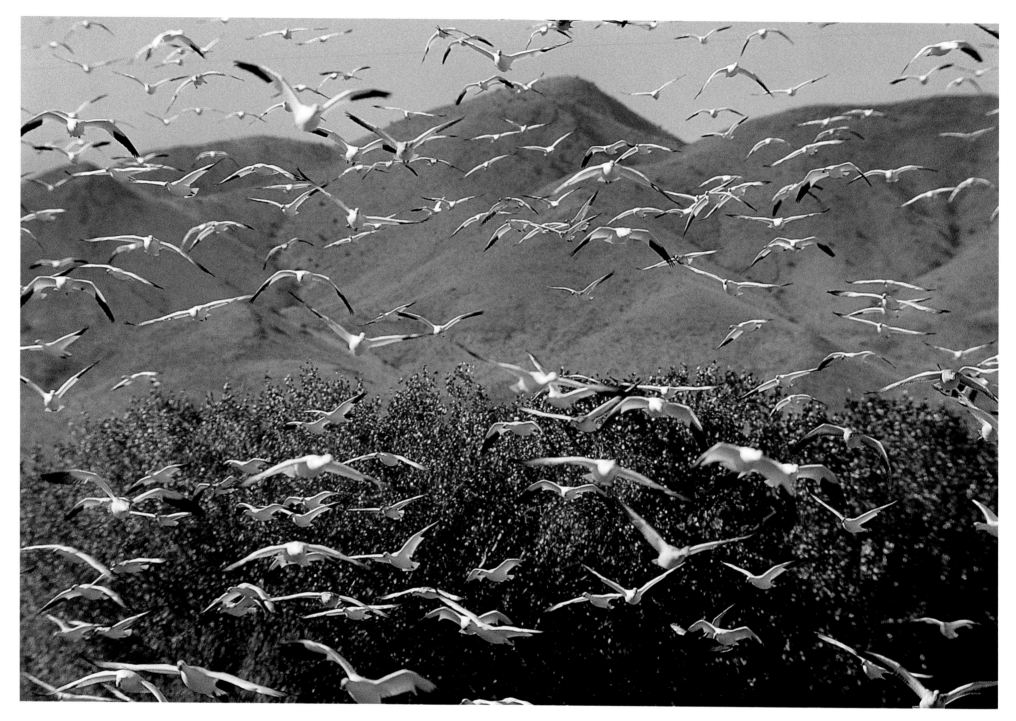

Snow geese, *chen caerulescens*, lift off against the Chupadero Mountains, Bosque del Apache National Wildlife Refuge.

Resources and Environment Corridor

*A*LTHOUGH PROSPECTORS HAD mined precious metals around numerous boomtowns such as Elizabethtown, Cerrillos, Magdalena, White Oaks, Pinos Altos, and Silver City during the mid-1800s, nothing prepared New Mexico for the magnitude of resource development experienced by the mid-twentieth century. A congressional report published in January 1965 ranked New Mexico seventh among all producers of strategic minerals in the United States and first among the Rocky Mountain states.

At that time, New Mexico led the nation in uranium and potash production, ranked third as a producer of copper, and sixth in oil and natural gas recoveries. The report estimated the state had produced a cumulative total of $9.1 billion in mineral resources, all but $26 million of that figure since 1900. The Santa Rita del Cobre Mine near Silver City, operational since 1803, was still a leading copper producer in 1965. Meanwhile, the Kennecott-owned Chino Mine, a child of the twentieth century, accounted for 90 percent of all copper production in the state since 1909. Ambrosia Lake northwest of Grants supplied uranium, vanadium, and other radioactive material. The story of those recoveries reads like a Hollywood script. In the 1920s, Los Angeles businesswoman Stella Dysart invested in Ambrosia

Lake property with the hope of finding oil. After twenty-five years of failed attempts, her nearly bankrupt company uncovered a seventeen-foot seam of pure uranium. Questa, located in the northern part of the state, cornered the market in molybdenum and manganese, two strategic minerals valued for their steel-hardening capabilities.

Despite the state's newfound mineral wealth, petroleum reigned supreme as New Mexico's most lucrative commodity. Oilfield workers discovered enormous pools in Lea and Eddy counties. Southeastern New Mexico is in effect the physiographic extension of the great Permian Basin. The oil industry transformed Hobbs and Artesia from agricultural centers into industrial meccas. A flood of geologists, petroleum engineers, and

Conoco Oil rig north of Jal in southeastern New Mexico on Route 18. Coal mining, gas, and oil production are large industries in northern and southern New Mexico.

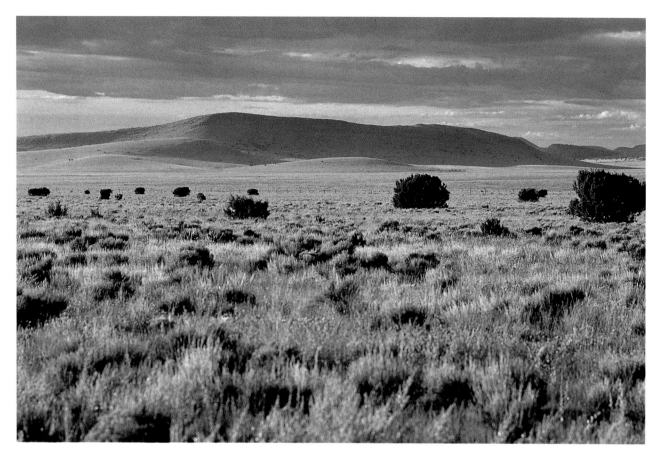

San Agustin Plain in monsoon season.

for Indian, Hispano, and Anglo wage earners. Subsurface activities and monumental undertakings—building a natural gas transmission pipeline from west Texas to Pacific Coast consumers—supported countless New Mexico families. Since the discovery of the state's first productive well in 1928, oil and gas revenues have consistently exceeded the totals for all other mineral recoveries combined.

Through all of the backwash of rampant mineral resource exploitation, agriculture and stock raising has tried—albeit with moderate success—to keep pace. While many envision New Mexico as a cattle state, it was not until 1956 that the number of cattle exceeded sheep for the first time in the state's history. Traditionally, New Mexico has been an importer and not an exporter of cattle. In recent decades, the increased production of feed grains encouraged the construction of feedlots and local processing plants across the southern landscape. Since the late 1940s, commercial dairy cattle and milk production have added immeasurably to the state's economy. Today, the dairy and cattle feedlot industry accounts for approximately 70 percent of the total agricultural output. In a startling reversal of roles, the sheep industry has fallen on hard times since the 1930s. During the so-called "dust bowl" decade, incessant drought and severe overgrazing exacerbated the dramatic reduction of sheep in New Mexico. A federally imposed policy of sheep reduction against the Navajos, during which time government agents literally shot entire flocks of sheep in front of their horrified owners, decimated the sheep industry on Reservation lands.

blue-collared "roughnecks," mostly from Texas and Oklahoma, increased the population as they introduced a conspicuous southern bent to that part of the state. A similar transformation occurred in the San Juan Basin. Unparalleled recoveries of natural gas caused a population explosion in Farmington. Like an unannounced earthquake, the traumatic effects rippled through outlying farming communities like Kirtland, Aztec, Bloomfield, and Shiprock. New Mexico's extractive industry translated to high-paying jobs

Meanwhile, the Taylor Grazing Act of 1934 removed millions of acres of pasturage from the public domain. Lands that were traditionally viewed as communal property by Hispano sheepherders and ranch operators were fenced and no longer accessible to their flocks except by special permit. In effect, the sheep industry never fully recovered from these environmental and politically driven setbacks. The estimated number of sheep in New Mexico declined from five million in 1880 to little more than 500,000 a century later. In 2003, that number has fallen further to 230,000—the largest producers being Chaves, Lincoln, McKinley, Cibola, and San Juan counties. Once again, several years of drought and shrinking markets in the wake of devastating import surges from Australia and New Zealand have nearly crippled the industry.

The federal government's monumental effort to capture and redistribute the life-giving waters of the Rio Grande, Pecos, Chama, and San Juan Rivers during the twentieth century enabled the revitalization of agricultural commodities long since removed from the New Mexico landscape. The 1970s witnessed the rebirth of the wine industry in New Mexico with the establishment of nineteen wineries that produce approximately 350,000 gallons annually. A seventeenth-century industry that the Spanish introduced to San Antonio de Padua Mission Senecú (present-day San Antonio) just south of Socorro, wine production was restricted to sacramental use in the Catholic Church.

By 1800, a strip of vineyards extended north to south along the Rio Grande from Bernalillo to

Grapes grown by the Ponderosa Vineyard in the Jemez Mountains near Ponderosa, which is owned by Henry and Mary Street.

Evergreen on Johnson
Mesa near Gallinas.

Socorro and west to east from Mesilla to El Paso. The industry received a boost during the early days of the Territorial Period with the arrival of Italian Jesuits at the request of the French-born prelate Archbishop Lamy. The Jesuit success in wine production, combined with a heavy monetary investment from French vintner Joseph Tondre, encouraged a proliferation of new wineries near Corrales, Alameda, Los Griegos, Los Candelarias, Albuquerque, Atrisco, Barelas, Isleta Pueblo, and Los Lunas. When the railroad reached New Mexico in 1879, the wine industry was firmly rooted in the territory.

Massive flooding of the Rio Grande and northern California's entry into the wine producing industry in the early decades of the twentieth century forced a precipitous decline of the industry. Violent avulsions along the Rio Grande destroyed vineyards and rendered the soil useless for new planting by the end of World War II. What remained of the old commercial wine industry in New Mexico never fully recovered from the calamitous flooding. The creation of the interior department's Bureau of Reclamation in 1923, coupled with the arrival of the U.S. Army Corps of Engineers to Albuquerque, marked an unprecedented era of federally sponsored public works projects in New Mexico. In less than a half-century the two agencies oversaw the completion of Conchas (1939), Jemez Canyon (1952), Abiquiú (1963), Navajo (1965), and Cochiti (1973) Dams to name a few. The prospect of longterm flood control and seemingly limitless supplies of irrigation water enabled the unbridled revival of the wine industry. The proliferation of new wineries mostly in the area north and west of Las Cruces and in the vicinity of the Albuquerque-Bernalillo metro-complex stimulated a brief resurgence of the industry. During the decade 1980–1990 wine production increased from 20,000 gallons annually to nearly 700,000, which attracted a new breed of speculators from northern Europe.

Ever-increasing demands for wine in the United States, coupled with the relatively low cost of farmland in New Mexico, spawned a dizzying but short-lived expansion of the industry. The environmental realities of New Mexico's early frosts in the north and the irrepressible heat of summer in the south stymied the industry. Worse, stiff competition from Californian and European vintners resulted in rapidly diminished markets. In their enthusiasm, New Mexico grape growers

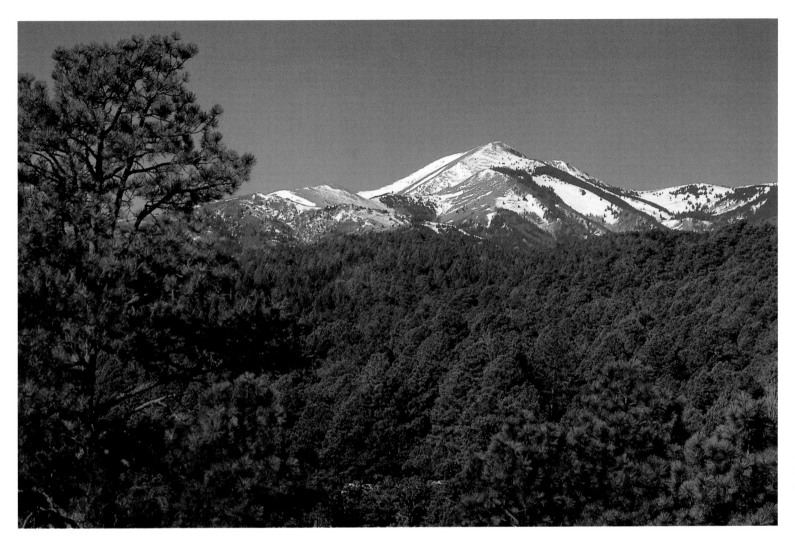

Sierra Blanca in the
Sacramento Mountains
on Route 220.

produced far more wine than they could market. Although neither the global nor even the national success local vintners dreamed of, New Mexico's 21 wineries do still produce 350,000 gallons each year for local and regional patrons. The once restricted Spanish colonial industry appears destined to remain principally an indulgence of New Mexican consumers.

The automobile and the necessity for improved roads ranks only behind the Army and the railroad as an agent of irrevocable change. Not since the great migrations to Oregon and California in the 1840s had the nation experienced such a profound demographic shift from east to west. When contrasted with the postwar exodus of the 1940s

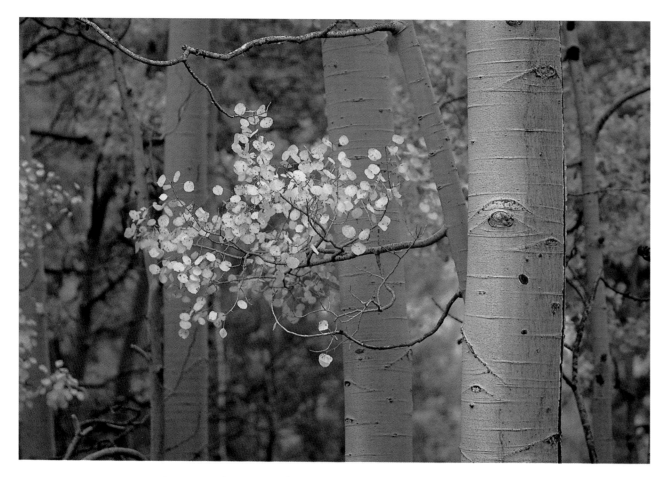

Aspen on the way to the
Santa Fe Ski Basin in the fall.

communities, barely accessible via ill-kept, dirt roads, embraced a rural lifestyle.

Recently paved U.S. 66, a two-lane highway linking Chicago to Los Angeles, was New Mexico's principal conduit to the outside world. Built in 1926 (realigned in 1933), the so-called "diagonal highway" reduced travel from the Midwest to the Pacific Coast nearly two hundred fifty miles. At the time, however, Texas, New Mexico, Arizona, and the desert region of southern California registered a cumulative total of 64 miles of surfaced byways. Nevertheless, in the 1930s an estimated 200,000 immigrants abandoned Oklahoma, Arkansas, Texas, Kansas, Georgia and other "dust bowl" states for better opportunities in California. During the nadir of the Great Depression (1933–1938), federal relief programs recruited thousands of half-starved teenagers to upgrade the well-worn Route 66. In 1940, travel magazines advertised the famous "Mother Road" as one of only two continuously paved highways to the West Coast.

The attraction of the "sun belt" West set into motion during World War II did not abate with the surrender of Germany and Japan. Thousands of returning servicemen, captivated by the scenic amenities and consistently sunny days they had enjoyed during basic training, packed up wives, kids, pets, and charcoal grills into newly financed automobiles and pointed them west. Nat "King" Cole's melodic hit, "Get Your Kicks on Route 66," became a lyrical road map for the mass westward migration. New Mexico was just one of several destinations. From 1940 to 1960 the western states added 39 million

and 1950s, the earlier westward movement pales in comparison. On the eve of the Second World War, the census listed New Mexico forty-first in overall population and ranked it among the nation's most sparsely populated states. Albuquerque remained the largest urbanized area with approximately 35,000 residents, followed by only a half-dozen municipalities in excess of 10,000 people. More than 50 percent of the state's

residents to the census, equal to about one-quarter of the nation's total population. Fourteen of the twenty fastest growing cities in America were located west of the Mississippi River—three of them in California.

New Mexico kept pace with this remarkable growth. The state experienced a 164 percent population increase from 360,000 in 1920 to 951,000 by 1960. Individual counties posted equally impressive statistics: Bernalillo, 80 percent; Chaves, 148 percent; and San Juan, 191 percent. By 1980, New Mexico was sufficiently transformed. Inhabitants now numbered 1.3 million, forty-one percent of whom considered themselves native New Mexicans. Most of the state's new inhabitants arrived from Arizona, Colorado, Texas, Utah, and California. Fewer still originated in the Midwest and the Deep South. Notably, Santa Fe accounted for 37 percent of all out-of-state immigrants. The city's scenic amenities, historical appeal, and diverse culture were a magnetic attraction to the newcomers.

Like other western states, New Mexico became decidedly more urbanized as fewer people chose to live in rural areas. What contributed to the unprecedented postwar growth? Several factors, but clearly the most important were the interstate highway system, the Cold War military-industrial complex, and a more leisure-oriented society with the means and the inclination to "hit the road." The interstate highway system, of which I-25 and I-40 are integral components, broke down the geographic isolation that historically separated New Mexico from the rest of the country. Senator Dennis Chavez stridently advo-

cated the federal highway and became its most resonant voice in Washington. President Dwight D. Eisenhower had been so impressed with Germany's autobahn that he vowed early in his presidency to construct a similar expressway in the United States in the interest of national defense. The high-speed, multi-lane freeway, coupled with an improved network of secondary roads—e.g. U.S. 44 (present U.S. 550) into the Four Corners region and U.S. 54 to El Paso—enabled the federal government to improve access to strategic

Founded as a coal mining town, Madrid's population dwindled in the mid-twentieth century. In the 1970s, it became an artists' community that still retains a lot of its original flavor. It is located on Route 14 south of Santa Fe.

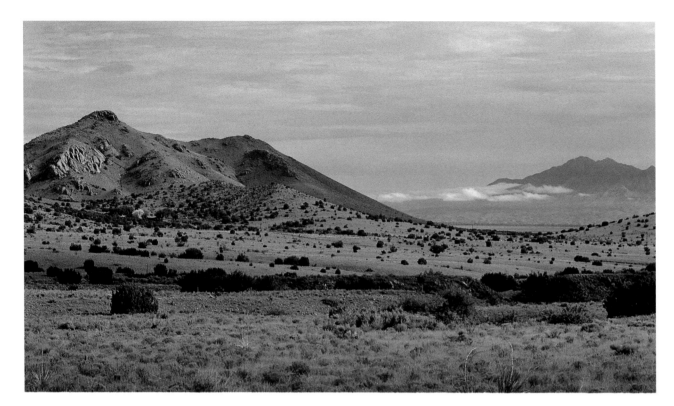

San Agustin Plain
during monsoon
weather in August.

within the numerous federal and state parks, assures perennial visitation. Similarly, cultural pride revived by the Chicano Movement of the 1960s and articulated through a cadre of Hispano artists beckons tourists to visit the Land of Enchantment. Meanwhile, a steady stream of Mexican and Central American immigrants reinforce the state's historic affiliation with the Spanish-speaking world. The recent diplomatic visit of Mexican President Vicente Fox to Santa Fe is further testimony to the longstanding affinity between Mexico and its former frontier province. The intoxicating blend of culture, environment, and historic tradition that summons admirers to this state has served an even greater purpose in forging a civic identity that is quintessentially New Mexican.

The expression of religious beliefs and cultural traditions through contemporary Hispano and Indian art work has become a favored avenue for the promotion of heritage tourism. Although the *santero* tradition existed during the Spanish colonial era, it flourished almost exclusively among the Penitentes until the early twentieth century. With the near displacement of New Mexico's rural agricultural villages before World War I, the art form was virtually lost. In 1925, local artists devoted to the state's scenic and cultural ambience founded the Spanish Colonial Arts Society. The society not only promoted the work of local *santeros* and *santeras*, but also revived other traditional art forms such as embroidery, weaving, furniture making, tin work, and straw appliqué. Federally sponsored WPA programs

minerals and an infrastructure to transport military personnel and equipment throughout the state. Some cities—Roswell, Alamogordo, Los Alamos, and Clovis—rose and fell in accordance with the level of scientific and military activity during the Cold War.

Among the myriad resources available to New Mexico, perhaps none has been more consistently reliable than tourists, foreign and domestic. Beginning in the 1930s, Hollywood directors showcased the state's scenic amenities in more than one hundred fifty films. Today, the prehistoric culture of the Southwest, preserved

strengthened the artistic revival during the Great Depression; the impetus greatly accelerated after World War II.

In 1965, the society sponsored the first Spanish Market, a festive event during which the creations of both experienced and prospective Hispano artists were judged for their creative as well as traditional value, after which the artists sold their work to the public. The weekend event has grown from 200 attendees in 1965 to more than 40,000 in 1997. That year, increased outside interest in the festival warranted the addition of a winter event. The extraordinary success of Spanish Market has inspired a new generation of New Mexican artists—Charlie Carrillo, Gloria López Cordova, Félix López, Arlene Cisneros Sena, José Floyd Lucero, and others—who have reclaimed a centuries-old folk tradition that nearly disappeared forever.

Each year, waves of enthusiastic tourists return to New Mexico and bring with them certain peculiarities that have in time had a positive, long-lasting effect on the local economy. Long regarded as the mecca for culinary enthusiasts, Santa Fe restaurants provide a repast for even the most discriminating palate. The recent environmentally-driven public appetite for naturally grown, healthier foods has, for example, stimulated a limited but nonetheless profitable comeback within New Mexico's ailing sheep industry.

Small, Hispano-owned sheep ranches in Tres Piedras and other mountain communities north of Santa Fe have encountered a new and promising market for organically grown mut-

ton. The dish is a popular feature on most menus throughout the city, and local sheep men are the exclusive suppliers. While in no way viewed as a commercial elixir for the sagging sheep industry, Santa Fe and Albuquerque restaurants do represent a consistently reliable outlet for New Mexico-bred sheep. Perhaps harder hit than other agricultural endeavors, the sheep industry has been sent reeling by sustained drought that has resulted in severely reduced and over-grazed pasturage. Recent attempts by New Mexico congressional leaders to bolster the industry through sorely needed federal subsidies speak to the historical importance of the state's oldest and most enduring tradition.

For all of the federal government's efforts to capture water for future municipal and agricultural use, the extreme drought of the 1990s and beyond threatens the sustained demographic and economic success New Mexico has enjoyed for the past half-century. The calamitous 45,000-acre Cerro Grande fire near Los Alamos in May 2000, which decimated 235 homes, endangered the Los Alamos National Laboratory, and forced the evacuation of 18,000 New Mexico residents from Los Alamos and nearby Indian pueblos was in effect only a prelude to an unparalleled incendiary episode in the history of the modern West. Disastrous fires in Montana, Colorado, Arizona, and most recently California have devoured the tinder-dry landscape of the West in unprecedented quantities. In New Mexico, severe drought stimulated an infestation of bark beetles that guarantees the loss of 80 to 85

St. Francis Cathedral. On Christmas Eve Santa Feans join together singing carols and wishing each other a Merry Christmas while walking among the candle lit farolitos on Canyon Road.

percent of the ubiquitous piñon trees. The vast stores of water so accessible in the 1980s and 1990s are clearly no longer perceived as infinite. Municipal water users in the northern communities of Albuquerque, Bernalillo, Los Alamos, and Santa Fe find themselves in direct competition with southern agriculturalists in Las Cruces, Roswell, Artesia, and Clovis for rapidly depleting resources.

For those of us who reside in the astringent reaches of the American Southwest, history has proven that New Mexicans are no strangers to adversity. To live here, one must accept that New Mexico is at once a land of wondrous beauty as well as an environment that gives no quarter. Throughout the centuries, long before the arrival of Europeans, the U.S. Army, the Denver & Rio Grande Western Railroad, and more recently the Albuquerque Balloon Fiesta, the inhabitants of this region—old and new—have learned that adaptation, resilience, respect for and personal commitment to the land and its people are crucial to a sustained livelihood in this state. Even in the face of these uncertainties, New Mexicans—Hispano, Indian, Anglo, and others—reaffirm their allegiance to this state in the mantra: "If I ain't happy here, I ain't happy nowhere."

I WAS BORN IN SOUTHWESTERN COLORADO, the geographic and cultural extension of New Mexico. But my spirit and identity are firmly rooted in this state. My paternal grandfather was a cowboy, more specifically a *vaquero*, who herded cattle in the Valle Grande and on the Pajarito Plateau when the famous Los Alamos Ranch School was still a cattle operation. Born in Los Ojos and educated at the reservation school in Dulce, Guillermo Gómez spoke Jicarilla Apache as readily as he did Spanish. When the cattle business waned in the early 1900s, he, like many of his *compadres* found alternative employment in the sawmill towns of Lumberton and El Vado.

Trailing the Denver & Rio Grande Western railroad as it inched deeper into the woodlands of northern New Mexico and southwestern Colorado, the Gómez family permanently settled in the lush Dolores River Valley.

Meanwhile, my maternal grandfather, Antonio Lobato, a native of Taos and track foreman for the Denver & Rio Grande Western, worked alongside Navajo and Hispanic laborers to extend the narrow gauge rails to the bustling lumber camp of McPhee, Colorado. It was there that my mother and father met and married.

The fascinating stories both grandfathers shared about the adventurous early days in New Mexico inspired me to learn all that I could about the Hispanic experience in the American Southwest. I am especially indebted to a handful of mentors and colleagues for their part in enhancing my education. The publications of Marc Simmons, John Kessell, and Joseph Sanchez, all graduates of the history program at the University of New Mexico, set the standard for scholarly research and readable history. These works mirror the tradition of France V. Scholes, Donald C. Cutter, and other esteemed faculty that earned the university its national reputation.

This particular narrative would not have been possible without the added contributions of Oakah L. Jones, Jr. and Frances Swadesh Quintana. Their sensitive, penetrating accounts of Spanish settlers—pobladores—are unparalleled to the present day. Few historians before or since have undertaken the difficult task to enlighten readers about the enduring contributions of farmers, herdsmen, militia, and other lesser-known heroic figures on New Spain's northernmost frontier.

I thank photographer/author Lucian Niemeyer for the passion, sensitivity, and artistic expression reflected in his breathtaking images and the opportunity to write the text for this book. His compelling photography inspired my narrative. My deepest gratitude, however, goes to Penny, my partner in life and most devoted friend. Her unwavering faith in me often exceeds my own belief in myself. To my sons, Paul and Chris, I hope this book is a lasting reminder of the profound cultural legacy that rightfully belongs to them.

Acknowledgements

Selected Sources

Agriculture Made New Mexico Possible. Las Cruces: New Mexico Department of Agriculture, New Mexico State University, 1977.

Barbour, Barton H. "Kit Carson and the 'Americanization' of New Mexico." In *New Mexican Lives: Profiles and Historical Stories* Ed. Richard W. Etulain, 163–92. Albuquerque: University of New Mexico Press, 2002.

Baxter, John O. "Livestock on the Camino Real." *El Camino Real de Tierra Adentro, vol. II,* comp. Gabrielle G. Palmer and Stephen L. Fosberg, 101–11. Santa Fe: Department of the Interior, Bureau of Land Management, 1999.

Beck, Warren and Ynez D. Hasse. *Historical Atlas of New Mexico.* Norman: University of Oklahoma Press, 1969.

Boyle, Susan Calafate. *Los Capitalistas: Hispano Merchants and the Santa Fe Trade.* Albuquerque: University of New Mexico Press, 1997.

Brooks, James F. *Captives & Cousins: Slavery, Kinship, and Community in the Southwest Borderlands.* Chapel Hill: University of North Carolina Press, 2002.

Carlson, Alvar W. "Spanish-American Acquisition of Cropland Within the Northern Pueblo Indian Grants, New Mexico." *Ethnohistory* (Spring 1975): 95–107.

Cunningham, Elizabeth and Skip Miller. "Trade Fairs in Taos." *El Camino Real del Tierra Adentro.* Vol. II Comp. Gabrielle G. Palmer and Stephen L. Fosberg, 87–102. Santa Fe: Department of the Interior, Bureau of Land Management, 1999.

Deutsch, Sarah. *No Separate Refuge: Culture, Class, and Gender on the Anglo-Hispanic Frontier in the American Southwest, 1880–1940.* New York: Oxford University Press, 1987.

Echevarría, E. A., and J. Otero. *Hispanic Colorado: Four Centuries of History and Heritage.* Fort Collins: Centennial Publications, 1976.

El Camino Real de Tierra Adentro National Historic Trail: Comprehensive Management Plan & Environmental Impact Study. Santa Fe: U.S. Department of the Interior, Bureau of Land Management, 2002.

Esquibel, José Antonio. "The Romero Family of Seventeenth Century New Mexico, Part I." *Hacienda* (January 2003): 1–25.

Frazer, Robert W. *Forts of the West: Military Forts and Presidios and Posts Commonly Called Forts West of the Mississippi River to 1898.* Norman: University of Oklahoma Press, 1965.

Garate, Don. *Juan Bautista de Anza: National Historic Trail.* Tucson: Southwest Parks and Monuments Association, 1994.

Gardner, Mark L. "Bent's Fort on the Arkansas." Unpublished manuscript. Santa Fe: U.S. Department of the Interior, National Park Service, Intermountain Region.

Gómez, Arthur R. "Royalist in Transition: Facundo Melgares, The Last Spanish Governor of New Mexico." *New Mexico Historical Review* 65 (October 1990): 371–87.

———. "Mining New Mexico: A Photographic Essay." *New Mexico Historical Review* 69 (October 1994): 357–68.

———. "Significance and History of Route 66." *Special Resource Study: Route 66,* 7–18. Santa Fe: U.S. Department of the Interior, National Park Service, 1995.

———. *Quest for the Golden Circle: The Four Corners and the Metropolitan West, 1945–1970.* Albuquerque: University of New Mexico Press, 1994. Reprint, Lawrence: University Press of Kansas, 2000.

Gómez, Penny. *Coronado State Monument: Kuaua Trail Guide.* Santa Fe: Museum of New Mexico–State Monuments, 2002.

Jones, Oakah L., Jr. *Los Paisanos: Spanish Settlers on the Northern Frontier of New Spain.* Norman: University of Oklahoma Press, 1979.

Josephy, Alvin M., Jr. *The Civil War in the American West.* New York: Alfred A. Knopf, 1992.

Kessell, John L. *Spain in the Southwest: A Narrative History of Colonial New Mexico, Arizona, Texas, and California.* Norman: University of Oklahoma Press, 2002.

———. *The Missions of New Mexico Since 1776.* Albuquerque: University of New Mexico Press, 1980.

———. *Kiva, Cross, and Crown: The Pecos Indians and New Mexico, 1540–1840.* Washington, D.C.: U.S. Department of the Interior, National Park Service, 1979.

Knowlton, Clark S. "The Town of Las Vegas Community Land Grant: An Anglo-American Coup D'État." *Journal of the West* (July 1980): 13–21.

Lecompte, Janet. "Manuel Armijo and the Americans." *Journal of the West* (July 1980): 51–63.

Lang, Charles H. "Relations of the Southwest with the Plains and Great Basin." *Handbook of North American Indians,* Vol. IX. Ed. by Alfonso Ortiz, 201–5. Washington, D.C.: Smithsonian Institution, 1979.

Lamar, Howard R. *The Far Southwest 1846–1912: A Territorial History,* 1966. Reprint, Albuquerque: University of New Mexico Press, 2000.

Leach, Nicky. "Capulin Volcano: Violent Beginning, Enduring Serenity." *New Mexico Magazine* (September 2002): 26–31.

Levine, Frances. "What is the Significance of a Road?" *El Camino Real de Tierra Adentro*. Vol. II. Comp. by Gabrielle G. Palmer and Stephen L. Fosberg, 1–13. Santa Fe: Department of the Interior, Bureau of Land Management, 1999.

"Los Alamos: Beginning of an Era, 1943–45." Los Alamos: U.S. Atomic Energy Commission, Los Alamos National Laboratory, 1986.

Mares, E. A. "Padre Martínez and Mexican New Mexico." *New Mexican Lives: Profiles and Historical Stories.* Ed. by Richard W. Etulain, 106–30. Albuquerque: University of New Mexico Press, 2002.

Montoya, Maria. E. *Translating Property: The Maxwell Land Grant and the Conflict over Land in the American West, 1840–1900.* Berkeley: University of California Press, 2002.

————. "Dennis Chavez and the Making of Modern New Mexico." *New Mexican Lives: Profiles and Historical Stories.* Ed. by Richard W. Etulain, 242–64. Albuquerque: University of New Mexico Press, 2002.

Morin, Raul. *Among the Valiant: Mexican Americans in W. W. II and Korea.* Alhambra, California: Border Publishing Company, 1966.

Myrick, David F. *New Mexico's Railroads: A Historical Survey,* 1970. Revised, Albuquerque: University of New Mexico Press, 1990.

National Historic Trail Feasibility Study and Environmental Assessment: Old Spanish Trail. Santa Fe: U.S. Department of the Interior, National Park Service, 2000.

Nunn, Tey Marianna. *Sin Nombre: Hispana and Hispano Artists of the New Deal Era.* Albuquerque: University of New Mexico Press, 2001.

Pearce, T. M., ed. *New Mexico Place Names: A Geographic Dictionary.* Albuquerque: University of New Mexico Press, 1965.

Price, B. Byron. "Working the Range—The New Mexico Cowboy." *El Palacio* (Spring 1988).

Riley, Carroll L. *Rio del Norte: People of the Upper Rio Grande from Earliest Times to the Pueblo Revolt.* Salt Lake City: University of Utah Press, 1995.

Rivera, José A. *Acequia Culture: Water, Land, & Community in the Southwest.* Albuquerque: University of New Mexico Press, 1998.

Rockwell, Wilson. *The Utes: A Forgotten People.* Denver: Saga Books, 1956.

Rosenak, Chuck, and Jan Rosenak. *The Saint Makers: Contemporary Santeras and Santeros.* Flagstaff: Northland Publishing, 1998.

Sanchez, Joseph P. *Explorers, Traders, and Slavers: Forging the Old Spanish Trail, 1678–1850.* Salt Lake City: University of Utah Press, 1997.

————. *The Rio Abajo Frontier: A History of Early Colonial New Mexico, 1540–1608,* 1987. Reprint, Albuquerque: The Albuquerque Museum, 1996.

Sanchez, Joseph P. and John V. Bezy, eds. *Pecos: Gateway to Pueblo & Plains.* Tucson: Southwest Parks and Monuments Association, 1988.

Schroeder, Albert H. "Pueblos Abandoned in Historic Times." *Handbook of North American Indians,* Vol. IX. Ed. by Alfonso Ortiz, 236–54. Washington, D.C.: Smithsonian Institution, 1979.

Simmons, Marc. "Spanish Irrigation Practices in New Mexico." *New Mexico Historical Review* (Summer 1972): 135–47.

————. "History of the Pueblos Since 1821." *Handbook of North American Indians,* Vol. IX. Ed. by Alfonso Ortiz, 206–23. Washington, D.C.: Smithsonian Institution, 1979.

————. "History of Pueblo-Spanish Relations to 1821." *Handbook of North American Indians* Vol. IX. Ed. by Alfonso Ortiz, 178–93. Washington, D.C.: Smithsonian Institution, 1979.

————. "Settlement Patterns and Village Plans in Colonial New Mexico." *New Spain's Far Northern Frontier: Essays on Spain in the American Southwest, 1540–1821.* Ed. by David J. Weber, 97–115. Albuquerque: University of New Mexico Press, 1979.

————. "New Mexico's Colonial Agriculture." *El Palacio* (Spring 1983): 3–10.

————. "The Rise of New Mexico Cattle Ranching." *El Palacio* (Spring 1988): 5–13.

————. *New Mexico: An Interpretive History.* New York: W. W. Norton & Company, 1977. Reprint, Albuquerque: University of New Mexico Press, 2001.

————. "Santa Fe's presidio soldiers protected the province and the passage west." *Santa Fe New Mexican*, February 8, 2003, B-1, B-4.

————. "The history of La Bajada: 'Down the frightful hill.' *Santa Fe New Mexican*, February 15, 2003, B-1, B-3.

Stoller, Marianne L. "Grants of Desperation, Lands of Speculation: Mexican Period Land Grants in Colorado." *Journal of the West* (July 1980): 22–39.

Swadesh, Frances Leon. *Los Primeros Pobladores: Hispanic Americans of the Ute Frontier.* South Bend, Indiana: University of Notre Dame Press, 1974.

Utley, Robert M. *Frontiersmen in Blue: The United States Army and the Indian, 1848–1865.* New York: Macmillian Company, 1967. Reprint, Lincoln: University of Nebraska Press, 1981.

Van Ness, John R. "Hispanic Village Organization in Northern New Mexico: Corporate Community Structure in Historical and Comparative Perspective." *Survival of Spanish American Villages* Ed. Paul Kutche, 21–61. Colorado Springs: Colorado College, 1979.

Van Ness, John R. and Christine M. Van Ness. "Spanish & Mexican Land Grants in New Mexico and Colorado." *Journal of the West* (July 1980): 3–11.

Weigle, Marta: *Brothers of Light, Brothers of Blood: The Penitentes of the Southwest.* Albuquerque: University of New Mexico Press, 1976.

Welsh, Michael E. *U. S. Army Corps of Engineers: Albuquerque District, 1935–1985.* Albuquerque: University of New Mexico Press, 1987.

Williams, Jerry L. *New Mexico in Maps.* Albuquerque: University of New Mexico Press, 1986.

Yue, Charlotte and David. *The Pueblo.* Boston: Houghton Mifflin Company, 1986.